Surviving Vancouver

Surviving VANCOUVER

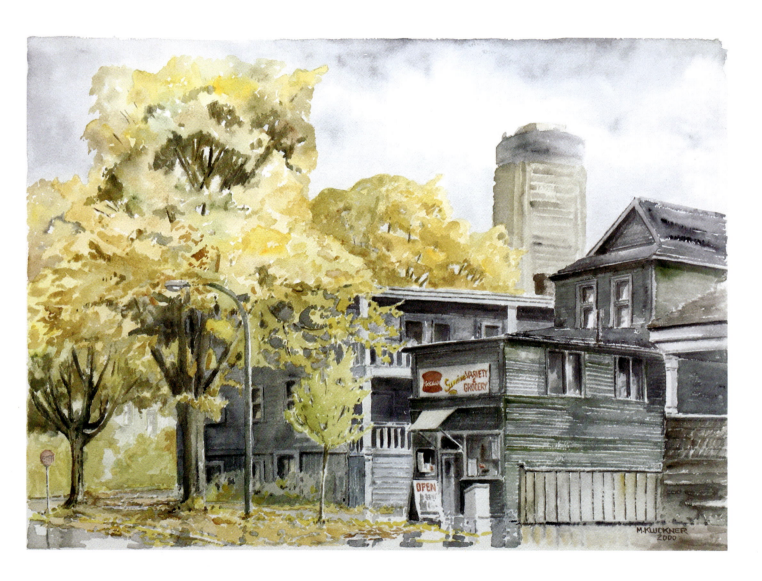

Text and art by Michael Kluckner

Midtown Press

Surviving Vancouver
© Michael Kluckner, 2024, text and illustrations
© Midtown Press, 2024

All rights reserved. No part of this publication may be reproduced or transmitted in any form or by any means, electronic or mechanical, including photocopying, recording, or any information storage and retrieval system, without permission in writing from the publisher.

Midtown Press
7375 Granville Street
Vancouver, BC V6P 4Y3
Canada
midtownpress.ca

ISBN 978-1-988242-54-5 (Print)
ISBN 978-1-988242-55-2 (PDF)

Legal deposit: Library and Archives Canada, 2024

Printed and bound in China
This book has been typeset in Cheltenham, Franklin Gothic, and Rollerscript.

Editor: Louis Anctil
Layout and production assistance: Denis Hunter Design

Library and Archives Canada Cataloguing in Publication

Title: Surviving Vancouver / text and art by Michael Kluckner.
Other titles: Vancouver
Names: Kluckner, Michael, author, artist.
Description: Includes bibliographical references and index.
Identifiers: Canadiana (print) 20230583970 | Canadiana (ebook) 20230583997 | ISBN 9781988242545 (softcover) | ISBN 9781988242552 (PDF)
Subjects: LCSH: Vancouver (B.C.)—Description and travel. | LCSH: Vancouver (B.C.)—Pictorial works. | LCSH: Vancouver (B.C.)—In art. | LCSH: Vancouver (B.C.)—Social conditions. | LCSH: Vancouver (B.C.)—History.
Classification: LCC FC3847.37 .K585 2024 | DDC 971.1/3304—dc23

(Title page) The Sunrise Grocery on Cardero Street between Nelson Street and Henshaw Lane as it was in 2000. It had become almost derelict in the rapidly changing West End, and as I painted it I thought of the Landmark Hotel in the distance at Robson and Nicola – the tallest structure in the city when it was built in 1974 – and how it would certainly survive long after little wooden buildings like those I was painting. As it turned out, the grocery became the Cardero Café, a busy and popular neighbourhood coffee shop, and the solid concrete Landmark Hotel was torn down – a climate crime – and replaced by two new towers of luxury condos.

Table of Contents

Foreword — 6
 A Note About the Art — 7

Introduction — 11
 A Brief Historical Geography of the Vancouver Area — 22
 The Evolution of the Vancouverite — 24
 A Location in Search of a City? — 26

Surviving (an adjective) — 39
 The Curious Case of Shaughnessy Heights — 56
 Resilient Chinatown — 74
 Hogan's Alley — 76
 Cabins and Conflicts — 79
 A Mobile Home — 84

Surviving (a verb) — 87
 The Great Divide — 88
 Making Room for the Rich — 102
 "Amazing Brentwood" and the Flight to the Suburbs — 109
 It's Not Easy Being Green — 112
 The Great Escape — 118

Acknowledgements — 122
Bibliography — 123
Index — 125

Foreword

Forty years ago, in October 1984, I launched *Vancouver The Way It Was* at the brand new second-generation Oakridge mall – the one now demolished for the new Oakridge mini-city – in the Woodward's bookstore there. Few things last for long in Vancouver. The city was emerging from a deep economic depression and optimistically anticipated the city's centennial and the much bigger party of Expo 86.

In the years since, Woodward's Department Store disappeared (in 1993) along with many of Vancouver's bookstores. With my publisher of that decade, Whitecap Books, I produced *Vanishing Vancouver* in 1990 and gained a reputation as a heritage advocate – a harsh critic of the city's willingness to clearcut itself the way the settler culture did with the forests that stood here in Indigenous times.

The starting point for *Surviving Vancouver* is a book called *Michael Kluckner's Vancouver* that I wrote and illustrated for Raincoast Books in 1996. It was a gentle thing, done at a time when the city seemed quite stable and affordable, in a pause between the post-Expo boom and the development frenzy that began soon after the Millennium.

Christine and I had moved to a sheep farm in South Langley in 1993, and with it up and running I went back to painting on daytrips into the metropolis and almost felt like a tourist. I painted watercolour vignettes of people and recorded the city's setting of harbour and mountains and beautiful parks and trees. There was no angst in it at all.

My publisher since 2015, Louis Anctil of Midtown Press, liked that book and wondered whether he could reprint it, but there was too much of it that I no longer valued and, as well, I lacked good "copies" – the 35 mm. Fujichrome slides that were my archive in the analog age – of some of the pictures. All of the original watercolours had been long sold to private collectors, as were many others I've included in this book that I did for shows at the Petley Jones Gallery over the next half-dozen years.

The sentiments and images of that 1996 book make it a period piece, the city having changed since then as much as the society it hosts. Even ignoring the upheavals wrought by the online world, Vancouver is a much harsher, more stratified place. Many of the 50+% of Vancouverites (38% of the 2.5 million people in Metro Vancouver) who are tenants are a besieged underclass, paying the highest rents in Canada to maintain a toehold and having little chance of the security of property ownership. Homelessness and drug deaths are a national scandal.

Thus, this book is about "surviving" and is divided into three sections: an introduction that looks back to my 1996 book and reproduces some of the images and thoughts from that tranquil time nearly 30 years ago; a second section about "surviving" as an adjective – what has survived of its fine buildings and beautiful neighbourhoods; and a third one of "surviving" as a verb – how people are surviving in Vancouver.

I have used "Vancouver" both as a term for the city itself and sometimes for Metro Vancouver – the region which includes Burnaby, New Westminster, the North and West Vancouvers, Surrey, Richmond, Delta, Port Moody, White Rock, the Coquitlams and the Langleys. The final section of the book considers that geography, and the "great escapes" further afield.

A Note About the Art

Sharp-eyed readers will note the shift in my illustrations from the soft watercolours of the '90s to a more graphic style, more often drawn than painted, especially in images involving people. In that earlier book, people looked like on the left.

More recently, sometimes in black and white, sometimes in colour, they've tended to look like below.

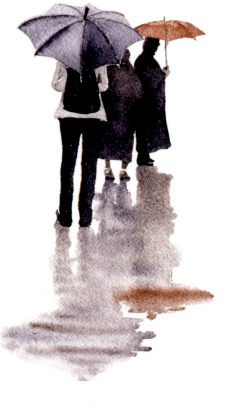

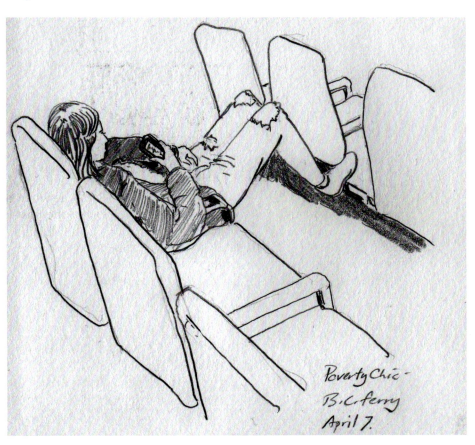

FOREWORD 7

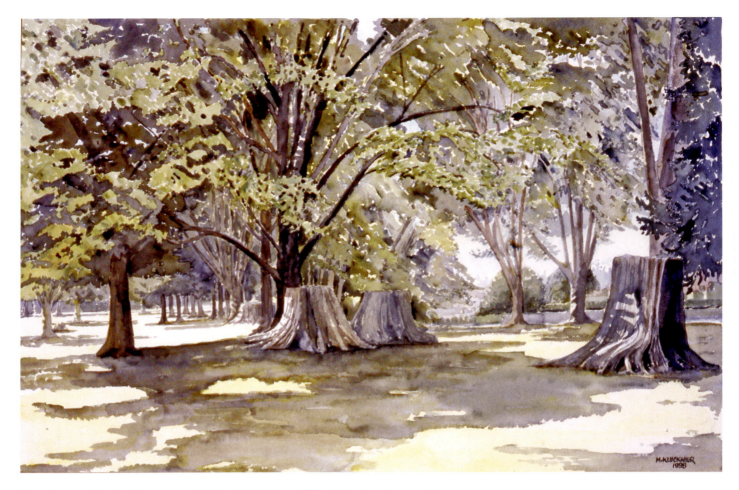

The stumps of ancient trees were left in Maple Grove Park in Kerrisdale more than a century ago in a rare (for the time) acknowledgement that there was anything here before. A watercolour from 1998.

8 FOREWORD

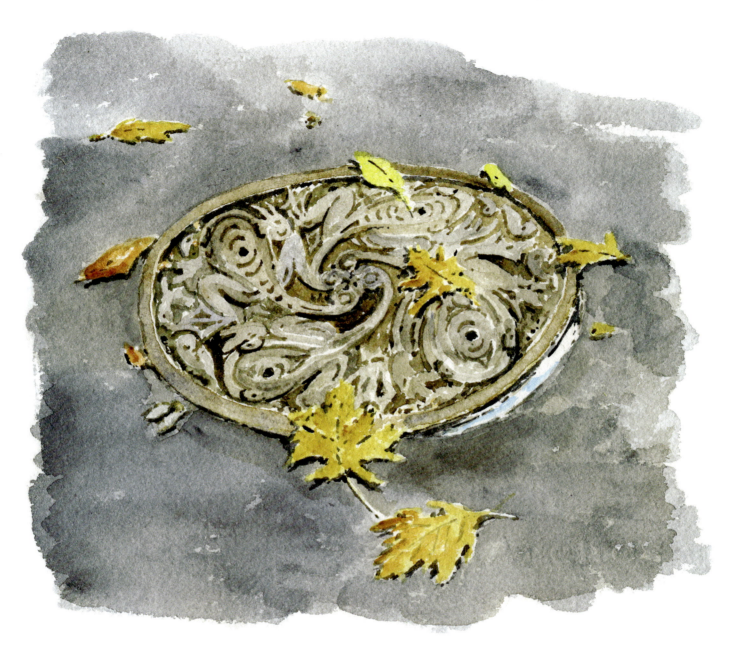

Amidst the glass, steel and stucco, the exotic trees and gardens, it is easy to forget that Vancouver was exclusively an Indigenous place until the 1860s, and then was overrun with immigrants. Indigeneity was erased, in historian Jean Barman's expression. It is returning slowly, most dramatically in developments by the Musqueam, Squamish and Tsleil-Wauteuth Nations on the Heather Lands, Jericho, UBC, and Senákw at the mouth of False Creek.

An early sign of that return was splendid Coast Salish artwork, seen in murals, entryways and sculptures, and, for the last 20 years, in storm drain covers created by Musqueam artists Susan Point and her daughter Kelly Cannell for the City's Art Underfoot program. A constant reminder for anyone who walks in the city as I do, they are everywhere.

FOREWORD 9

"On rainy days the modern towers of downtown Vancouver and the 'sails' of the Trade and Convention Centre on the waterfront lose their pushy, me-first angularity and seem to hang in the misty air… At this point a walker proceeding along the seawall has left the yachty clutter of inner Coal Harbour behind; Deadman's Island, on which stands the naval cadets' station known as HMCS *Discovery* [in the middle ground], was a burial ground for the Squamish Nation until European colonization began in the 1870s." (1996)

1996

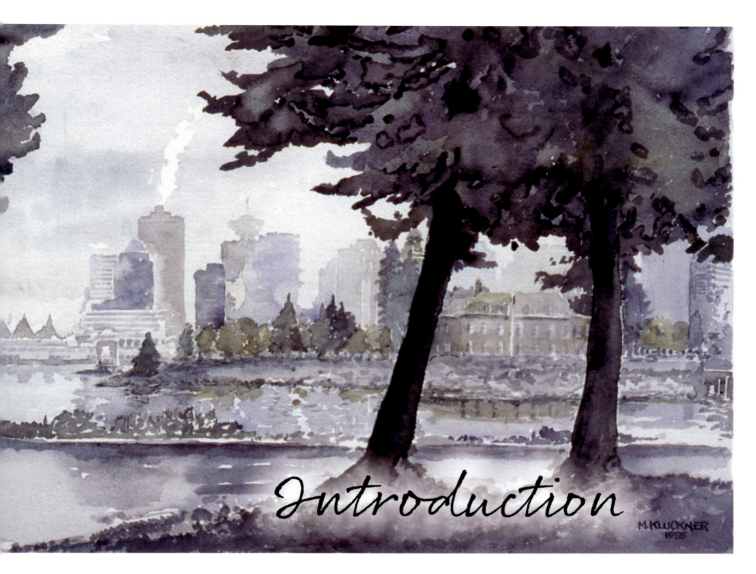

Introduction

"Why should we not just disappear, separately, to British Columbia, and have no scandal?" — LADY CHATTERLEY TO HER LOVER

"A lot of people have been disappearing to British Columbia lately. Attracted by its booming economy while savouring its unusual combination of the urban and the natural, many have chosen to settle in the province's Lower Mainland. It appears that all the people who have been predicting greatness for Vancouver over the past century will finally have their vision come true. But the city's grandeur will not be due to its industrial greatness, as it was believed in 1887 when the little mill town was connected to the rest of the world by the trains and steamships of the Canadian Pacific Railway. Instead, the city has become a curious combination of financial centre, trade centre, and home of the vaunted West Coast lifestyle, which attracts retirees and tourists who pump up the local service economy.

"...Those who stayed in Vancouver and got used to the wet winters, the cool summers, and the puttering indifference in which most people passed their lives, became quietly proud of their curious West Coast city. It was not a city of the Englishmen's 'quiet desperation,' but rather one of shy contentment. 'Canada' was something that happened somewhere else, except on wintry Saturday nights when streets divided into Toronto Maple Leafs and

1 Port Metro Vancouver handled 2,677 vessels in a year compared with the 1867 handled at the putative largest port in North America, Los Angeles. The port has direct and indirect employment of 115,300 in a region of 2.5 million people. See shipafreight.com.

Montreal Canadiens fans. The nearby Americans, who also got wet in the winter, ... were perhaps a bit brash, flag-wavey, and fond of uniforms.

"... Long-time residents are used to the battle of expectations that is a constant theme of life on the West Coast. The Lower Mainland has never had the single-mindedness of an Ontario or a Hong Kong on matters of business and development."

That is how I began my 1996 "gentle" book. It touched on the battle of expectations – the sense of contested space – that is a theme in every history book written about Vancouver, most recently in Daniel Francis's *Becoming Vancouver* (Harbour, 2021). Was it to become an industrial giant, a financial centre, or just a sleepy backwater compared with the Seattle of Boeing and Starbucks or powerful Toronto with its banks and factories? As it turned out, it became two places. First, it's a desirable home for relatively wealthy people from all over the world (and for people who got here a while ago and were able to buy housing when it was still affordable), with bubbles of high-wage economic activity in "Hollywood North" and technology and gaming businesses. Second: the port is one of the 10 largest shippers of cargo in North America.[1] Burrard Inlet's location as a gateway to Asia was foreseen by the Canadian Pacific Railway 140 years ago.

The port and the city have been two solitudes for more than 20 years, the separation enforced by fences and gates in a campaign of tightened security in the wake of the 9/11 terrorist attacks in 2001. The easy-going accessibility of the Campbell Avenue Fishermen's Wharf, the Rogers Sugar Refinery museum, and Bud Kanke's Cannery restaurant, to name a few, became memories. The one recreational incursion onto port lands – CRAB Park (standing for Create a Real Available Beach) at the foot of Main Street – was intended to provide a window onto the waterfront for the Downtown Eastside community. Like that community, it has become a homeless camp, still tolerated at this writing in 2023. Port Metro Vancouver also has terminals on the Fraser River and at Roberts Bank near Tsawwassen, and could well have had docks at Kits Point and Spanish Banks more than a century ago if the economy had grown faster.

A century ago the dream of a port on English Bay, avoiding the tricky First Narrows, almost came to pass. Instead, Spanish Banks remains as in the watercolour on p. 13, overseen by some of the most expensive properties in Canada. This map is in the collection of the invaluable City of Vancouver Archives. (COV-S397–; LEG1362.03)

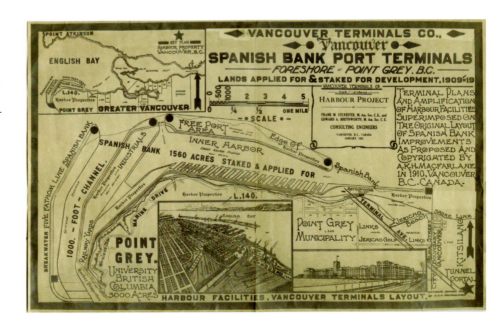

12 INTRODUCTION

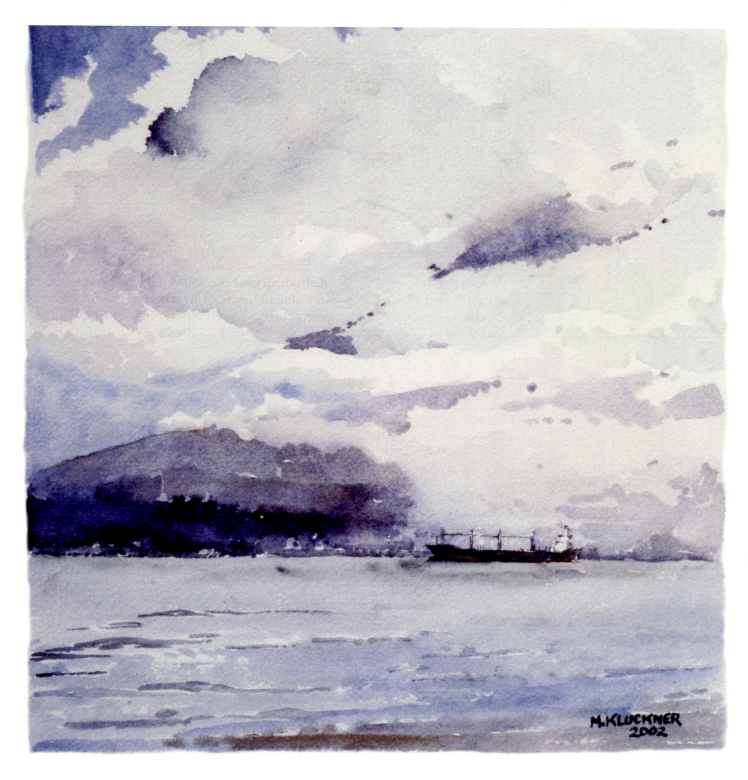

Freighters hanging in the mist, 2002, a picturesque aspect of Vancouver's connection to the outside world.

The working harbour itself is very visible from the downtown waterfront and from East Vancouver neighbourhoods, especially the enormous orange cranes of the two container ports, one just east of Main Street on the Kumkumalay / q'emq'emal'ay) peninsula of the Hastings Mill, the other farther east at the foot of Victoria Drive. The bulk-loading terminals on the North Shore, especially the yellow piles of sulphur just east of the Squamish reserve, add to the "industrial honesty" of the harbour, at least to my eyes, saying, "this is where your money comes from." But from the West End and the West Side, the only evidence is the freighters in English Bay.

INTRODUCTION 13

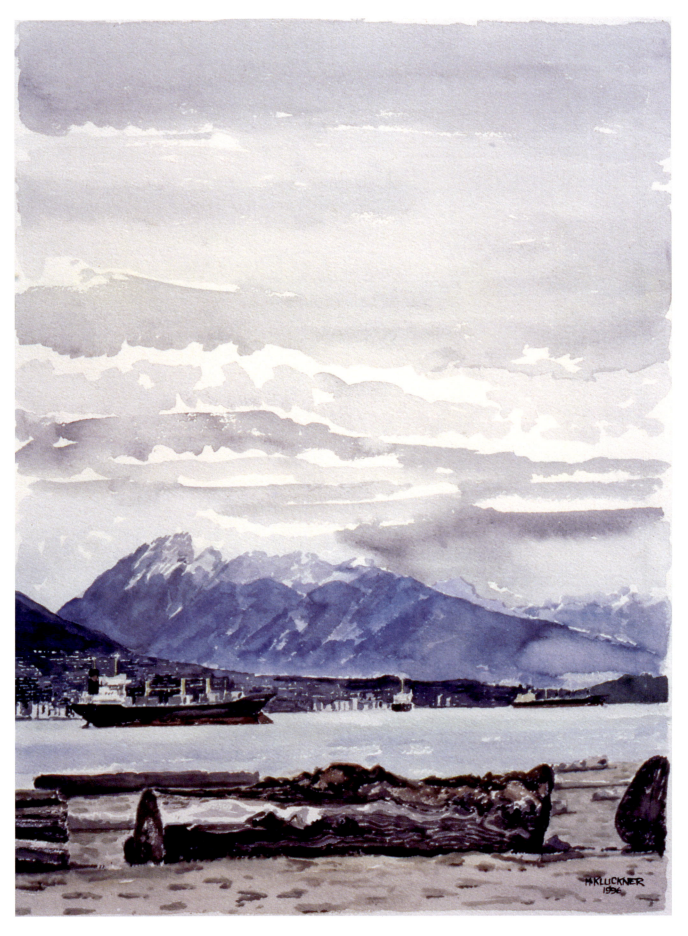

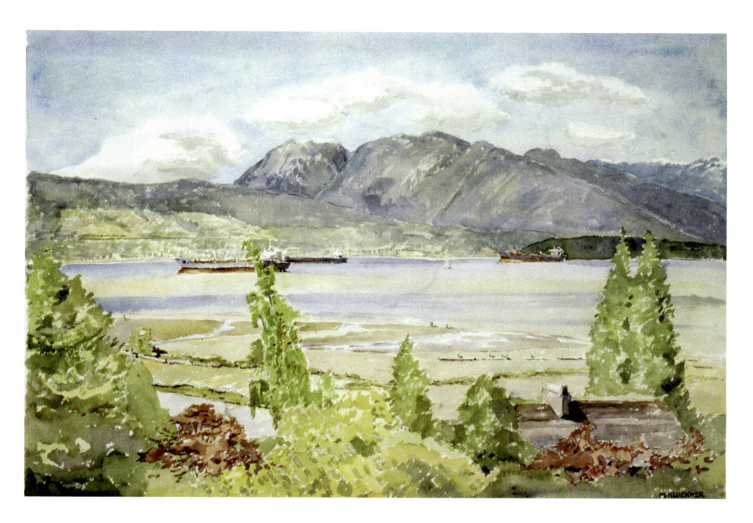

An interesting contrast is Sydney, Australia, where no freighters enter its famous harbour anymore and most of the old wool and goods warehouses have been replaced by condo towers. Shipping now goes into Botany Bay, south of the main city. But as is the case with Vancouver, cruise ships sail right into the heart of the city, bringing millions of tourist dollars every year.

"We don't mind the rain because we don't have to shovel it." That sums up the attitude of the proud, defensive, Vancouverite when challenged by a Canadian, usually someone from Toronto, or a Californian. The climate takes some getting used to, at least from November to March. For many people, a winter getaway on a discount airline to a resort in Mexico is a necessary survival technique. A surprising number of "snowbirds" own winter homes in places like Palm Springs and Scottsdale, returning to Vancouver in time to avoid paying the vacancy tax (for a home unoccupied for six months or more in a year). But the winter weather is more than compensated by the summer – usually dry and with little of the deadening humidity of places like, well, Toronto.

Not surprisingly for a landscape painter with a medium like watercolour, many of my images are about the weather, following the seasons from wet to dry and back again.

(Above) Low tide at Spanish Banks with freighters awaiting their turn at the port, on a summer day in 2004 from a house on 2nd Avenue.

(Previous page) Winter colours and freighters in the bay in 1996. The beach logs that demarcate space for sunbathers are famous enough to have warranted a story in *The Guardian,* on July 11, 2022, noting that fewer logs had returned from the Covid "log jail" established for social distancing during the pandemic, and reporting on the largely humorous debate about the value of public space and tradition.

INTRODUCTION 15

Winter in Vancouver, the typical scene of puddles on sidewalks, umbrellas, reflections, and mist. (2000)

On the next page, the aftermath on Commercial Drive of a February snowstorm. (2022)

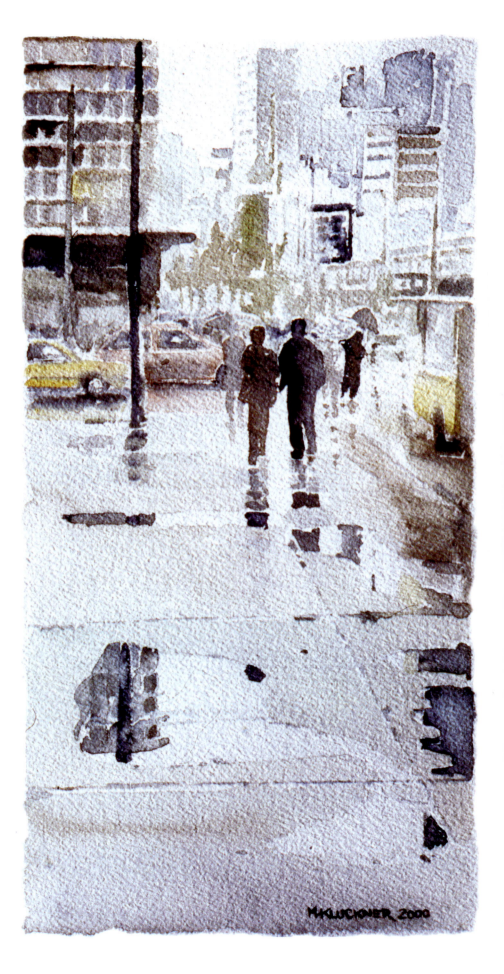

16　INTRODUCTION

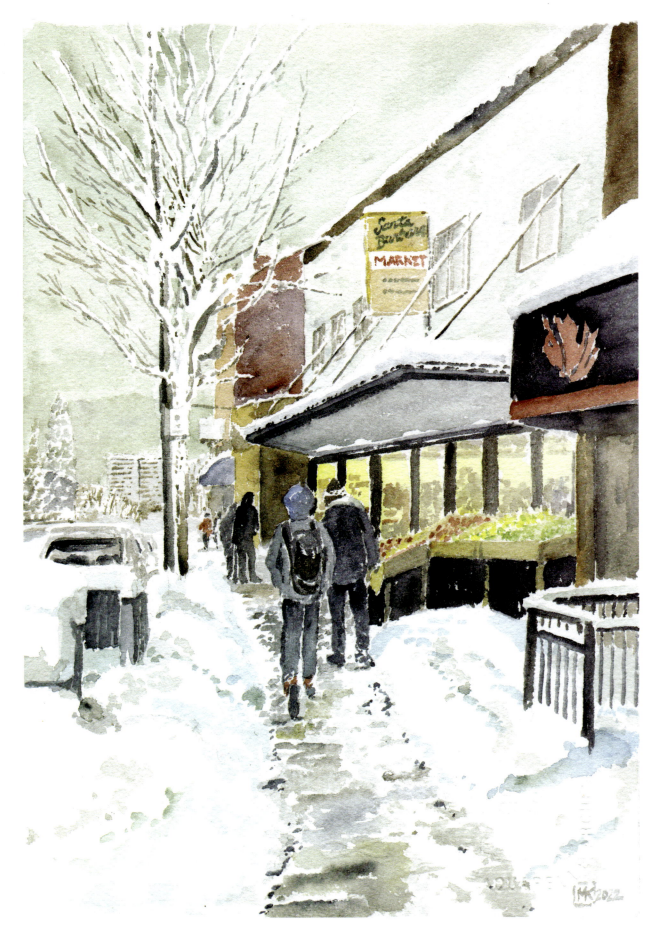

INTRODUCTION 17

February brings crocuses popping up on mossy lawns and among the massive roots of boulevard trees.

By early March, plums and some Japanese cherry trees have come into bloom, and Vancouverites become almost giddy with anticipation of Spring. The Cherry Blossom Festival is an annual April highlight, usually accompanied by Sakura Days, a celebration at VanDusen Garden.

The watercolour on the right looks toward English Bay past the English Bay Mansions at 1306 Bidwell, a 1908 design by architects Townsend & Townsend and one of the earlier apartment buildings in the West End.

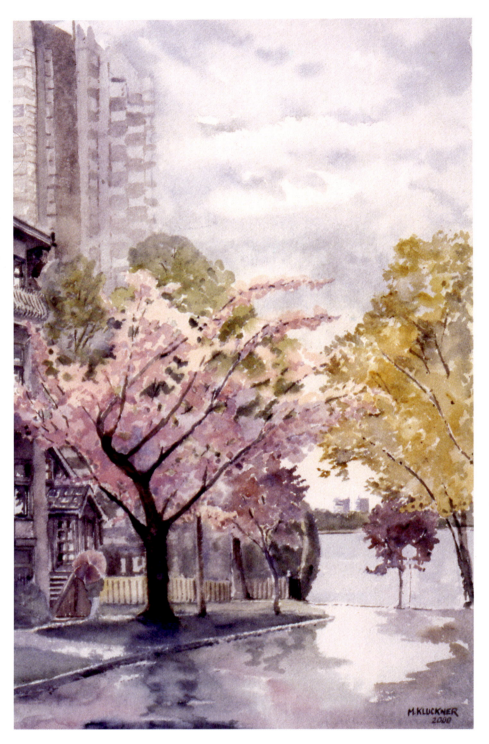

(Next page top) On a summer day in 2004, the Kitsilano foreshore west of Macdonald, still in its natural state, below the mansions lining Point Grey Road (including Lululemon founder Chip Wilson's, the most expensive home in British Columbia and assessed at over $70 million).

(Next page bottom) I wrote in 1996 that "sometimes in September the city awakens to a heavy fog, which the late-summer sunshine quickly burns off the streets and parks. But the cool English Bay water keeps a fog bank hanging just offshore, shrouding the patient freighters in a damp chill months removed from the hot sun on the beach. Every few seconds the doleful, two-note foghorn brays. At low tide the flats extend out hundreds of metres into the bay, exposing the bases of the radar towers that are usually successful at keeping ships in the harbour's deep water."

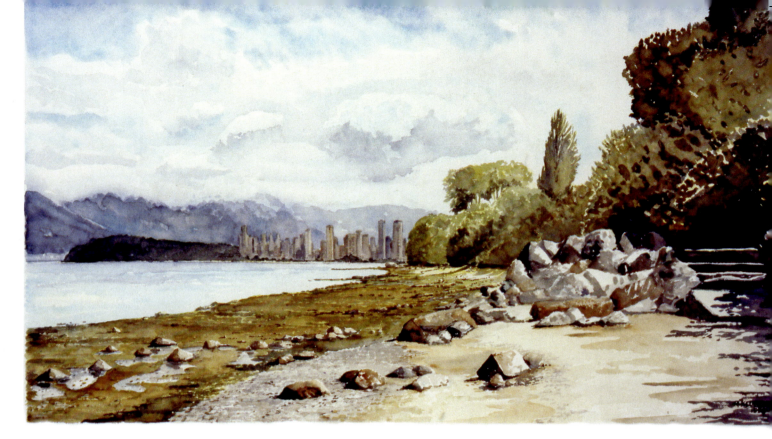
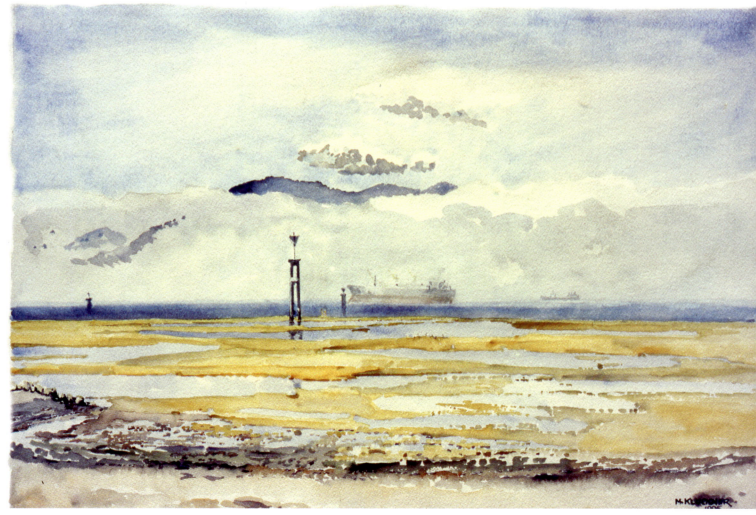

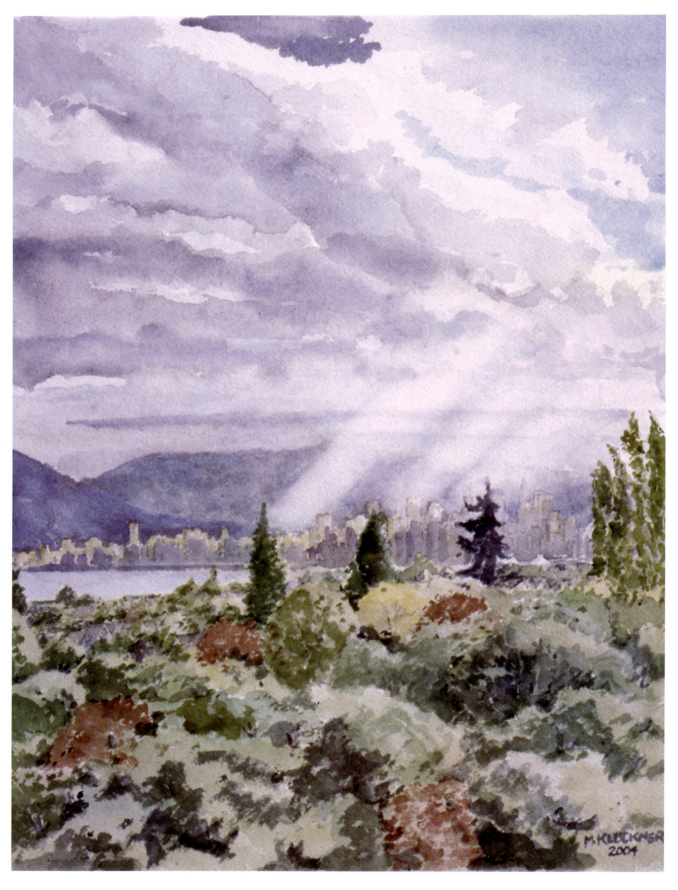

Rain shower over downtown, painted from a roof deck in heavily treed West Point Grey, 2004.

20 INTRODUCTION

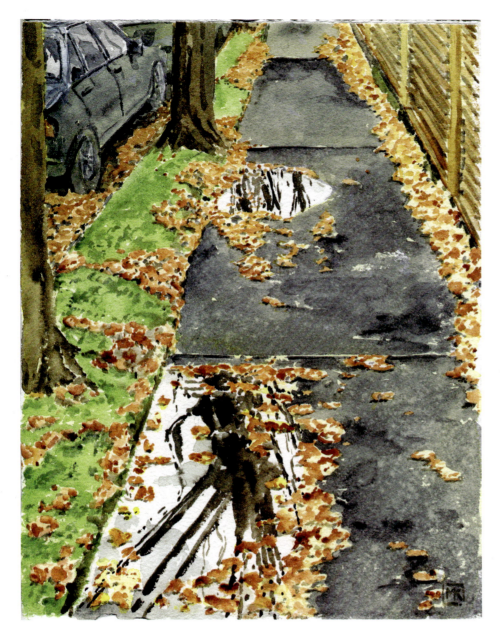

Vancouver autumns are children of the rain. When the monsoon, which used to be called the Pineapple Express and is now called an atmospheric river, holds off till November, the leaves stay brightly coloured and fall crackling dry to the ground, ideal for scuffing by strollers or scattering by bounding dogs. Usually, though, there is a week or two of rain by then, and leaves float decorously in the puddles formed in the dips and dents of sidewalks which have been heaved up by tree roots. (2022)

There are still Vancouverites who rake leaves and maintain their own yards, sidewalks and boulevards, but as the proportion of stratas increases more commercial lawn-maintenance people with their noisy equipment disrupt the quiet. The City of Vancouver banned gas-powered leaf blowers in the West End two decades ago, and in 2023 was moving to do so for the rest of the city, partly due to the annoyance factor but more significantly for their environmental impact: according to the California Air Resources Board, a commercial leaf blower operating for an hour emits as much pollution as a car driven for 1,700 kilometres.

INTRODUCTION 21

A Brief Historical Geography of the Vancouver Area

(Below) For thousands of years, the area has been home to Coast Salish people.
1782: smallpox spreads northward via intertribal trade routes from Mexico and kills about two thirds of the Indigenous population in two months.
1858: the Cariboo Gold Rush begins and British Columbia becomes a colony, with New Westminster established as the colonial capital the following year.
1860s–1870s: following a British naval survey, government and military reserves are marked off. Indigenous people are effectively confined to assigned reservations and settlers establish farms on land along the lower Fraser River and delta. The Moodyville Sawmill on the north shore and Hastings Mill on the south shore open; the latter begins to log a huge timber lease of much of the west side of future Vancouver. In 1870, "Gastown" is surveyed as the Town of Granville.
1867: the Chief Commissioner of Lands and Works, Joseph Trutch, refuses to recognize the original reservations of the Stó:lo people in the Fraser Valley and reduces them to one tenth of their size. Indigenous individuals are banned from choosing land for settlement as immigrants can, making it impossible for them to integrate into the new economy; the forced assimilation of their children in residential schools begins in the 1870s.
1885–1887: the Canadian Pacific Railway (CPR) completes its tracks to tidewater at Port Moody; Vancouver incorporates as a city on April 6, 1886, and the following year the railway is extended to the Vancouver waterfront at the foot of Howe Street, where ocean docks are constructed.

1913: the provincial government illegally seizes the Kitsilano Indian Reservation; following years of litigation, the Squamish receive $92.5 million in 2000 for the loss of their land, part of which became Vanier Park. In 2003, ten acres seized by the CPR for railway purposes were returned to the Squamish, setting the stage for the Senákw mini-city of the 2020s.

(Next page above) Vancouver initially has a southern boundary of 16th Avenue. The Hastings Townsite, a government reserve on the east side between Nanaimo Street and Boundary Road, joined Vancouver in 1910.
1870s–1910s: Richmond, Surrey, Langley, Delta, Burnaby, Port Moody, Coquitlam and North Vancouver establish municipalities, many with agrarian economies.
1908–1929: Point Grey, west of Cambie Street, separates from the Municipality of South Vancouver in 1908. In 1929 both agree to amalgamate with the City of Vancouver, which assumes its current boundaries.

(Next page below) The map shows in pink the land grant given to the CPR which included Fairview, Shaughnessy, much of Kitsilano and Kerrisdale, and property east as far as Ontario Street. The grid of many east-west streets takes a perceptible jog at Trafalgar Street on the west and Ontario Street on the east.
It also, in blue, delineates what might have become a separate municipality, Shaughnessy Heights, as described beginning on page 56.

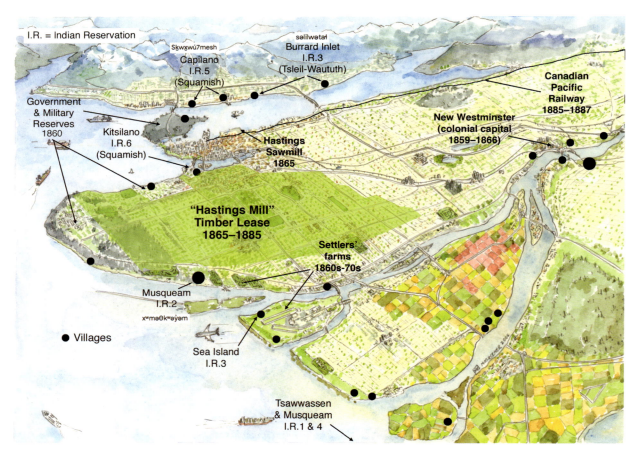

22 INTRODUCTION

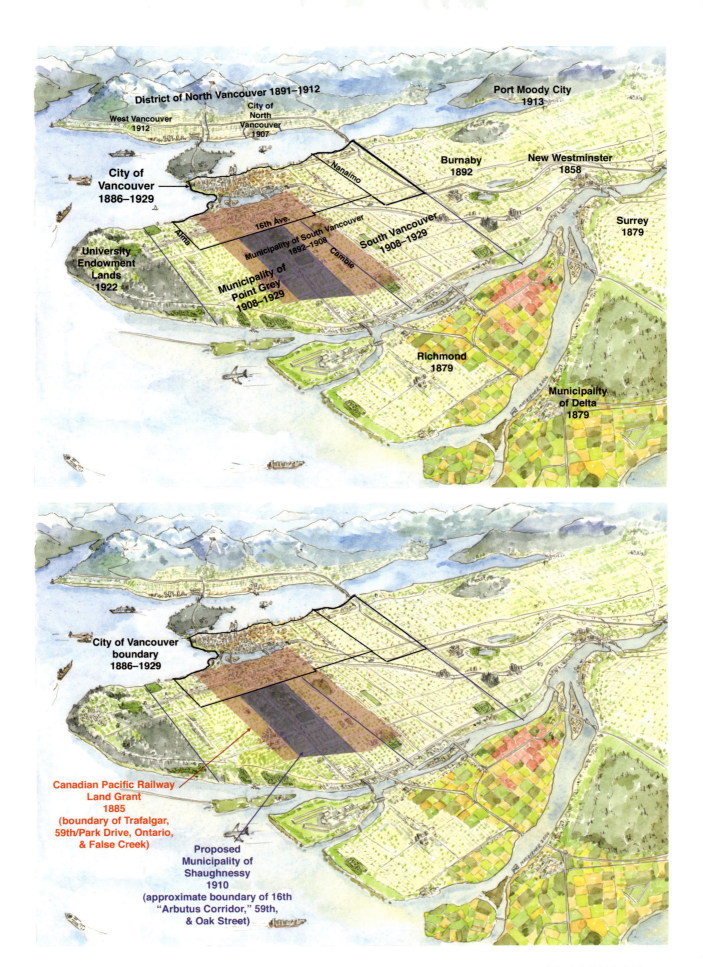

INTRODUCTION 23

The Evolution of the Vancouverite

I realized long after the 1996 book came out that there was only one vignette of a person on a cellphone. While quickly drawing the couple looking at a menu on the sidewalk, I thought "realtor," because they were just about the only people who had mobile phones – large heavy things like Maxwell Smart's shoe that only made phone calls.

There were also vignettes of people at phone booths, since vanished from the landscape, and people sitting reading newspapers, an occasional sight in 2023. Here are a few of the images from that distant era – the 1990s.

24 INTRODUCTION

And there were dogs, not many of them in the '90s, although the late Marg Meikle[2] caught an uptick in pet ownership with her 2000 book *Dog City: Vancouver.*

Then came Covid. "Retail sales of dog food grew to $2.8-billion in 2020, up from $2.2-billion in 2016, according to an Agriculture Canada analysis. With food, toys, insurance and all the other costs of looking after their furry friends, Canadians spent an average of $3,999 on their dogs in 2022, according to Statista. And there are now more dog owners than ever before. A survey released in June 2021, found that 3.7 million Canadians adopted, purchased or fostered a cat or dog during the pandemic."[3] And in a further development in March 2023, "pet custody" was added into provincial law relating to family disputes, while news stories featured overcrowded pet shelters and dogs abandoned by owners with financial problems.

[2] Meikle was the CBC's "Answer Lady" on the Vicky Gabereau radio show in the 1990s and the author of a number of books. She died in 2013 at the age of 57 after a long battle with Parkinson's Disease, during which she set up a series of charitable events called Porridge for Parkinson's. The donations funded the Marg Meikle Professorship in 2010 at the Pacific Parkinson's Research Institute.

[3] Dave McGinn, "Dog influencers are barking all the way to the bank," *Globe & Mail,* January 21, 2023.

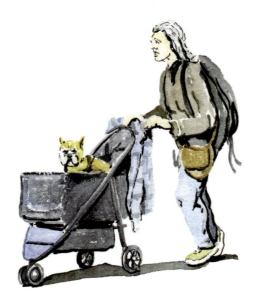

"Service Dog!" she cried, pushing the stroller onto a crowded bus (2022).

INTRODUCTION 25

A Location in Search of a City?

The battle over Vancouver's future in the 2022 civic election appeared to be about two issues that were fought over in newspapers, open-line radio shows and blogs. First, would more housing supply actually solve the affordability problem, especially for tenants? Second, would the Broadway subway and its accompanying Broadway Plan create more jobs and housing, with an eventual extension of the subway through the First Nations-controlled Jericho Lands to UBC, or would it merely disrupt established rental neighbourhoods, displace tenants in affordable apartment buildings, and increase land speculation?

A curious amalgam ostensibly of the left, led by incumbent mayor and former NDP MP Kennedy Stewart, sided with the development industry. Academic heft for more housing supply and "The Death of the Single Family House" – the title of his book – came from UBC sociology professor Nathanael Lauster. In the past, such alliances coalesced around right-wing politicians, especially from the Non-Partisan Association, such as 2005–8 Mayor Sam Sullivan, who actually trademarked the term EcoDensity to reflect his belief that clusters of concrete highrises were better for the environment and created a better city than other forms of housing.[4]

An equally curious amalgam, said to be of the centre right, was led by Vancouver councillor Colleen Hardwick, who reinvigorated the progressive 1970s political party TEAM (The Electors Action Movement) that had included her father Walter, an urban geographer at UBC. It staked out a slow-development position, one of moderate growth in keeping with the historic patterns of the city and its distinctive neighbourhoods. Although branded as NIMBYs[5] due to the support of conservative residents' groups on the affluent west side of the city, they gained academic heft from the pen of UBC planning professor Patrick Condon, the James Taylor Chair in Landscape and Liveable Environments, who had run for mayor in 2018 under the banner of the left-wing Community of Progressive Electors, once the home of legendary politicians including Libby Davies and the late Harry Rankin and Bruce Yorke.

As it happened, the one third of eligible voters who bothered to turn out on election day were uninterested in that debate and gave a majority to the new ABC Party led by Ken Sim, the city's first mayor of Asian ancestry, despite (or perhaps because of) them saying very little of what they would actually do. However, as the election neared, they promised to hire more police and nurses. Evidently "public safety" and the increasing disorder on the streets were on the minds of the majority.

In that election cycle, Burnaby, New Westminster, the North Shore, Delta and Richmond stayed pretty much with the status quo, while Surrey politicians fought about separating their police force from the RCMP. Their futures, most notably Burnaby's with its extraordinary tower communities (see page 109), seem set on a path of unhindered growth, and Surrey's population is predicted to surpass Vancouver's by 2030.

"Livability" is a "vague word that has become one that dozens of global agencies have adapted largely to rank cities for how appealing they might be to the transnational elite."[6] Vancouver topped *The Economist*'s Global Livability Index from 2002 to 2010, a period when the city's house prices tripled. Its rating slipped, famously, when the magazine's geographically challenged advisers reported that Malahat Highway traffic jams on Vancouver Island were a problem for Vancouver.

4 Frances Bula, "Mayor seeks to trademark 'Ecodensity' for himself," *Vancouver Sun*, June 23, 2007. The belief that slim glassy towers above lowrise podiums would create dense, appealing, environmentally benign communities was most strongly promoted under the brand "Vancouverism," principally by planner Larry Beasley in his book of that name (UBC Press, 2019).

5 Not In My Back Yard, usually an epithet directed at people said to be privileged, established, and resisting change and densification. YIMBYs are, of course, the opposite, and are identified with various "Making Room" zoning policies.

6 Douglas Todd, "How global livability rankings cursed Vancouver," *Vancouver Sun*, March 2, 2023.

For most people, reality is a struggle for affordability. A decade ago the STIR (Short Term Incentives for Rental) and Rental 100 programs were put into place by Vancouver's Vision council, and Mayor Gregor Robertson said: "We're seeing new housing built that meets the needs of people who live and work in the city. Our housing plan and programs are working and the shovels in the ground prove it."[7] Rents were high, but was there an alternative?

Toronto had the same problem. "The situation we are in – negative real interest rates and a tide of capital washing around the world in search of safe assets – is unusual, perhaps without precedent," said Doug Porter, chief economist of the Bank of Montreal.[8] Proposed solutions included a speculation tax to hit "flippers," a foreign buyers tax, a ban on foreigners buying resale homes (an Australian policy) and, of course, a program to build as much housing as possible as quickly as possible without flooding the market and causing prices to collapse.

Affordability had a brief win when the foreign buyer tax (officially the Additional Property Transfer Tax) came in, but it was temporary. Some said it was too low, even at 20%, to have enough of an impact. Kerry Gold profiled a property developer named Derek Wilson who left Vancouver and moved to London because he said Vancouver was becoming a resort town, with 80% of the windows he could see from his Coal Harbour apartment in darkness.[9]

According to rentals.ca, the average rent in Canada reached $2,024, a new record, in December 2022. Vancouver, never to be outdone, soon saw average rent reach $3,000 for a one-bedroom apartment. The average rent for a two-bedroom apartment in Vancouver – the minimum possible size for a family, one would think – was a staggering $3,598 in 2022. Next-door Burnaby is the third-most expensive city in Canada, following Toronto.

How much of these price increases was due to speculators playing the housing market like the "pump and dump" of the stock market? The all-time high for speculative sales came in 1981, when they were as much as 40% of total sales; then, prices skyrocketed and interest rates peaked at around 20% before the market crashed. In 1989, they peaked again at 30% of total sales. Since then, the highest percentage came in 2007-8, at 20%, according to Helmut Pastrick, chief economist of Central 1 Credit Union.[10] Some in the industry, including Pastrick, suggested that some speculation such as the pre-sale of condos was not a problem because it "generates a new market."

In 2018, the provincial government brought in a speculation tax, which was soon targeting BC residents as well as overseas investors. In 2021, 57% of the $78 million collected was from foreign owners and "satellite families." Was it unfair? "The number of British Columbians hit by the province's speculation tax continues to rise sharply, as the government tries to shift the justification for the tax from one that targets absentee foreign owners and moderates housing affordability into one that generates revenue for the provincial treasury. New figures released this week show BC residents defined as speculators increased almost 51 per cent in 2020."[11]

The debate continued with the Trudeau government's announcement in the spring of 2022 that it would impose a two-year ban on foreign investors in Canadian real estate. Whether it would have an effect on affordability and supply was doubtful, as Statistics Canada reported that 30% of BC (and Ontario) homes are owned by individual investors. The richest ten percent of them hold around one quarter of the total housing wealth. Another ten percent of the housing stock is owned by corporations.

Adding further complexity was research by SFU's Josh Gordon, who revealed that many purchases of real estate are made by proxies – Canadian

7 "City Incentives produce thousands of new suites at punishing rents," *Vancouver Courier,* October 1, 2014.

8 Janet McFarland, "What can the province do to help Toronto's 'dizzying' housing market?" *Globe & Mail,* March 25, 2017.

9 "Chalk up a win for affordability," *Globe & Mail,* November 16, 2018.

10 Quoted in "Speculating on the speculation tax," by Pete McMartin, *Vancouver Sun,* January 2016.

11 Rob Shaw, "Pure speculation," *The Orca,* November 10, 2021.

INTRODUCTION 27

12 Douglas Todd, "Trudeau's crackdown on real-estate investors won't work. Here's why," *Vancouver Sun,* April 15, 2022.

13 Laine Mitchell, "Canada's new ban on foreign homebuyers is now in effect." *Daily Hive,* January 2, 2023.

14 Kerry Gold, "Market watchers have little faith anti-flipping tax, foreign buyers ban will improve housing affordability in Canada," *Globe & Mail,* January 13, 2023.

15 See Douglas Todd, "Luxury homeowners in Metro Vancouver pay low income taxes, says UBC study." *Vancouver Sun,* November 9, 2022.

16 Joanne Lee-Young, "Bank mortgages, not bags of cash, behind mainland Chinese home buys: study," *Vancouver Sun,* November 2, 2015.

17 Charlie Smith, "Yan's 2015 study still stirs foreign-money debate." *Georgia Straight,* May 13, 2021.

18 Lisa Cordasco, "Governments and non-profits urged buy more land rather than build more housing units," *Vancouver Sun,* November 15, 2021.

residents acting for overseas investors. And meanwhile, adding to the demand for housing, the federal government raised limits on immigration and numbers of foreign students.[12]

The foreign buyer tax defined residential property as buildings with three homes or less, as well as parts of buildings like a semi-detached house or a condominium unit. The law does not prohibit the purchase of larger buildings with multiple units.

"Through this legislation, we're taking action to ensure that housing is owned by Canadians, for the benefit of everyone who lives in this country," said Housing Minister Ahmed Hussein in a news release on December 21, 2022.

"Homes should not be commodities. Homes are meant to be lived in, a place where families can lay down roots, create memories and build a life together."[13]

But, said pundits, there was little chance that the ban and BC's speculation tax would have an impact on prices or on money laundering. The penalties were little more than a wrist slap of a fine: $10,000. Toronto mortgage broker Ron Butler noted that the ban ignored the money brought into the country by international students, funded from elsewhere, and that these so-called "satellite families" typically declare little income tax in Canada.[14] Vancouver, with its luxurious properties owned by students and "homemakers," is a classic example. A 2022 study by UBC's Tom Davidoff, Paul Boniface Akaabre and Craig Jones noted that the owners of Greater Vancouver homes with a median value of $3.7 million pay income taxes of just $15,800 – exceedingly low for North American cities.[15]

A sideshow to the debate about foreign ownership and speculation was whether commentators were racist, with many, including then-Mayor Gregor Robertson, focusing on SFU City Program director Andy Yan's 2015 study[16] that identified non-Anglicized Chinese names in a paper about 172 housing transactions, leading to an ugly social-media war about intergenerational wealth, racism, exclusion, and privileged White people. The irony of Yan, a Canadian of Chinese ancestry, being somehow "racist," was duly noted by reporters and commentators.[17]

Was Vancouver not building enough due to the toxic mix of civic bureaucracy and NIMBYism? Reporter Lisa Cordasco quoted planning professor Patrick Condon: "The City of Vancouver has added more housing units per capita than any city in North America over the last 30 years, yet housing prices have increased faster in Vancouver than any other North American city." Getting land out of the private real-estate market, he said, is the only way to moderate its value and eventually lower the price of rental housing.[18]

If you are living in Vancouver on a median income and started saving in 2022, it will take 28.5 years to be able to afford a down payment to buy a house, according to a report on housing affordability from the National Bank of Canada. The bank estimated how long it would take a household to build the minimum down payment on a typical home in a city by saving 10 per cent of the pretax median income, which is an aggressive target. It was assumed the savings earned no interest.

Winnipeg stood out among the 10 cities examined as a place where young adults can relatively quickly save a down payment. Just over 29 months of saving were required to buy a home in the final three months of 2022, compared with an average 22.3 months going back to 2000. Calgary also got a lot of attention as a landing spot for young adults priced out of Ontario and BC housing markets, but Edmonton is even friendlier to home buyers. The median house price is cheaper, and the 29.2 months needed to save a

down payment is a little more than six months less than Calgary.[19]

As an example, a carpenter who had rebuilt our front stairs decamped to Calgary with his wife, saying he had no chance of a secure future even with his skills and good income in Vancouver.

It is just over half a century since the Income Tax Act changed, making the capital gains from a principal residence tax-exempt. The housing security of many of the Boomer generation and of their children through the "Bank of Mom and Dad" date from that quiet, economically depressed time in the early '70s.

A modest example of a Downtown Vancouver capitalist, 1995.

Pension funds and Real Estate Investment Trusts look for places to invest, and Vancouver's real-estate market is a top draw. For all the arguments that, without them, there would be no new homes and not even any maintenance on older apartment buildings, it becomes a chicken-and-egg question. As Kerry Gold wrote, "The big investor is in the Vancouver market expressly because growth is the expectation."

She quoted UBC's Patrick Condon: "Housing is no longer valued for its utility. It is now valued as a commodity, just like gold, Bitcoin or stocks and bonds. We have moved from an economy based largely on wages to one based largely on investments, with investors now in the driver's seat. It's extra complicated, because most of us participate in it and benefit from it, with our RRSPs and our pension fund contributions, not to mention the baby boomers benefitting from a passive gain of $4 million for their Dunbar home."[20]

Is the supply of housing keeping up with the demand by new immigrants and families? An authoritative source is the 2022 report from the Union of BC Municipalities,[21] which concluded that housing supply has kept pace with population growth in British Columbia over the previous five years. More housing has been built in British Columbia over the past three years than in any three years in the past 20 years, and that growth in the number of dwellings in BC has closely tracked population growth. It also noted that the development sector is currently facing significant trade and supply chain shortages, such as my carpenter mentioned above. Who will build new housing? As always, it's a question of "supply for whom" or the "right supply."

An unlikely source, perhaps, of new units, not necessarily more units, arises from the liquidation of stratas and their sale to developers. Poorly maintained condos are low-hanging fruit for developers, as are older ones in prime locations that become more valuable as vacant land.[22]

Before November 2015, 100% of owners had to agree to liquidate a strata. Then the threshold dropped to 80%. Adding to the complexity is BC Assessment, which doesn't value strata units based on their current use, but rather as part of a future development site, the same challenge affecting retail property and business owners.[23]

The newly anointed BC Premier, David Eby, jumped onto the "supply" side in November 2022, announcing legislation that would override what he claimed to be municipal barriers to the construction of more housing and arguing that a "trickle-down" or "filtering" process – rather Reaganesque, unusually for an NDP politician – would reduce demand on existing units

19 Rob Carrick, "The good, the sad and the unaffordable: Saving for a home down payment in Canada's big cities," *Globe & Mail,* March 21, 2022.

20 Kerry Gold, "Investors flock to Vancouver property market," *Globe & Mail,* April 11, 2022.

21 UBCM, *Building BC: Housing Completions & Population Growth 2016–2021.* Published March 23, 2022.

22 The Strata Titles Act dates from 1966, and condominiums began to be constructed in the '70s once banks got used to the idea and would lend money for them. There hasn't been a more significant piece of legislation affecting property ownership since colonial times. See my *Vanishing Vancouver: The Last 25 Years,* pp. 152–8.

23 Michael Geller, "So you want to liquidate your aging condo building…", *Vancouver Sun*, September 28, 2017.

INTRODUCTION 29

24 Dr. Elliot Rossiter: "More supply won't stop B.C.'s housing crisis on its own," *Vancouver Sun,* November 28, 2022.

25 The process whereby tenants are evicted for "renovations," the suite then being rented to new people at much higher rents. "Demovictions" are evictions for new construction, which might be rental homes at much higher rents. The average rent increase in Vancouver recently after tenants vacated a unit was 24 percent, according to the Canada Mortgage and Housing Corporation. Recent rent controls limited increases to 2.6 percent in 2020, 0 percent in 2021, and 1.5 percent in 2022. See also Douglas Todd: "Why more housing supply won't solve unaffordability," *Vancouver Sun,* November 26, 2021.

26 Melody Ma, "'Upzoning' might mean more apartments – But it'll wreck neighbourhoods," *The Tyee,* December 5, 2019. A more recent story is Dan Fumano's "Hanging by a thread: the push to save Vancouver's heritage businesses," *Vancouver Sun,* June 26, 2023.

27 John Mackie, "The fight for Kingsway: Small working-class businesses versus residential redevelopment," *Vancouver Sun,* January 22, 2022.

28 Reid's granddaughter Alison Wyness wrote a history of the store and family, *The Larder of the Wise,* released in 2020 (Figure 1 Publishing).

that could then be occupied by lower-income individuals.[24] It ignored the evidence that renovictions[25] and demovictions were the actual culprits in lowering the supply of affordable units.

What might all this new supply mean, if it were to happen, following an upzoning? Activist Melody Ma suggested that "working-class, racialized people will be driven out by city-promoted gentrification" in a *Tyee* article focusing on a planning proposal to allow four- to six-storey market rental housing in commercial zones and on side streets, especially in South and East Vancouver. Not just housing, but the commercial life of neighbourhoods was in play, such as the diversity of "Little Saigon" between Fraser and Nanaimo along Kingsway, with "Filipino eateries, affordable Chinese grocers, Hong Kong cafés, bakeries, hair salons, laundromats, dentists, hole-in-the-wall bubble tea shops, Indian and Pakistani restaurants, temples, churches, and more."[26]

Another story on the subject quoted Andy Yan, who was raised in East Van and calls himself the East Van Avenger: "A lot of these businesses are ones that planners and developers may not see as important. Just working-class businesses. In one way, it's the other side of Vancouverism [see page 26]. Vancouverism is all towers and glass, all clean postmodern buildings. This is the blood, sweat and tears of an immigrant working class. It's the gritty city, [one] that doesn't fit well in a *Dwell* magazine."[27]

Compared with redeveloped parts of Kingsway, or parts of East Hastings with new buildings, there are few chain stores on the old city streets, whether in Little Saigon, on Victoria Drive between 33rd and 41st, or on Commercial Drive.

"Residential is overwhelming commercial," said Yan, noting that there was a lot of "invisible manufacturing" going on for the food industry on Kingsway. It's a throwback to a much earlier Vancouver, the one of the legendary butcher James Inglis Reid Ltd. on Granville Street, which cut, cured, smoked and baked its own products in rooms behind the retail shop.[28]

V ancouver is no stranger to boosterism – it's the cocaine in its veins. Many people with even a passing interest in the city's history will have heard the slogan from the 1900 era that "Vancouver Then / In 1910 / Will Have a Hundred Thousand Men." The population did indeed

1995

A stacked townhouse, 2023.

quadruple in the first decade of the 20th century, expanding onto cheap land subdivided from the large holdings of early, well-connected officials and settlers once the region's Indigenous people had been confined to reservations and barred from taking up "Crown land" themselves (see page 22).

A 2022 conference boosting the future was "The Next Million," hosted by CityAge, a Vancouver-based company that has held events in London, Hong Kong and across North America. One panel, entitled "Planning for Growth: How to Sustainably Add the Next Million," featured Wesgroup Properties vice-president of sustainability Malcolm Shield, whose company is one of Western Canada's largest private real estate developers. He cited a CMHC report from earlier that year which estimated BC needs 570,000 new homes by 2030 to restore any semblance of affordability. That equates to roughly triple the province's current level of construction, Shield said. "It's just beyond what the system can currently manage."[29]

The absurdity of the "supply" arguments can be summed up with a simple question: "Where are the skilled workers to build all these new houses and apartments?" The construction industry is at full employment, leading

[29] Dan Fumano, "Planning for Metro Vancouver's 'next million' residents is just as hard as it looks." *Vancouver Sun*, November 24, 2022.

INTRODUCTION 31

Guys with guitars, 1995.

30 One tragic aspect of the story is the number of injured construction workers, addicted to opioids while trying to keep working and then dying of overdoses of fentanyl and the other components of the toxic drug supply. Seventy percent of the drug deaths in 2022 were working age, between 30 and 59, and 79% were male. Construction and extraction workers were the most likely to die, with a rate more than quadruple that of the average across the civilian workforce, according to the Centre for Disease Control in the USA.

31 "Viewpoint Vancouver," April 10, 2022.

32 Patrick Condon, "Am I the last voice against SkyTrain to UBC?" *The Tyee,* January 29, 2019.

to the classic supply-demand scenario of wages and costs increasing at a staggering rate, and along with them the affordability of new homes. By some estimates, construction costs have gone up 50% since Covid began in 2020. Can more construction workers be enticed to move to BC? Perhaps, but where will they live?[30]

It's one thing for private developers to be boosters, another when the City and its planning department become cheerleaders by promoting initiatives such as the Broadway Plan to densify Broadway between Main and Arbutus in order to justify the huge public expense of a subway. Then-Mayor Kennedy Stewart's promise during the 2022 municipal election campaign to create 80,000 new housing units in Vancouver over 10 years was a particularly blatant example.

Regardless, politicians continued to lock horns, fighting over whose predictions were correct. (In the expression of my father's day, "Figures lie and liars figure.") In reality, Vancouver and Burnaby have a net negative migration of current residents, with Surrey, Langley and Maple Ridge receiving most of the outflow. Vancouver is also seeing a significant reduction in its share of immigrants moving into the region, with Surrey now the most common destination for them.

As former councillor and director of the SFU City Program Gordon Price wrote on his blog: "To 2050, it is projected the region will grow on average by 35,000 people a year. For Kennedy Stewart's promise of 8,000 units a year to be valid, Vancouver would need to receive half the regional growth. Vancouver has grown by 3–4,000 units each year. The projection on the Metro Vancouver web page is an annual growth of about 5,500 people a year in CoV, which would be approximately 2,750 housing units a year if we assume household sizes growing smaller."[31]

Then-UBC President Santa Ono touted the extension of the Broadway subway to UBC for $7 billion (the estimated cost of the complete line from the VCC-Clark station) as a way to encourage economic growth and prosperity throughout the region, saying that UBC would not use academic funds but would contribute "new revenue from the introduction of the line to the university," meaning money from the sale of market condos on university lands.

UBC's Patrick Condon argued that subways are anything but green – green infrastructure should be "lighter, greener, cheaper and smarter"; as well, the costs are staggering: an estimated $491 million per kilometre, while modern trams, as in Europe, could be built for about $50 million per kilometre of double track. Light rail would spread development around the city into villages, like Kerrisdale or the old streetcar suburbs of Kitsilano and Grandview, rather than concentrating it into bloated luxury developments like Oakridge, which Condon described as a "monument to class war in its marketing and financial aims," that is, "a war of the investor class against the wage-earner class."[32]

32 INTRODUCTION

Between 1958 and 1972, doctors, dentists, lawyers and other professionals could write off capital cost allowance, or CCA, against other income, and many invested in rental properties. It was a safer bet than the stock market – especially the notorious 'penny-stock' Vancouver Stock Exchange – in an era before mutual funds and bond funds became widely accepted.

During this period, approximately 35,000 rental units were built throughout the city, including most of the low-rise walk-ups found in the West End, Kitsilano, Kerrisdale, Marpole, and Grandview – much of the stock of affordable apartments in the city. The 1960s was the era of highrise construction in the West End, and midrise 10- to 12-storey buildings were also erected in South Granville and Kerrisdale.

In 1973, in response to the housing crisis, the NDP provincial government introduced rent controls. The allowable annual increase varied, but in 1975 it was 10.6 percent and new construction was exempt for five years. It coincided with the introduction of condominiums, made possible by the Strata Titles Act of 1966, which became popular with developers who otherwise would get their return on investment in a trickle over subsequent years. Suddenly, there was little incentive to build rental.

The federal government responded with an alphabet soup of programs, most significantly the MURBs. Between 1974 and 1981, the Multiple Unit Residential Building program created thousands of rental apartments across the country. MURB units could be strata-titled and sold following a rental period. Four decades later, many MURB apartments continue as rentals, although there were never enough to keep up with demand.

In the 1980s, financial institutions increasingly required condominium developers to pre-sell a percentage of the units in a building before approving financing. Coinciding with societal changes to smaller family units, and more people living alone, it created a demand for small suites, the kind of investment that would appeal to investors. More than 40 percent of Vancouver's new condominiums were purchased by investors and rented out, depending on whether the strata itself voted to allow rentals, a number that has continued to this day.[33]

While rents did not always cover costs in the initial years, over time investors earned a profit and tenants helped pay off their mortgages. In 2022 42.5 percent of all new rental units built in Vancouver were condominiums.[34]

Inevitably, private-sector voices called for a return to the MURBish years. One writer pointed out the high costs to subsidize affordable housing, such as the $415,000 per suite for a project in South Surrey that had "the resulting rent... not much lower than in the current market."[35]

And then there are the basement suites and secondary suites in detached houses, many of those houses being owner-occupied. The dividing-up of detached houses began in the 1910s and 1920s as people moved out of some areas for more exclusive ones, the most extreme example being the exodus from the mansions of the West End to Shaughnessy Heights and the absolute determination in the latter to limit developments to one family (plus servants) in one house on one property (see page 56).

There were extreme housing shortages in Vancouver during the Second World War due to the boom in wartime construction and the flood of workers into the city. The War Measures Act overrode municipal bylaws and encouraged additions of suites into existing houses. But with the return of

People in the rain, 1996.

[33] Adapted from Michael Geller, "Rent control history," *The Tyee*, February 23, 2023.

[34] A study by Andy Yan, director of SFU's City Program, showed how important condo rentals are to the housing supply. The peak in the region was the UEL, where 49% were not owner-occupied, with Vancouver close behind; White Rock, at 21%, had the fewest. It demonstrated how many were investor-owned, potentially a valuable source of rental housing, but also questioning how many were seasonally empty or kept vacant. See also "Close to half of Vancouver condos aren't occupied by owners," by Naoibh O'Connor, *Vancouver Courier*, June 27, 2019.

[35] Frank O'Brien, "Rental crisis cries for return of investor tax incentives," *Western Investor*, December 20, 2019.

INTRODUCTION 33

Perplexed (with throwaway water bottle), 2022.

36 City of Vancouver, *The Role of Secondary Suites: Rental Housing Strategy – Study 4,* December 2009.

37 The municipal government's November 2022 report on storefront vacancies showed the highest storefront vacancy rate in Hastings Crossing, a staggering 28%. This is followed by Dunbar Village (17.8%), Point Grey Village (17.5%), Strathcona (16.9%), Chinatown (16.8%), and Robson Street (15.5%). Quoted from "Troubling trend as more of Vancouver's retail spaces sit empty" by Joanne Lee-Young, *Vancouver Sun,* April 4, 2022.

38 Frances Bula, "Vancouver explores tax relief for small businesses," *Globe & Mail,* March 11, 2023.

39 Sarah Grochowski, "Rising rent and taxes threaten Vancouver non-profit that provides space to artists," *Vancouver Sun,* March 18, 2023.

prosperity postwar, the City adopted a Zoning and Development by-law in 1956 which made secondary suites illegal in RS-1 (single family) areas. Although the core of the bylaw in the Harland Bartholomew Plan of 1930 left the option open for single-family areas to become duplex ones, depending on the desires of residents, Council mandated the closing of all illegal suites over a 10-year period, removing more than 2,000 of them.

Then came the acute housing shortage of the early 1970s, with vacancy rates hovering near zero, leading to some extensions of timelines and hardship exemptions. By that time, "the basement suite" had gone into the lore of Vancouver as a kind of right of passage between leaving the family home and becoming a respectable citizen. The City backed off a little in 1981, enforcing closures only on a complaint basis.

In 2004, the City reversed course and began to reduce barriers hindering the legalization of existing suites and the creation of new ones. Then, as part of its EcoDensity initiative (see page 26), in 2007 the City expanded the allowable size of single-family houses with the new floor space to be in the basement, thus reducing the above-ground bulk of houses while providing new accommodation.[36]

Unlike the 1982 housing meltdown, when retail was thriving but residential streets had dozens of mossy for-sale signs, the most visible sign of the 2020s malaise has been the empty storefronts on Vancouver's main streets. Certainly, part of that is the popularity of online shopping for goods, food and meals among the superbusy, young, cashed-up, tech-savvy set. Some days it is hard to move around neighbourhoods for the Amazon, FedEx and Fresh trucks and the DoorDash and Skip The Dishes delivery bikes. Another culprit is the popularity of big-box stores and bulk-buy places like Costco.

The vacancies were not unique to any one specific area of the city, but rather cut across various districts, highlighting social problems on the edge of the Downtown Eastside and the depopulation of west-side neighbourhoods.[37]

Small business were clearly being taxed out of existence, with the culprit in this case being the provincial government's property assessment system, which set the taxation rate based on a "highest and best use" of the land – its development potential, perhaps four or six storeys when there is just a single-storey shop on the site. The hapless retailer would be forced, based on the "triple-net lease" usually signed with the landlord, to pay a much higher amount of tax.

The newly elected Vancouver Council announced in 2023 that it would pilot a program to reduce business taxes. The provincial government was lobbied for a decade by cities including Victoria and Kelowna to fix the unfair situation.[38] Among the victims identified were arts groups such as Beaumont Studios in Mount Pleasant, whose rent had risen to $42,000 a month.[39]

34 INTRODUCTION

Broadway during subway construction, 2023

At a public workshop in 2018 to discuss planning principles and the proposed Broadway Plan, I sat at a table with the legendary former Director of Planning, Ray Spaxman. The question posed to the participants, in the wake of years of fractious public hearings, was how to restore public confidence in Vancouver's planning process. Spaxman suggested one fix: get rid of "conditional zoning."

Unique among BC towns and cities, Vancouver has its own charter with the provincial government – under the Canadian constitution, municipalities are "children" of the provinces and have a limited capacity to tax and make laws. One right they all have is the ability to zone properties for specific uses: retail-commercial, multi-family, industrial, single-family detached house, and so on. In the Bartholomew Plan of 1930, the City's first formal attempt to plan and regulate, there were six zones. By the 2010s, that number had ballooned to more than 80, evidence of the bureaucratization of city government and the hoops that builders had to jump through in order to do their building.

In the 1950s, Vancouver obtained an additional development option: CD-1 or "conditional" zoning, creating a "comprehensive development" plan for a specific piece of property. The first piece zoned was the site for Oakridge Shopping Mall on April 23, 1956[40]; another significant one was the decision, in the face of the proposed demolition of Christ Church Cathedral and its replacement by a highrise tower and the church in a crypt, which allowed the church's "unbuilt density" to be sold to a site next door, creating a taller office building while saving the 19th-century church building.

People on the Art Gallery steps, 1996. For two years until 2023, those steps hosted a memorial of hundreds of pairs of small shoes to honour Indigenous children who attended residential schools.

40 Thanks to Michael Gordon, planner and adjunct professor, for the information about CD-1.

Man in a red chair, 1996.

36 INTRODUCTION

Poverty chic, 2021.

41 The City announced in 2023 that it was moving toward a fixed rate of CACs for low- and mid-rise residential projects. See the *Daily Hive Urbanized* blog by Kenneth Chan, April 11, 2023.

42 *The Tyee,* December 3, 2021.

The use of CD-1 has expanded wildly – there are now 875 individual pieces of property with CD-1 zoning across the city. In recent years, almost every new residential development has come forward looking for more height, more density, than the multi-family zoning will allow. The developer enters into a bartering process with City officials, resulting in the developer paying CACs (Community Amenity Contributions) to the City, ostensibly to fund parks or community centres but, increasingly, to fund the city government itself.

From the viewpoint of some critics, this is close to "selling zoning," explicitly prohibited under the provincial rules that underpin the municipal system. Each CD-1 application has to go to a public hearing, sometimes stretching over many days with hundreds of speakers, usually mostly opposed, and typically followed by the approval of the project as if the hearing never happened.

The CACs are determined by area-based targets and negotiations between City staff and developers. Large-scale and luxury projects generate the most CACs. The existing process of determining CACs by negotiation has contributed to housing affordability issues, given that negotiations can often be a years-long, drawn-out process. Some major developers have spoken out against Vancouver's CACs systems for their unpredictability, and they no longer prefer to build within this city, instead choosing to build in suburban cities with simpler regulations.[41]

"Planning by Torture" is how former *Georgia Straight* editor Charles Campbell described one public hearing for the redevelopment of the Safeway property at Commercial and Broadway – the SkyTrain crossroads.[42] Having engaged citizens in a multi-year planning process that stipulated heights and densities, the City then ignored its own plan. Repeatedly, across the City, the millions of dollars spent on zoning plans are rendered useless by spot zoning, and the faith of the public in its municipal government is whittled away.

Tattooed girl, 2022. Adolf Loos, the Viennese architect, hater of decorated buildings, and founding spirit of Modernism, wrote in his 1910 essay-lecture *Ornament and Crime:* "The modern man who tattoos himself is either a criminal or degenerate."

INTRODUCTION 37

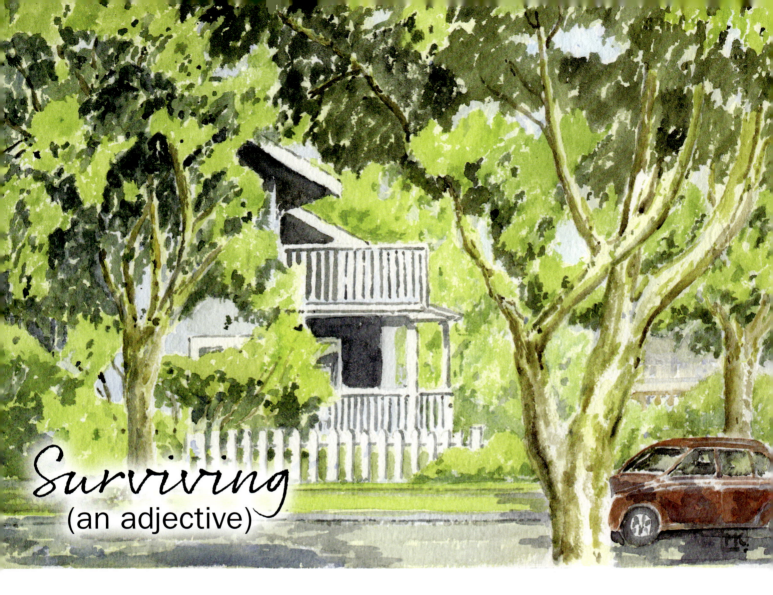

Surviving
(an adjective)

An East Vancouver street: Venables near Lakewood, 2021.

"Surviving Vancouver," in this chapter, is the places that have somehow managed to survive. Conservation-minded residents in the city's crescent of old neighbourhoods – Strathcona, Grandview, Mount Pleasant and Kitsilano – have retained many vintage streetscapes of mature trees, brightly painted wooden houses and gardens – the "garden suburb" from the streetcar era of a century ago – as have New Westminster residents in the Queens Park district, a Heritage Conservation Area. Vancouver's First Shaughnessy, also designated as a Heritage Conservation Area in 2015, is described beginning on page 56.

Other parts of Metro Vancouver have seen a steady turnover in buildings, with the old discarded, sometimes for apartment buildings and condos as befits a growing region, but too often just replacing what was there with something bigger and new. In the wealthy areas of the North Shore, a generation of "Mid-Century Modern" houses by architects including Ron Thom and Erickson-Massey – the houses photographed by Selwyn Pullan for *Western Homes & Living* magazine in the 1950s – have been lost along with their complementary landscapes. The replacements are grand and impressive, bombastic even, like the polished luxury SUVs in their driveways.

Thirty years ago in the 1990s, there was an uptick of support for heritage and preservation, but it has dwindled in the last decade as the demands of growth and the scarcity of affordable housing, and affordable land, have

SURVIVING (AN ADJECTIVE) 39

given ammunition to architects, developers, and housing-supply activists. People such as me who see social, cultural, and environmental value in the retention of old buildings are usually dismissed as nostalgic, romantic, privileged, and out of touch with the realities facing young people and migrants. I and my ilk lash back, arguing that mature cities have layers of different landscapes that tell stories, and that the "new Vancouver" is a generic infant of little character and architectural merit that is doing little for the poor.

What of the downtown of fine office buildings and skyscraper hotels, the economic engine of the region? In the almost three decades since I sat at my friend Sam Gudewill's office window and painted the Marine Building (next page) there has been a lot of change to the downtown in the form of additions, but only a few significant deletions to the streetscapes.

The Royal Bank building at Hastings and Granville is receiving a seismic upgrade courtesy of a new tower placed against it. The huge former Post Office building on West Georgia has a multi-storey addition atop it and a swarm of tech workers waiting to open their laptops. The venerable Hudson's Bay Building at Georgia and Granville may get a glass box plunked onto it, and the 800-block of Robson Street, home to the Orpheum and the Commodore Ballroom, may get an addition like a huge cruise ship marooned above the low shopfronts.

Downtown's front door is still in play while the City's Waterfront Hub study drags on since 2009. Developer Cadillac-Fairview tried to jump the gun with a radically shaped glass office tower, dubbed "The Icepick," that

"The Icepick" office tower was to be dropped onto the edge of historic Gastown, a scenario so far rejected by city staff and advisory groups including the Heritage Commission. With the uncertain market for office space in the post-Covid, work-from-home world, perhaps it will turn out that the developer was done a favour.

SURVIVING (AN ADJECTIVE)

As I wrote in 1996, "The Marine Building stands on the edge of the escarpment above Coal Harbour's tidal flats. At the time I painted it, only a few wharves and pilings remained along the shore, although the working harbour was once centred here. The gasoline barges visible in Coal Harbour have acquired the respectability of age – the first one opened for business in 1917… New developments at the end of the 20th century will insert a row of residential and office towers between the Marine Building and the water, completing the transformation of the city's historic harbour from its salad days of shipping and muscular industry to a new age of grey-flannelled finance, tourism, and luxurious urban residences…"

New buildings now line the harbourfront. You can no longer see water from the same viewpoint.

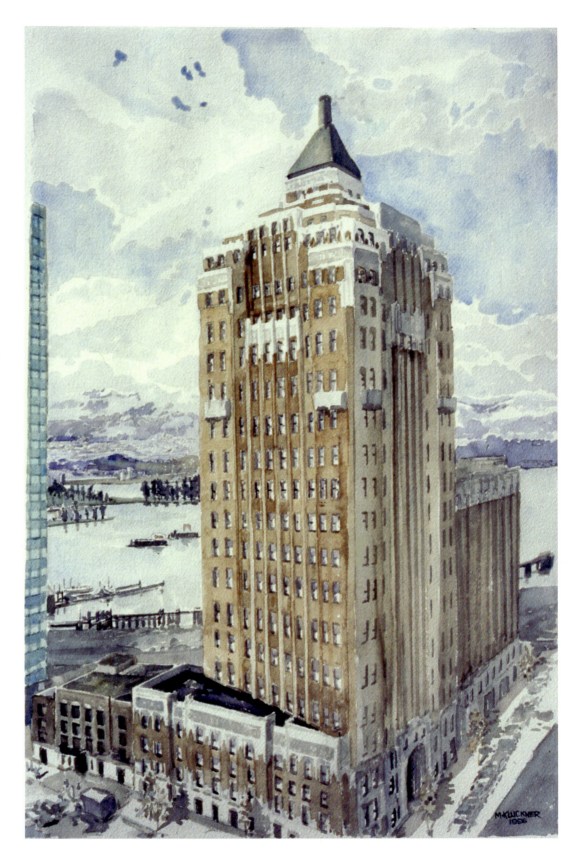

SURVIVING (AN ADJECTIVE) 41

Nelson Street, looking east toward Burrard, as it was in 1986.

42 SURVIVING (AN ADJECTIVE)

was to be placed beside, and looming above, the historic Waterfront Station – the former Canadian Pacific Railway station. It has so far been beaten back by an informal coalition of planners and heritage advocates.[1]

Covid heralded a change in 2020 when offices closed, commuting all but ceased, and the downtown streets of shops and cafés clung to survival. Nevertheless, the shovels are still in the ground in Vancouver and Surrey, an indication that the smart money is betting on a return to the office, regardless of the resistance from employees who are happy to work from home and avoid commuting at least for most of the week.[2]

In my 1996 book, I wrote about the watercolour on the facing page: "A walker on Nelson Street travelling east toward Burrard passes through all the stages of the West End's development in a half block. Visible are the edge of a 1940s apartment, two-family houses from the beginning of the 20th century, and on the corner the stone First Baptist Church, a solid relic from 1910, which was still a pious age." The 1957 B.C. Electric office tower, converted to condos in the 1990s, still dominates the corner.

In the interim, the houses and small apartment building have gone, replaced by a standout 57-storey condo tower called "The Butterfly" by the ubiquitous and audacious Westbank Developments (of Oakridge and Senákw fame), designed by Bing Thom Architects (now Revery Architecture) – one of the final buildings that the legendary Bing Thom had a hand in before his death in 2016. In 2023 as it neared completion, suites were advertised at prices from $3,508,900 to $7,873,900, obviously not the "right supply" for Vancouver's rental and affordability crisis, but…

The development came with the seismic upgrading and restoration of First Baptist Church, 66 below-market rental units and a social service space, "bonused" by the scale and luxury of the condos. This came during a period when there was a debate in the city about mixed condo/subsidized rental towers, many of which had "poor doors" to keep the tenants separated from the owners. Such are the trade-offs in the contemporary city to effect heritage preservation and create social housing.

The church across Nelson Street from First Baptist, St. Andrews-Wesley United, has also received a restoration and seismic upgrade but did so without needing the bonusing of a big development. It is one of the handful of churches in Vancouver that has adapted brilliantly to the changing needs of its diverse West End community as an inclusive place for all genders and spirits. Other churches have fallen on hard times, with disbanded congregations, demolitions and the sale of their properties. The Catholic cathedral, Holy Rosary on Dunsmuir Street, worked on a proposal in the 2010s to demolish its rectory and auditorium in return for seismic upgrading and the construction of new space within an office tower to be built adjoining the beautiful 1900 cathedral. It has not yet come to pass.

Other heritage projects in the past 30 years have been equally compromised (for a purist, perhaps) but evidently necessary. One such was Jameson House, a 2011 luxury condo building at 838 West Hastings that towers above two jewel-like terracotta buildings from the 1920s. The change in scale is dramatic but works very well from a pedestrian's viewpoint, and makes a link with the 1914 Crédit Foncier building next door at the Howe Street corner.

1 Jeff Lee, "Is the Icepick building hideous, or really just in the wrong place in Vancouver?" *Vancouver Sun,* January 22, 2015.

2 Vancouver, having resolutely defended its office-zoned areas against the march of the condos, continues to do so, unlike Calgary, which encourages owners to convert their office buildings to residential. See Frances Bula, "Calgary and Vancouver are reshaping empty office spaces in very different ways," *Globe & Mail,* March 31, 2023, and, for the backstory, my *Vanishing Vancouver: The Last 25 Years,* Whitecap Books, 2012, pp. 35-6.

With the demolition of a building on Pender Street, a spire of Holy Rosary Cathedral emerged in the gap. (2022)

SURVIVING (AN ADJECTIVE)

The most dramatic juxtaposition of new and old involves the little yellow house known since 1972 as Umberto's Restaurant, after Italian-born restaurateur Umberto Menghi. It was designated a heritage building in 1974. Built in 1888 when the City of Vancouver was two years old, George Leslie's two-storey Victorian home is a rare survivor from the days when "Yaletown" meant the community of workers at the Canadian Pacific Railway's False Creek yards and roundhouse (now the Roundhouse Community Centre, a fabulous adaptation of an industrial site). The 1890 Yale Hotel at Granville and Drake is the only other relic from that era.

For all those years, "Umberto's" faced Hornby Street. When the restaurant closed in 2013 and the site went up for redevelopment, it looked like the house would sit in the perpetual shadow of a new tower, but the decision was made to skid it around onto sunny Pacific Avenue where it crouches beside the 39-storey "The Pacific by Grosvenor," "an architectural monument to quiet sophistication in a spectacularly vibrant urban setting" according to its website, a symphony of grey glass under the grey Vancouver sky.

As strange as it all seems, the decision to move it and to keep it intact with a commercial use made preservation possible without resorting to the drastic code-upgradings necessary for residential renos, *including* those involving designated heritage buildings. Architect Robert Lemon supervised the process, as he did with the aforementioned buildings at Jameson House.

Since the Vision Vancouver party gained a majority in 2008, there has been only tepid support for heritage preservation, limiting it to the buildings with enough of an architectural or historical pedigree to be included on the Vancouver Heritage Register, about two percent of the 100,000 or so in the city, and linked to the Canadian Register of Historic Places. A process to add 300 buildings to the register, created in 1986 for the City's centenary, stalled in 2018, leaving many old buildings with little chance of protection. Robert Lemon summed up the problem: "Right now there is little incentive to keep a heritage building."[3]

In 2014, City Council sent a clear message of its non-support when it allowed the demolition of the 115-year-old Legg residence in the West End, an "A" on the register and thus supposedly inviolable. A 17-storey tower was planned for its large site, leaving room for either the house or an old tulip tree. Council chose the tree.

Heritage advocates have so far been unable to convince Vancouver decision-makers that saving buildings is a "green" strategy. "Technogreens," as they've been dubbed, are convinced that we can build and innovate our way out of the dire climate-change scenario that is becoming ever more real each year, while still growing the economy and the population.[4] But atmospheric rivers, the heat dome of 2021, and even the storm and king tide that pushed "Barge on the Beach" into the city's consciousness, make climate change hard to ignore.

3 Quoted in John Mackie, "Out of date heritage list puts historic old Vancouver buildings at risk of demolition," *Vancouver Sun*, December 4, 2021.

4 The essays by Andrew Nikiforuk, such as "Inflation, scarcity and the road to survival," *The Tyee*, June 3, 2022, and "The rising chorus of renewable energy skeptics," April 7, 2023, are good analyses of the topic.

(Left) The scale of two cities: the little yellow "Umberto's house" on Pacific at Hornby, drawn to scale next to "The Pacific by Grosvenor" luxury condos.

The classic Niagara Hotel neon sign on West Pender as it was in the '90s. It has been replaced by a more generic one advertising the current occupant, a Ramada Hotel.

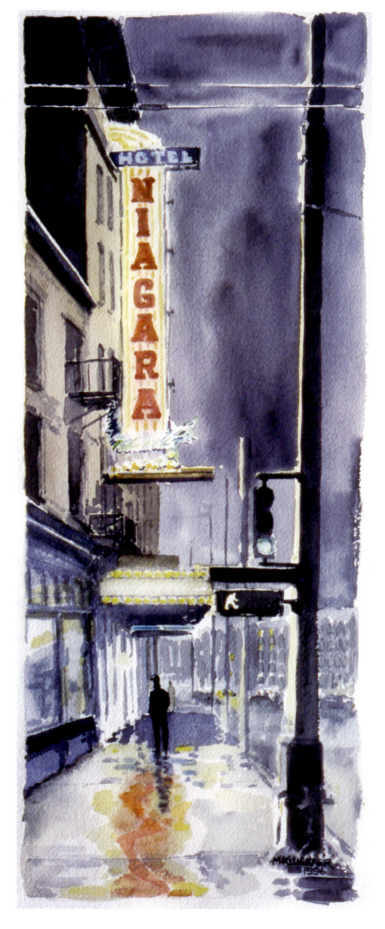

SURVIVING (AN ADJECTIVE) 45

Low rents and Fourth Avenue's "Haight-Ashbury North" attracted new businesses in the 1960s, with only The Naam at 2724 still open at its original location. (Banyen Books at 4th and Dunbar, opened in 1970, has had five different locations.) Founded in 1968 as a vegetarian food store and café, the Naam was managed by Ron Ferguson in its early years. It sourced local foods and sold them out of the western half of the store; later, the entire store became a restaurant. Following a period when it was managed by a loose workers' cooperative, Peter Keith and Bob Woodsworth bought it in the late 1970s. The property was listed for sale in 2022, prompting an outpouring of sadness; however, it appears to have been withdrawn from the market and continues in operation at this writing in 2023.

Once a very common type of shop in the city, the building has horizontal board siding, an indented centre doorway, two upstairs apartments and a wooden cornice. It was built in 1922, and originally had three addresses: 2722 and 2724 were the two storefronts, and 2726 the two apartments above. Albert H. Brereton's dry goods shop was the first tenant at 2722, followed in the 1930s by a bakery; a later, long-term occupant was G. Soon's Sincere Cleaners in the 1950s. Its last occupant before The Naam was the 4th Avenue Fish and Chips shop. On the 2724 side, Rainbow Beauty Salon operated from the 1930s into the late 1950s, followed by Pakistan-India Trading Importers.

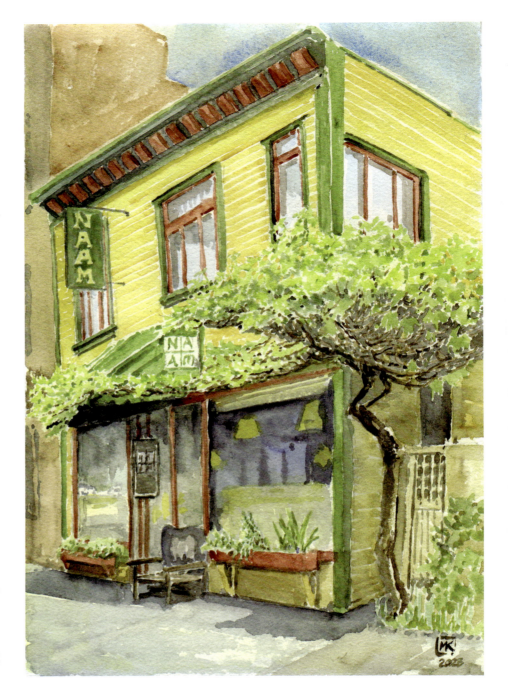

Electric vehicles, such as those recently announced with batteries that will weigh as much as a traditional small car, are seen as a big part of the solution, regardless of the huge energy inputs required to mine the minerals for their batteries, build them, recycle the cast-offs, and generate the electricity to move them around. Throw out your efficient gas furnace and replace it with an electric heat pump, says the City (and BC Hydro). All that fossil fuel is burned somewhere else, such as the steel-making plants of South Korea, allowing Vancouver to claim to be Green. "Reduce, reuse and recycle" was thought to be the solution a generation ago; although adaptive reuse fits the sustainability mantra of the "three Rs," it is usually overlooked by City officials and politicians.

"No matter how humble, Canada's architecture is a renewable resource that can help us meet sustainability goals," wrote Sarah Sheehan in a CBC

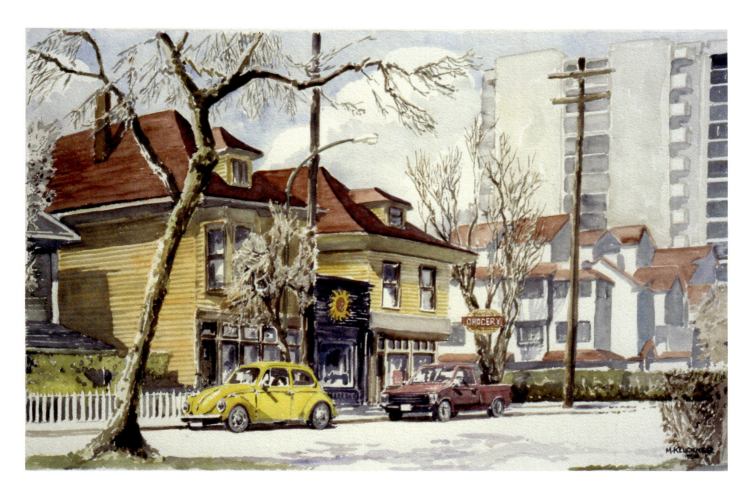

Opinion piece. "Whether it's a Gothic Revival church, a modernist Centennial project, or a contemporary design in glass and steel, a completed structure has a huge carbon footprint. Demolishing an existing building, throwing it away in a landfill, is a staggering act of conspicuous consumption. And yet this destructive, extractive approach to Canada's built heritage has been normalized over generations."[5]

A startling study by housing-supply advocates pointed out how far Vancouver had to go to become a "green city." "In Vancouver, we estimate that new single-family homes will take an average of 168 years of efficiency gains to recover construction impacts [of added emissions]," wrote co-author Jens von Bergmann of MountainMath Software.[6] However, the study wasn't an argument for retention of old houses, but rather for denser forms of housing that would reduce the energy-emission payback time (per household of 1.2 people) and "would increase housing stock, address affordability and create a more vibrant public realm." How affordable would the new housing be? Would there be enough room in these new "Missing Middle" units for people to raise families and live the way they wanted to?

In areas such as Kitsilano and Strathcona with consistent blocks of old houses – mainly the fine large ones that were built before the First World War, residents have worked to retain and define neighbourhood character. After having survived the rooming house decades of the 1930s–1970s, many houses have been converted into proper suites (some strata-titled, some rented) while others have reverted back to their original use as single-family homes. "Single family," as described below, is a misnomer.

The 1904 Barclay Grocery at Barclay and Nicola, as it looked when I painted it in 1996, has recently undergone a faithful restoration and remains as a neighbourhood hub, like the Cardero Café on this book's cover, amidst the apartments and condos of the modern West End. A migrant from Ontario named Albert Blain built it and the adjoining structures.

5 cbc.ca/news/opinion, January 26, 2022.

6 "Study highlights environmental cost of tearing down Vancouver's single-family homes." *UBC News,* May 23, 2018.

SURVIVING (AN ADJECTIVE) 47

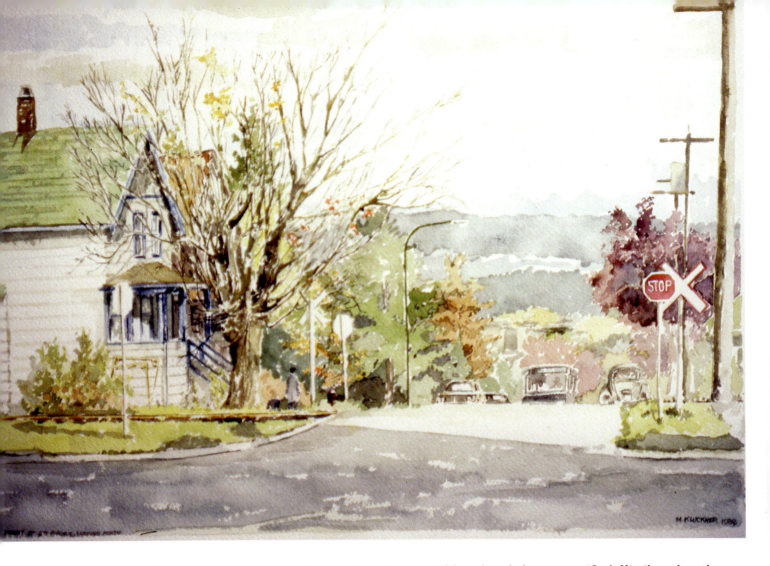

A tale of two eras in Kitsilano.

(Above) Looking north toward the cloud-shrouded mountains on Cypress Street at 6th Avenue in 1988. The BC Electric's short-line railway, using the interurban railway tracks, continued to service a handful of companies along False Creek and in the industrial area around 10th and Arbutus until the 1990s.

7 Statistics Canada, Census of Population.

No question, these neighbourhoods have gentrified. Kitsilano has the highest percentage of Caucasians of any Vancouver neighbourhood, which indicates a cultural preference for this type of housing, I suppose, because other neighbourhoods are more mixed ethnically but wealthier. Similarly, the home of The Drive and edgy leftist politics, Grandview-Woodland, saw its demographics change from the 1981 census to the 2016 one: "immigrants as percentage of population" dropped from 43% to 27% while the percentage in the City rose slightly from 39% to 42%; the same drop was noted for "population with a non-English mother tongue," while that percentage in the City rose from 32% to 46%.[7]

Kitsilano was once as Morag Gunn found it in Margaret Laurence's *The Diviners*: rooming houses "last painted around the turn of the century," their faded colour "the light sea-bleached grey of driftwood, silver without silver's sheen." They were "firetraps, lived in by people who can't afford to live anywhere else." These houses survived, but in other parts of the city that were built up in the interwar and postwar (1920s to 1950s) era, whether East Van, Kerrisdale, West Point Grey or Dunbar, the houses didn't attract much interest from potential residents. The lots were, in most cases, much bigger than the 33 × 120 foot standard lots of the old city, allowing for a greater indoors in a big new house.

The demolition of thousands of these "humble" detached houses in the so-called "single family" areas of the City, and their replacement by larger detached houses, became the subject of an impassioned Facebook page

48 SURVIVING (AN ADJECTIVE)

called "Vancouver Vanishes" by novelist Caroline Adderson, which evolved into a book of the same name, subtitled "Narratives of Demolition and Revival," by her, John Atkin, Evelyn Lau, Eve Lazarus, John Mackie, Elise and Stephen Partridge and Brent Simmers (with an introduction by me), published by Anvil Press in 2015.

It noted that since 2004 an average of three houses a day had been torn down, and "a whole history goes with them – the materials that were used to build them, the gardens, the successive owners and their secrets… The story of our city is diminished every time one disappears."

The city responded with the "Character House Initiative," which was so bureaucratic and complex that the demolition cavalcade didn't miss a beat. Yes, the old houses could be renovated at great expense following the city's complex regulations, and infill dwellings could be built, but a larger new house could be erected much more easily. Arguments to create simple disincentives to demolition, which would allow only the construction of a smaller new house than the one being torn down, fell on deaf ears. Had the city reduced the size of any new house significantly, then character houses could have been saved and reused, the city's environmental footprint would have been lowered due to a reduction in demolition waste, and ensuing policy developments such as the much-touted "four units per lot anywhere in the city" might have had a chance.

Whether it's four or six units proposed for any lot in the city, the flaw in the new zoning is captured in a single phrase: people "will be allowed to

(Above) The recreational city in 2022: the railway has become the Arbutus Corridor for cyclists and walkers, allotment gardens line its edges, and the houses – the closest one from 1907, a year before the streetcar began to run on 4th Avenue – have been fixed up and brightly painted.

SURVIVING (AN ADJECTIVE) 49

8 John Mackie, "Could more housing density be coming to Vancouver's wealthy Shaughnessy neighbourhood?," *Vancouver Sun,* November 14, 2023.

9 Kerry Gold, "Downzoning gets denied," *Globe & Mail,* March 11, 2017.

10 Denise Ryan, "Laneway homes decrease real-estate value in affluent Vancouver neighbourhoods: Study," *Vancouver Sun*, November 22, 2021.

11 Kenneth Chan, *Daily Hive Urbanized* blog, March 20, 2023.

build…"[8] People are hard-wired to defend turf and privacy, and people with money do it very effectively by building single-family homes in desirable neighbourhoods, which the City can't disallow. If they add a suite it will be a "lock off," accessible from the main house and thus not subject to the vacancy tax.[9] A study by Dr. Tom Davidoff examined the "laneway effect" – the reduction in property value in affluent areas if a home has a laneway house, which would have to be rented or otherwise subject to a speculation or vacancy tax. "The adverse effect is significantly more negative on the west side, with a dip of five to seven percent, but very little effect on the east side," he said.[10] An example of the reversal of density, on Ogden Avenue at Cypress Street on toney Kits Point, will see an apartment building demolished and replaced by three single-family houses.[11]

The extant single-family house is vilified as the ogre, the bastion of the privileged, the pothole on the road to an equitable, green, and affordable

The little faux Cotswold cottage on King Edward Avenue just west of Cambie, properly known as the James House but usually called the Hobbit House, was saved and restored in 2016 in the midst of a large townhouse development – it's less than a block from a SkyTrain station. I painted it in 2004 when it was part of a row of postwar bungalows. It sits on its own single-family lot rather than being part of the complex's strata, so that it could be preserved without stripping it to the frame for rain screening (required even for heritage buildings that are converted to strata title). Definitely a success, it's a vintage jewel in a new streetscape.

(Previous page) "Wilmar," painted in 2017 when it was vacant and overgrown, is the mansion at 2050 Southwest Marine Drive. Built in 1925, it is awaiting a heritage restoration and infill project that was proposed by builder James Evans in 2016. He walked away from it following protracted and fruitless negotiations with city officials. Evans has created successful heritage projects involving townhouse infills at the "Jeffs Residences" on Salsbury at Charles Street (right), and at "Brookhouse," another Queen Anne-style house a few blocks away at the corner of Victoria and Parker.

(Below) In 2023, he began work on the retention of the old St. Clare's Convent, part of the St. Francis of Assisi Church complex at Napier and Semlin, infilling its lot with new homes. See my *Vanishing Vancouver: The Last 25 Years,* pp. 182–7, for its history.

SURVIVING (AN ADJECTIVE) 51

12 Kerry Gold, "Vancouver's single-family myth," *Globe & Mail,* May 2, 2017.

13 Kerry Gold, "2023 is shaping up to be the year of the multi-family house," *Globe & Mail,* January 6, 2023.

(Below) Another saved building: the former rectory of the Grandview Methodist Church on Venables at Victoria, used as administrative and rehearsal space by the adjoining Vancouver East Cultural Centre. It was rehabilitated after the threatened demolition in 2013 that spurred me to paint the watercolour.

future, but its alleged ubiquity – reflected in the claim that 80% of the City of Vancouver's land is zoned single-family – is tempered by some facts.

In Vancouver, only 15% of dwellings are considered "single-detached houses," according to 2016 census data. Andy Yan, director of the SFU City Program, noted that Vancouver has one of the lowest percentages of single-detached houses in Metro Vancouver. It is a "hidden density" of houses divided into multiple units, rooming houses, shared collective housing, and secondary suites both legal or illegal. Yan noted that the old nuclear-family-house lifestyle began to wane in the '70s, dropping from about 50% to the 15% found in the census data. New Westminster has a similar low rate; the average in Metro Vancouver is 29%. "We need to focus on who we are trying to house and what's actually on the ground, as opposed to a blind, dogma-driven assault on an imagined zoning type," he said.[12]

City planners presented their Adding Missing Middle Housing and Simplifying Regulations in Low Density Neighbourhoods report at a 2023 Council meeting, revealing a plan to build multiplex housing throughout low-density neighbourhoods zoned for single-detached houses (in Vancouver called RS zoning). The report didn't address retention and the hidden renter density – more than 40 per cent in most Vancouver neighbourhoods, even those perceived as filled with nothing but expensive detached houses.[13]

52 SURVIVING (AN ADJECTIVE)

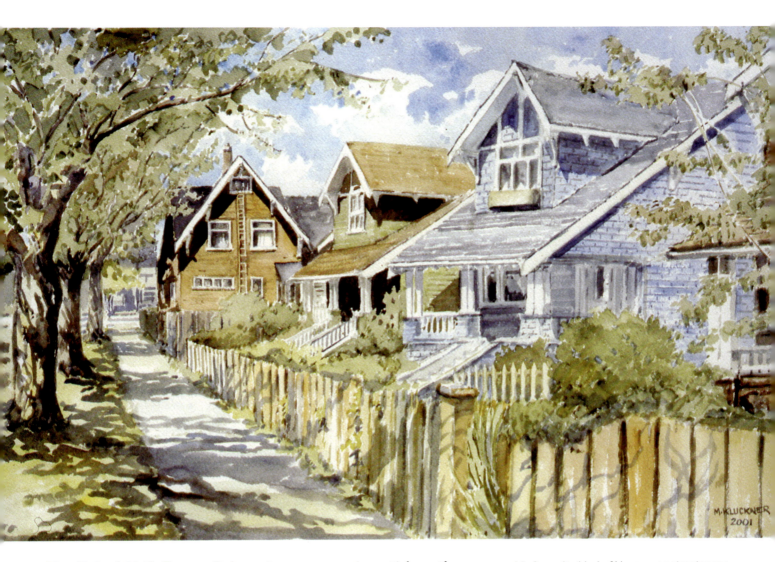

My favourite kind of Vancouver streetscape, in this case 6th Avenue near Macdonald in 2001. Old wooden houses carefully maintained with a mix of colours and textures, owners and renters, sun and dappled shadows on a summer day.

The *Globe & Mail*'s Frances Bula wrote a very amusing article on the trials and tribulations of a homeowner (herself) trying to build a lane house and contribute to the city's stock of affordable housing in Mount Pleasant.[14] It turned into a bureaucratic nightmare on the one hand, and pointed out the additional problems that would result if a family decided to strata-title its property or establish a formal joint-ownership arrangement.

In the duplex zones like Grandview, each half of a new front-back duplex costs almost as much as the demolished house, but this building type seems to be pointing the way to a new type of family housing. The newer ones have lock-off suites under each unit – that is, suites that can be accessed either from outside or from the main unit, with a lockable door to separate them if need be. Observations on the street indicate that many of these homes are occupied by young, growing families. In theory, a long-term rental would occupy the lock-off and help with the mortgage until the family needed the space (teenagers come to mind). In practice, from my observation, the lock-offs seem often to be used for (possibly illegal) Airbnb tourist accommodation or the pied-à-terre for an overseas owner.

They really work for multi-generational family homes, as described in the last-noted Kerry Gold article. Mom and Dad, for example, might live in the front unit, child, partner and grandchildren in the back one. It is a very practical evolution of the nuclear family model from the postwar years, and has the added benefit of reanimating the front yards of houses.

[14] Frances Bula, "Thinking about building a laneway house? Assess your capacity for patience," *Globe & Mail,* February 3, 2021.

SURVIVING (AN ADJECTIVE) 53

Although Vancouver houses before about 1925 were built with front porches, and design guidelines in some areas insist that porches be built on new houses, most people have turned their backs on the street, built a deck or patio at the rear of the house, and spend their leisure time in the back yard. For early Vancouverites, the back yard was a utilitarian space: fruit trees, vegetable garden, laundry line, chickens, even a horse or an outhouse. That evolution from a front porch culture to a courtyard culture seemed complete until the front-back duplexes came along.

A surviving building so far, but one slated either to be demolished or moved away from the First Nations' Heather Lands redevelopment east of Oak Street between 33rd and 41st, the Fairmont Academy at 33rd and Heather has challenged all the rules of memory, reconciliation, and adaptive re-use.

Constructed in 1911–12 as the Langara School and designed by the lauded architects Maclure and Fox, the building was itself, somewhat ironically, a boys' residential school; its sister school Braemar nearby (demolished) was for girls. Western Residential Schools established them due to "the increasing number of families in the Coast Cities who now send their children, at great expense, to be educated in the East or South."[15] The company and its schools could not survive the Depression of 1913 and the world war, and went into liquidation in 1918. Private schools for people wanting a British-style education for their children continued to thrive, however, notably Crofton House for girls and St. George's for boys, but most of the enrolment was day school rather than boarding.

The building briefly became Fairmont Military (Convalescent) Hospital in 1919, treating shell-shocked soldiers, before becoming Royal Canadian Mounted Police "E" Division headquarters in 1920, with barracks for 150 men and stables for 100 horses nearby. It remained so over the next 90 years, as the RCMP enforced federal statutes including laws forcing Indigenous children to attend residential schools. "E" Division moved to Surrey in 2013.

The Musqueam, Squamish and Tsleil-Wauthuth Nations that obtained the building as part of land settlements took the position that the erasure

15 Quoted in Jean Barman, *Growing Up British in British Columbia: Boys in Private School.* UBC Press, 1984.

54 SURVIVING (AN ADJECTIVE)

Fairmont Academy at 33rd and Heather, painted in 2021.

of Fairmont Academy from the landscape was a step toward reconciliation, rather than adapting and reusing it as a statement of their control over that history. In that, they followed other nations, including the 'Namgis at Alert Bay who demolished their St. Michael's Residential School in 2015, but not the lead of the Ktunaxa in the 1990s which preserved its St. Eugene's Mission school near Cranbrook and incorporated it as a museum and cultural centre into a resort development. I recall an Indigenous woman there telling me, "This is where they tried to take my culture away, so it is fitting that it will now help me get my culture back."[16]

As with many "decolonization" projects, the question becomes whether erasure of an offensive object will heal, or will simply lead to forgetting the history. If you remove a statue of Sir John A. Macdonald because of his role in the oppression of First Nations, will anyone in the future be reminded of that oppression? Could there be an explanatory plaque added to a statue? Could a building be interpreted further, as at St. Eugene's?

Or was Jorge Luis Borges right when asked if he'd forgiven the Peronists of Argentina? He replied, "Forgetting is the only form of forgiveness; it's the only vengeance and the only punishment too."[17] Most First Nations appear to agree.

16 Quoted and illustrated in my *Vanishing British Columbia,* p. 112.

17 Quoted in "The Dream of Forgetfulness" by Gavin Francis, *NY Review of Books,* March 9, 2023.

SURVIVING (AN ADJECTIVE) 55

The Curious Case of Shaughnessy Heights[18]

18 This is an extended version of an essay I wrote in 2016 for a book on the district proposed by the late Jacques Barbeau, which was never completed.

19 As explained below, the actual HCA is First Shaughnessy, the part of the community between 16th and King Edward Avenue.

As a Heritage Conservation Area, declared by Vancouver City Council in 2015,[19] Shaughnessy ought to be a contented, stable place, but it is anything but. The control of its private property by its owners is as fierce today as it was 110 years ago, when the neighbourhood tried to secede from the Municipality of Point Grey, which itself had seceded from South Vancouver. It was a unique enclave of wealth, equalled only by the blocks of mansions above Spanish Banks, until, in the 1930s, the British Properties opened on the Hollyburn Mountain slopes in West Vancouver. Its history is a harbinger of the "contested space" of the 2010s and 2020s, played out not in the luxury Coal Harbour condos and "Dunbar Castles" but in grand estate properties.

Private property is a lot of things: security, "A man's home is his castle," a place to fix up, and a place of memories, but when it comes down to the basics it grants the owner the ability to exclude unwanted people. "Get off my land" is more than just a trope of old Western movies.

The maps on pages 22 and 23 explain the geography of the emerging City of Vancouver. In the style of the time, the provincial government in 1885 offered a land grant to the Canadian Pacific Railway as an inducement to move its terminus from tidewater at Port Moody to the new city site at Coal Harbour, something the railway would have done regardless. A portion of the grant, ultimately the most valuable, was the unsold lots in the 200 hectares (500 acres) of District Lot 541 – effectively the downtown peninsula between Burrard and Carrall. The larger portion, called District Lot 526 and containing the future Shaughnessy District, was said to contain "five thousand seven hundred and ninety-five acres more or less" of the "lease dated the 30th day of November A.D. 1865 and entered into between the Honourable Joseph William Trutch acting on behalf of Her Majesty's Government and the British Columbia and Vancouver Island Spar, Lumber and Saw Mill Company Limited" (commonly known as the Hastings Mill), whose term was not due to expire until the end of November 1886. It was granted not to the railway company but to CPR directors Donald A. Smith and Richard B. Angus, "their heirs and assigns, forever." Minor easements were included, as was a royalty of five cents for each ton of coal extracted. It immediately became the property of the CPR.

District Lot 526 is the tract between Trafalgar and Ontario Streets south of False Creek/English Bay and extending roughly to 59th Avenue – the diagonal of Park Drive south of 57th is the southern boundary of the 1865 timber lease. CPR surveyor Lauchlan Hamilton set out to plan streets and subdivide lots both north and south of False Creek, setting his grid to benefit the CPR's downtown holdings by aligning his streets parallel with

56 SURVIVING (AN ADJECTIVE)

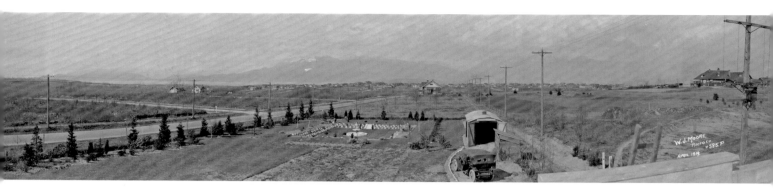

the boundary of District Lot 185 (modern Burrard Street), which was the eastern edge of the "Brickmaker's Claim" of 1862 – today's West End. The kink in the streets of the Town of Granville (Gastown) between Seymour and Carrall date from that alignment decision.

Hamilton's main street on the downtown peninsula, Granville, connected the CPR's wharves and railway station with a high point of land at Georgia, where the company immediately constructed the first Hotel Vancouver. Granville continued south to False Creek, which was crossed in 1889 by a bridge connecting to Centre Street, a slit in the dense forest that ran all the way to the Fraser River at Eburne. Centre Street was, aptly, in the centre of the CPR's DL 526 land grant; it became known as South Granville Street in 1907, when the CPR announced the development of Shaughnessy Heights – the area now usually called First Shaughnessy.

Colonel George Walkem, in a letter to city archivist J.S. Matthews in 1944, described the wilderness he recalled from the turn of the 20th century: "I came to Vancouver in 1898; if you crossed the old pile bridge, you, of course, expected to meet a bear on the south end. I think it was 1900 that I drove out to Steveston to help a fellow sell some salmon nets to the canneries. There was a track or a trail up Granville Street; we followed that up on the high lands where Shaughnessy is now and on the 3rd or 4th of June… saw snow about fifty feet away from the road; very thick forest, and no clearing, had been done except for the trail."[20]

The CPR's early land sales south of False Creek were mainly within the City of Vancouver's boundaries – north of 16th Avenue. For example, Fairview Slopes lots went on sale in 1891, Kitsilano north of 4th Avenue in 1905. South of 16th Avenue, the CPR's land holdings lay within the Municipality of South Vancouver, established in 1892 and focused on the scattered population of homesteaders along Main and Fraser Streets as well as the farmers near the river. Fraser Street was, in fact, an earlier "North Arm Wagon Road" than Granville; it was cut through the forest in 1875 from the Westminster Road (Kingsway) to the River Road (Marine Drive). Produce from the river-delta farms had to make it to markets in the city and this was the easiest route. Accordingly, South Vancouver's electors established a Municipal Hall on Fraser at Wilson Road (modern 41st Avenue), near Vancouver's cemetery. The first school in South Vancouver opened in 1886 at the corner of Fraser and Marine.

A class distinction rapidly emerged between the South Vancouver settlers, who in many cases were workers, artisans and subsistence farmers, and the purchasers of the CPR lands, especially those in Kerrisdale. The B.C. Electric Railway Company's interurban train system, established in 1905 along the "Arbutus Corridor," made Kerrisdale a viable suburb; people there were interested in civic improvements, paved roads and orderly tax

The *tabula rasa* of Shaughnessy in the Spring of 1919 from about 37th Avenue, one of the fabulous W.J. Moore panoramas in the collection of the City of Vancouver Archives. Granville Street goes from left to right; the houses just left of the fold are in the Strathcona Heights subdivision, on the hill just north of today's Point Grey School. The houses of Shaughnessy Heights are in the right distance, and the elaborate Tudor building on the far right is the clubhouse for Shaughnessy Golf Course (now VanDusen Garden). Note the smoke in the distance on the right: the lumber mills on False Creek.

20 J.S. Matthews, "Notes on Street Names and Places," CVA.

SURVIVING (AN ADJECTIVE) 57

paying regulations, certainly by comparison with many east-siders who preferred a semi-rural, unregulated existence (to the point that South Vancouver went bankrupt and was taken over by the provincial government in 1918).

A split developed, engineered by influential west-siders and doubtless supported by the CPR Land Department, leading to the secession of the area west of Cambie Street and the incorporation, in 1908, of a new Municipality of Point Grey, headquartered in Kerrisdale in a rambling Tudor building at 42nd and West Boulevard (demolished in the early 1950s). This set the stage for the establishment of Shaughnessy Heights. Point Grey Municipality promptly paved Granville Street south of 16th all the way to Marine Drive, and paved Marine itself all the way around Point Grey back to the Vancouver city limits at Alma Street. Automobile ownership was becoming possible for wealthy Vancouverites, even in 1910.

The prosperity of the city in the years after the 1898 Klondike gold rush and the haphazard evolution of the existing residential areas, especially the West End where most of the city's Establishment resided, encouraged the CPR to plan a very exclusive suburb on the rise of land above 16th Avenue. A sudden, sharp recession in 1907, prompting a mob of thugs led by the Asiatic Exclusion League and representatives of trade unions and militias to sack Chinatown and unsuccessfully attempt to invade Japantown, did nothing to dissuade the company.

Land clearing began that summer. City archivist Major Matthews recalled: "The clearing of Shaughnessy Heights was an event in the life of the city. It was undertaken by the CPR Land Department, and after 'blowing' the stumps, they collected them with gin poles and donkey engines, and piled the roots and stumps in huge piles, which were, after a proper period of drying, set on fire, and the light the great fires on the skyline presented [was] an interesting spectacle to watch at night."[21]

The new suburb took the name of the CPR's president, Sir Thomas Shaughnessy, a Milwaukee native noted for his sharp accountant's pencil. His knighthood dated from 1901; in 1916, King George V elevated him to the peerage as Baron Shaughnessy. He continued as president for two more years and died in 1923.

Residential suburbs of all social levels in the early 20th century were made possible by the newly invented electric street railway, which efficiently moved people away from the grit and smoke of inner-city industrial areas to streets of homes and gardens. Older cities were greatly limited by the distance a worker could walk; commercial, industrial and residential uses shared most streets. Expanding Vancouver depended on the electric streetcar for its success, and the "SHA'NESSY" line (as it appeared on the tram's roller board) did run south on Granville Street to 41st in the '20s and thereafter, but Shaughnessy residents typically moved about in their own carriages and automobiles. The *lack* of access to it by public transit would have been seen as an advantage by prospective purchasers.

Shaughnessy Height's uniqueness was stamped onto the Vancouver landscape, which until that time had been locked onto Hamilton's grid, with curving streets focusing on an oval park (The Crescent) east of Granville and gracious boulevards (Angus Drive and Osler Street). The designer was Frederick Gage Todd (1876–1948), who had established Canada's first landscape architecture firm. He had apprenticed in the 1890s with the firm Olmsted, Olmsted and Eliot in Brookline, Massachusetts, before moving to Montreal in 1900, where he contributed to the design of its elegant Mount

21 J. S. Matthews, "Notes on Street Names and Places," CVA.

Royal suburb. Todd followed the picturesque sensibilities of the 19th century, reflected in the idea of the Garden City suburb – a far cry from the Fairviews and Mount Pleasants in a city like Vancouver.

The CPR spent $2 million on grading, grooming and paving, including sidewalks, and purchasing and planting exotic trees. It concentrated its efforts first on the area bordered by 16th, 25th Avenue (named after the late King Edward VII in 1912), the interurban line along Arbutus, and Oak Street, and named it Shaughnessy Heights. The land directly south, known as Second Shaughnessy, was divided into smaller lots along curving streets, and was unoccupied until the end of the First World War; in the 1920s, it filled up as far as 37th Avenue. The final piece to 41st Avenue, beyond which the city grid resumed in Kerrisdale, was known as Third Shaughnessy, opened for sale in 1926, and echoed the grandeur of the original area.

Crushed rock from the CPR's quarry, now the rock garden at Queen Elizabeth Park, provided much of the matériel for streets and sidewalks. Newton J. Ker, the former CPR land agent, recalled in 1938 that "the original bunkers for sand and gravel were where D. E. Brown afterwards built his house, 3651 Granville Street; Brown named it 'The Bunkers.' My office, still standing, was close by, now 1592 Nanton Avenue. Afterwards we moved the bunkers to the corner of 27th Avenue and Alexandra Street; the B.C. Electric [Railway] had a track up to it... I was in charge; we had 1,200 men working at one time. Macdonell Gzowski & Co. did the first part; M. P. Cotton Ltd. [were] contractors for the second part."[22]

Many of the streets bore the names of CPR officials or their families: Richard B. Angus was a director of the CPR and the president of the Bank of Montreal (his niece Mary Isabella Angus married Benjamin T. Rogers, owner of the sugar refinery on the waterfront); Marguerite was the daughter of Sir Thomas Shaughnessy; William Delouir Matthews was a director of the CPR, as was Charles Rudolph Hosmer, head of the telegraph section. A few of the "tree streets" – Cedar, Cypress and Maple – named by surveyor L. A. Hamilton for the roads between Cambie and Trafalgar, extended into Shaughnessy Heights, too. Others were named for historical figures, such as Wolfe Avenue for the British general who defeated Montcalm at Québec in 1759.

The amenity for the new community was Shaughnessy Golf Club,[23] opened in 1912 on land southeast of 33rd and Granville, much of which is now VanDusen Botanical Garden. Langara and Braemar academies were private schools on CPR land that never became properly established due to the First World War (page 54).

The new homes rising on estate-sized lots were products of the wealth of "merchant princes," in the expression of the time, and the pens of talented architects, notably Samuel Maclure with his partner Cecil Crocker Fox, and Thomas Hooper. Hooper's Shaughnessy masterpiece is "Hycroft," built for A. D. (Alexander Duncan) and Blanche McRae on McRae Avenue; Maclure & Fox's works include "Miramar," the W. C. Nichol house at 3333 The Crescent, and liquor agent Albert Edward Tulk's splendid "Rosemary" at 3689 Selkirk Avenue.

A "Shaughnessy style" emerged – basically British Arts & Crafts, with prominent hipped roofs, multiple picturesque tall chimneys, and half-timbering. The house at 1551 Angus Drive, built for Sir Thomas Shaughnessy himself in 1911, is another example.

"Hycroft" has a Neo-Classical flair to it, as does "The Hollies" at 1388 The Crescent; other houses are examples of southwestern American styles, like the Mission Revival-style home of John West at 3290 Granville Street and

22 J. S. Matthews, "Notes on Street Names and Places," CVA.

23 Established on land leased from the CPR for 50 years from 1912; when the CPR declined to renew the lease, much of the site became VanDusen Botanical Garden after a multi-year public process. Other portions became housing, Eric Hamber School, and the Louis Briar Home. Shaughnessy Golf Club re-established itself on 162 acres of the Musqueam Reserve in southwest Vancouver in a deal negotiated by the Indian Agent at a rate so cheap that the Supreme Court of Canada in Guerin v. The Crown awarded the Nation $10 million compensation in 1984. A 2015 attempt by Musqueam to have the golf course taxed as residential land failed. The club's 75-year lease there will expire in 2032.

the W. F. Salsbury house at 1790 Angus Drive. Some modest houses adopted the Craftsman Style, which was popular at the time in neighbourhoods such as Kitsilano.

The architectural consistency, and the way the CPR's "public" landscaping reflected itself in the garden plantings and siting of individual houses, reinforced the cultural sameness of the clients, and was ensured by the CPR and its staff of taste-making plan checkers. According to a 1919 newspaper story, the minimum construction value of a house was $6,000 – about six times the cost to build a typical single-family house – although it is unclear whether this was a policy applied to Shaughnessy Heights when it opened for settlement a decade earlier.

H. A. Price, a long-time official of the CPR Land Department, left a description of the process in a letter written in 1993, describing how he found contracts for the sale, purchase and construction of Shaughnessy houses in a locked cage in the basement of the CPR Station (now Waterfront Station):

"These were neatly folded dockets, with the appropriate legalese, and, as I recall, there was a folded set of house plans with the document. This set of plans was on linen, in India ink, in other words, what seems to be the original plans. What this all suggests to me is that the contract original was held by the local law department of the CPR which acted in close liaison with the Right of Way, Lease and Tax Department. It also suggests to me that the owner of the house and lot would have an identical agreement, but the house plans would be blueprints made from the original tracings attached to the original copy of the agreement."[24]

All these records were destroyed, Price surmised, after the creation of Marathon Realty as the CPR's development arm.

In a conversation with city archivist J.S. Matthews in 1938, a "Mr. Armstead, former chief clerk in the CPR Land Department," said: "We advanced building loans on about thirteen hundred houses in Shaughnessy [all three sections], and about two hundred of them have come back on our hands." He went on to say that he considered this satisfactory, as the object was to develop the section, sell the lots and get them to be taxation properties.[25] Royal Trust acted as financial agent for the CPR and as mortgagor for the sale of the lots and appears on many of the early titles.

The cultural sameness of the clients was not enforced by restrictive covenants banning any particular race or religion. The only restrictive covenants appearing on early titles in Shaughnessy Heights, in their transfers from Royal Trust to individual buyers, concerned the erection of single-family homes and necessary outbuildings. The racial exclusiveness of the area was more a result of the local economy – at the time, there were no non-Christian Caucasians in the city with either the wherewithal or the desire to try to buy in. The occupancy in 1926 of 3351 The Crescent and its subsequent sale to the Japanese consul, mentioned below, proves there were no area-wide racial restrictions. Although there certainly were restrictions put on individual titles by owners, there was no explicit racism in its initial property sales, unlike the situation 25 years later with the British Properties and in scattered subdivisions in North Vancouver.[26]

The restrictive covenant had a standard wording throughout documents in the 1910s and 1920s, as in the sale of the lot at 3351 The Crescent by the Royal Trust Company to Edmund James Palmer of Chemainus for $11,250:

"1. There shall not prior to the first day of January one thousand nine hundred and twenty-five be erected on the lot (or on any of the lots if more than one) hereby conveyed any building other than one private dwelling house, either with or without stables, coach houses, green houses and

24 599-B6-file 11, CVA.

25 J. S. Matthews, "Notes on Street Names and Places," CVA.

26 "Most famously, clause no. 7 from the British Pacific Properties Schedule of Restrictions states: 'No person of the African or Asiatic race or of African or Asiatic descent (except servants of the occupiers of the premises in residence) shall reside or be allowed to remain on the premises.' Jewish people, while not specifically named, were also excluded, although a number of Germans and Scandinavians made the cut. BPP's race exclusion was successfully challenged in court, and by 1961 the clause had no effect." Francis Mansbridge, *Cottages to Community, The Story of West Vancouver's Neighbourhoods*, p. 73.

1550 Marpole Avenue, built in 1910 for a CPR superintendent and used for many years as a seniors home, had been unoccupied for a lengthy period when I painted it in 2015.

necessary outbuildings. A flat or apartment building or any building constructed to accommodate more than one household shall not be deemed to be a private dwelling house within the meaning of this covenant.

"2. The private dwelling house or any other building erected or to be erected upon the lot (or any one of the lots if more than one) hereby conveyed shall not be used for any purpose other than that of a private dwelling house, and nothing shall be done or suffered on the land hereby conveyed or any part thereof or in or upon any building erected or to be erected thereon anything which shall be a nuisance to the person or persons for the time being owning or occupying any of the lots of land shown on the said plan."

No sooner had homes begun to be built in 1910 than the residents, with support allegedly from the CPR, lobbied to become a municipality separate even from Point Grey.

Miss M.E. McCleery, daughter of the pioneering farmer Fitzgerald McCleery whose farm is now McCleery Golf Course, provided an intimate view of the process in a conversation with Major Matthews in 1938. "The CPR were putting on the new Shaughnessy Heights, and they wanted everything to themselves … [they] did not want the rest of Point Grey tacked on. Frank Bowser,

SURVIVING (AN ADJECTIVE) 61

[mayor of Point Grey and] brother of [Attorney General] W. J. Bowser, came to father, and said, 'Fitzgerald, you are the only man who can stop this; will you go to Victoria to see [Premier] Sir Richard McBride?' Sir Richard was at one end of the table; W. J. Bowser was there too, and they talked. I was just a girl, father was deaf, and I told him what they said."

Matthews' notes continued: "They both [McBride and Bowser] objected and so did the people of Point Grey. The Municipality of Point Grey had issued debentures on the security of lands which included Shaughnessy, and this new municipality would have created confusion. Hon. W. J. Bowser said 'It could not be done' and it was not done. The new Municipality of Shaughnessy would have extended from 16th Avenue – the city boundary – away down Granville Street to about 57th Avenue, about 4,000 acres in all."[27]

The issue, then and for much of the following century, concerned the desire of residents for "one property, one house" – they did not want Shaughnessy Heights to go the way of the West End, which even by 1910 had become a mixture of estate houses, smaller homes, rooming houses and apartment buildings. It was resolved uniquely in the Shaughnessy Settlement Act of March 4, 1914, passed into legislation by the provincial government, which began:

"Whereas a petition has been presented by Francis W. Rounsefell, T. W. Fletcher, William Ernest Burns, Norman MacLean, Joseph N. Ellis, Charles H. Gatewood, George E. Macdonald, William Murray, Charles Wilson, Peter Winram, and Robert Scott Lennie, property owners and residents of a portion of the Municipality of Point Grey... to divide the present Municipality of Point Grey by incorporation into a district municipality, under the name of 'The Corporation of the District of Shaughnessy,'... [and have] agreed that the said petition should be dropped, and have agreed to a settlement of all matters of difference..."

In ensuing paragraphs, it defined the boundaries of Shaughnessy and repeated clause (1) of the restrictive covenant noted above. It was set to expire on January 1, 1925.

However, in anticipation of the floodgates of change opening, *Daily Province* owner and Lieutenant-Governor Walter C. Nichol (resident of 3333 The Crescent) gave royal assent on December 16, 1922, to the Shaughnessy Heights Building Restriction Act, 1922 (SHBRA), with an expiry date of January 1, 1935. It repeated more or less word-for-word the language of both restrictive covenants cited above, adding a section 2(d), to ensure "... no further subdivision shall be made of any lot as shown on the original plan of the subdivision."[28]

It also amended the control over the original grand scheme, stating that the Royal Trust Company could sell or lease any of the Shaughnessy lands for "Dominion or Provincial Government, municipal, religious, educational, park or recreation purposes. No building shall be erected upon lands disposed of by the Royal Trust Company for any such purpose without the approval of the said Company being first obtained." It added the Second Shaughnessy lands as far south as 33rd Avenue east of Oak Street, 37th Avenue west of Oak Street, taking into account the existence of Shaughnessy golf course. The SHBRA was renewed and amended in 1933 (changing the southern boundary to 41st Avenue and strengthening the rules against commercial encroachment), 1939 (extending it for 30 years), 1950 (for an expansion of Shaughnessy Heights United Church), 1951, 1957, 1960, and 1962, before finally expiring in 1970, by which time the provincial government had grown tired of its unique involvement in municipal affairs.

27 J. S. Matthews, "Notes on Street Names and Places," CVA.

28 J. S. Matthews, "Notes on Street Names and Places," CVA.

The first bloom of Shaughnessy Heights was blighted for almost a decade by a deep economic depression in 1913, the declaration of war in 1914, the catastrophic loss of life over the next four years, the levying of federal income tax starting in 1918, and the economic recession that continued in the war's wake through 1922. Subsequently, however, with trees growing, gardens maturing, and a return to prosperity, the area became what its promoters and residents had dreamed of. As newspaper columnist Allan Fotheringham quipped many years later, Shaughnessy Heights had a population of six people per acre, four of whom were gardeners.

There remains in archival photo collections some evidence of grand soirées and a Gatsby-quality lifestyle in Shaughnessy. Garden parties, weddings, and the McRaes' New Year's Eve costume balls dominated the Society pages of the newspapers. The Hambers at "Greencroft" (3838 Cypress Street) owned a movie camera in 1928, and filmed a hilarious "Harem Party" of their friends, a copy of which is in the City Archives, along with other films of tennis afternoons and visits to their country property in Coquitlam.[29]

Any hint of crime or debauchery, especially involving race, titillated and scandalized the wider city. Most notorious was the 1924 murder of nanny Janet Smith in the Frederick Baker house at 3851 Osler. A botched autopsy (by coroner and neighbour William Disbrow Brydone-Jack of 4237 Angus Drive) and public allegations of a cover-up led to the accusing and kidnapping of one of the Bakers' Chinese servants, his beating and arrest, but ultimately his acquittal. The Scottish Society hired a solicitor to ensure the investigation wasn't a whitewash, and newspapers repeated rumours of nefarious guests who had been at the Bakers' home the previous night for a party. Whispered accusations focused on a son of Lieutenant-Governor Nichol, who was said to be a morphine or cocaine addict (as were a number of veterans, including Reginald Tupper, who had become addicted to morphine while recovering from war wounds).[30]

The early 1920s saw an uptick of anti-Asian racism. In Shaughnessy Heights, the Ku Klux Klan rented "Glen Brae," the mansion of the late sawmill owner W. L. Tait at 1690 Matthews Avenue (now "Canuck Place"). As in the events of 1907, economic recession was the trigger. Anti-Asian sentiment was prominent in the political platform of the provincial Liberal Party and in statements such as this, from General A. D. McRae describing his life at "Hycroft": "When I get through paying the butcher, the baker, and candlestick maker, and the staff of ten or twelve which I keep around me, what I have left out of $25,000 at the end of the year would not wad a gun. Incidentally, it is a happy white man's home. No Oriental has ever been employed within its walls for an hour."[31]

One notorious piece of legislation of the period was the euphemistically named Women and Girls Protection Act of 1923,[32] which superseded an amendment to the Municipal Act making it illegal for a White woman to be employed in any business owned or operated by a Chinese person. In its

29 City of Vancouver Archives films MI-137, MI-150 and MI-151.

30 See my *Vanishing British Columbia,* p. 43.

31 Vancouver *Daily Province*, March 15, 1923.

32 Another example of the Canadian gift for concealing its racism is the "Continuous Journey Regulation" of 1908, stating that immigrants to Canada could only arrive on a single voyage from their home country, making it impossible for South Asians, who were British subjects but not mentioned anywhere in the text, to immigrate; it was the trigger for the infamous *Komagata Maru* standoff in 1914. It was also used to thwart Jewish immigration from Eastern Europe in the 1920s (see Norman Ravvin, *Who Gets In,* p. 58). Yet another is the Chinese Immigration Act of 1923, which was in fact an exclusion act.

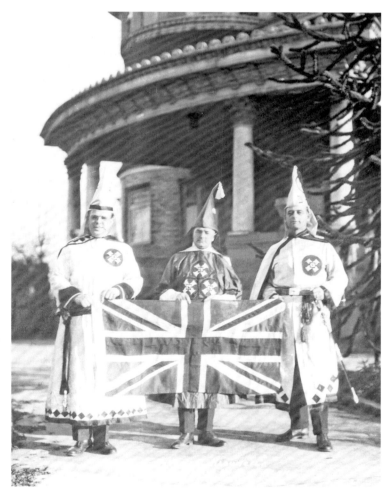

Stuart Thompson photo, CVA.

SURVIVING (AN ADJECTIVE) 63

33 An excellent 1999 *BC Studies* article by Scott Kerwin called "The Janet Smith Bill of 1924 and the Language of Race and Nation in British Columbia" is available online on the UBC Library site.

34 A chapter of historian Martin Robin's *The Rush for Spoils: The Company Province 1871–1933,* (McClelland & Stewart, 1972), is entitled "The Shaughnessy Crusade: 1921–1924."

slippery Canadian way, the final bill deleted the reference to Asian people and gave the power to local police chiefs to ban employment "in the interest of morals." The following year, 1924, the "Janet Smith Bill" outlawed the employment of Asians and White women in the same house. Both bills were part of the broader eugenics or "racial purity" movement of the time, and were enthusiastically supported by Mary Ellen Smith, the first woman to be elected to the BC legislature in the wake of the suffrage referendum of 1916. They complemented anti-Asian statements by organized labour in the province that dated back several decades.[33]

An anomaly was the occupancy, beginning in 1926, of the house at 3351 The Crescent, just around the corner from McRae, by the Japanese consul as his official residence. In the 1927 directory, the house is listed merely as "Japanese."

Many of the province's political battles of the early 1920s were fought between Liberals and Conservatives who were neighbours in Shaughnessy Heights.[34] The Liberals, who had come to power in 1916 in the same election that passed a referendum in favour of Prohibition (the other referendum on that ballot, also passed, gave women the vote), were forced to clean up the mess of widespread bootlegging and smuggling. They ordered a referendum to end Prohibition for October 20, 1920, which passed with a majority vote, and then passed a Moderation Bill in February 1921, allowing for government control and sale of liquor in sealed bottles. A tsunami of allegations of corruption and cronyism swamped the government, especially its Attorney General, John Wallace de Beque Farris of 3351 Granville Street. An earlier Liberal Attorney General, Malcolm Archibald Macdonald of 3450 Osler Street, had been forced to resign when a donation of $25,000 to him by a Canadian Northern Railway executive came to light. A later occupant of that house, John Hart, became Liberal premier in 1941.

The other major public issue of the period was the Pacific Great Eastern Railway, chartered in 1912 to be the link from the Grand Trunk Pacific, where it passed through Prince George, to the coast. By the 1920s, it had connected only its terminus in North Vancouver with Whytecliff in West Vancouver, then resumed at Squamish with tracks as far as Quesnel. One of the biggest properties in Shaughnessy Heights, "The Hollies" at 1388 The Crescent, was home to George MacDonald, the general manager of the PGE.

The railway's principal contractors had been Foley, Welch and Stewart; its president was John Stewart of 1675 Angus Drive. Mired in controversy, including allegations of corruption and fraud, the company abandoned its enterprise in 1918; however, Stewart's reputation due to his war service was such that the Prince of Wales (the future Edward VIII) stayed at his home during his Vancouver visit of 1919. Stewart had commanded Canadian railway-construction troops on the Western Front and was lauded as "one of the men who really helped win the Great War," according to a British historian. Stewart invested heavily in the *Vancouver Sun* and was credited with promoting Robert Cromie to publisher; the Cromies themselves were Shaughnessy Heights residents for two generations. The *Sun* supported the Liberal Party despite all scandals; Nichol's *Daily Province* supported the Conservatives.

PGE and liquor scandals, and the moribund nature of the Conservatives under W.J. Bowser, who had succeeded Sir Richard McBride, set the stage in the early 1920s for the arrival of a political messiah in the form of General McRae of "Hycroft." McRae was a controversial figure, extremely wealthy from his land dealings on the prairies. He was an "economic buccaneer" or "robber baron" even for the age. His military credibility came from

his service during the First World War as Chief Remount Officer; he later became Quartermaster General and ended the war in the Ministry of Information under Lord Beaverbrook. His angry, publicly expressed desire to "clean up politics" led him in 1922 to form the Provincial Party, consisting of disaffected Conservatives and members of the United Farmers of BC, but he was soon discredited by the latter because of tales of his land dealings with prairie farmers two decades earlier. Nevertheless, the party published a muckraking broadsheet called "The Searchlight" and managed to elect three members (not including McRae) with 24.2 percent of the popular vote in the 1924 election.

The Provincial Party declined rapidly when Conservatives pushed out Bowser and rallied around the new Tolmie government, elected in 1928 with baker and industrialist William Curtis Shelly of 1563 Matthews Avenue appointed as Minister of Finance. Another member of that "businessmen's government" was George Walkem of 3990 Marguerite Street, an industrialist who controlled shipping and manufacturing over much of False Creek and had served as reeve of Point Grey.

The amalgamation of Point Grey and South Vancouver with the City of Vancouver in 1929 created the modern city's boundaries just at the point when the stock market collapse in New York City triggered the start of the Great Depression. A homeless camp sprang up on the abandoned site of the Hastings Mill at the foot of Dunlevy Avenue; later, a larger "jungle" of unemployed men who had been "riding the rods" across the country looking for work established itself on the old city dump site at Hawks and Prior on the edge of Strathcona. Within a few years, owners unable to pay their taxes were losing their homes to the city, and newspaper advertisements offered hundreds of properties at auction for prices starting in the hundreds of dollars.

Many grand homes in Shaughnessy Heights rapidly became white elephants, but the resolve of the residents for an exclusively single-family enclave, expressed through the Shaughnessy Heights Property Owners Association (SHPOA), only strengthened. The first challenge was to keep the area free of any commercial activity.

Lawyer Cecil Killam acted on behalf of SHPOA through the 1930s and early 1940s and led the campaign against a block of stores proposed for the northwest corner of King Edward and Granville. On March 15, 1933, stating that he represented some 3,000 adult residents and 1,200 property owners in all three Shaughnessy districts, Killam urged the private bill committee of the provincial legislature to extend restrictions against commercial establishments until 1950; the committee recommended extending them only to 1945.

The Pappajohn brothers of Kerrisdale nevertheless applied on December 11, 1936, to the city for, and were granted, a building permit for the site. Four days later, Mr. Justice D.A. McDonald of the B.C. Supreme Court overturned the permit. The property remained vacant until the 1970s – ironically, Boy Scouts' Christmas tree sales were the only commercial activity tolerated on the lot by the neighbours for many years.

Meanwhile, the conversion of Shaughnessy Heights to rooming houses and convalescent homes was happening by stealth. "Glen Brae," one of the biggest of the old homes, lost its KKK tenants as the economy improved in the late 1920s and a new city bylaw made face-covering illegal. A kindergarten rented it in 1929 for $75 a month; historian Chuck Davis found an advertisement offering the house as a prize in a raffle, with tickets at a dollar each.

35 *The Province,* August 19, 1937.

In the late summer of 1937, the conversion issue became public with two requests to the Board of Zoning Appeal, one to alter the old J. P. Blowey house at 1068 Wolfe Avenue into a convalescent home, the other to remodel 1490 Balfour into a duplex. A solicitor for the CPR opposed both applications.[35] On September 2, a news story entitled "Fire Gongs or Empty Beds" said that unofficial boarding houses were caught between the requirements of the Fire Marshall's Act and the SHBRA. The Fire Marshall had issued "10 or 11 orders" to install fire escapes and alarms.

By 1939, Shaughnessy property owners were protesting loudly about their assessments and taxes; for example, the newspapers quoted the former provincial finance minister, W.C. Shelly of 1563 Matthews, complaining that his assessment of $19,500 was "out of all reason." On February 9, the *Daily Province* editorialized that it was a "topsy-turvy age," when owners in Shaughnessy Heights would come to City Hall seeking relief.

Arguing that many owners were taking in boarders to help pay taxes, Alderman H. J. De Graves had tabled a motion on February 7 to establish a special committee on the housing situation in Shaughnessy Heights with a view toward repealing the SHBRA. By March 7, according to the newspapers, residents had divided themselves into two camps "in preparation for a pitched battle" over the repeal proposal. George McCrossan, former corporation counsel for the city, said the SHBRA was killing the assessed value of properties in the area. "This is a hypocritical restriction. There are boarding houses and hospitals operating in Shaughnessy. Taxes on my 18-room house run to $700 to $800 per year and I'm getting fed up. I've been a Heights' resident for 27 years. I've tried to sell and I couldn't get a nibble at the land price alone [$10,000]." He stated that the CPR had needed to repossess 250 properties because of costs of taxes and maintenance.

The term "Mortgage Heights" appeared for the first time that day in a newspaper headline, coined by A. B. Fleishman, a barrister, who led the delegation intent on repealing the SHBRA. The opposing camp, SHPOA, met on March 18, and voted to ask the provincial government to extend the SHBRA until 1970; on November 30, the provincial legislature gave third reading to an amendment doing just that.

Eastern European Jewish refugees provided a brief glimmer of hope for Shaughnessy Heights in 1939, according to J. C. McPherson of SHPOA. "A number of wealthy CzechSlovakians [sic] and Austrians, fleeing from Nazi terrorism, are purchasing or leasing palatial homes in Shaughnessy Heights and provide a striking demonstration of the need which still exists for an exclusive dwelling district."[36] Anglo-acculturated Jews like the Koerners, Hellers, Sauders, and Bentleys rapidly became part of the province's business Establishment, mainly through their investment in and development of the forest industry.

36 *The Province,* November 13, 1939.

The 1922 marriage of Russian-born Jewish pianist Jan Cherniavsky to Elspeth, the second daughter of sugar refinery owner B. T. Rogers, provided another link. Mrs. Rogers, following the death of her husband in 1918, had become increasingly involved with the city's symphony orchestra, acting as its principal financial prop in the 1920s and 1930s. Her son-in-law's connections with the international music scene made her home "Shannon" at 57th and Granville the centre of a kind of salon, which went with her to 3637 Angus Drive when she moved to Shaughnessy Heights in 1936. The Hart House Quartet was one of the many groups that played regularly for her there. Mrs. Rogers also attempted to arrange the immigration of Jewish families, including the Bettelheims and the Hubermanns.

However, nothing could change the long-term downward trend of Shaughnessy property value. "People of Vancouver must come to realize that real estate values are gone," according to George Martin, president of Vancouver Mortgage Corp Ltd., speaking to the court of assessment revision.[37] He claimed that General McRae paid $500 a day to live in his home the previous year. A. N. Ker, a realtor, said that Shaughnessy homes were on the bargain counter. Many were run down and so dilapidated it was impossible to sell them, he claimed. Regardless, city council had refused to consider a cut in the valuation of Shaughnessy Heights property; however, a month later it reversed itself and cut assessments, in some cases as much as 20 percent.

A news article on February 9, 1940, said there was "much talk locally about … following the Winnipeg example" and tearing down old homes. The next January, a realtor named George Martin said: "Homes in Old Shaughnessy are worth 25 percent of what they were 15 years ago."[38] One estimate put the total assessment value of Shaughnessy Heights at only $3 million. Council promised to do a survey of the buildings in the area.

The European war that had begun in September 1939, seemed very distant. Mrs. Rogers wrote in her diary on February 14, 1941: "Mrs. Laing and Mrs. Kidd had a monster cocktail party in the vacant Hendry House [3802 Angus Drive] in aid of the Artillery Auxiliary." General McRae, who had moved in the 1930s to his "Eaglecrest" estate at Qualicum Beach, turned "Hycroft" over to the Canadian government as an annex to Shaughnessy Military Hospital on Oak Street.

With the declaration of the Pacific War following the Pearl Harbor attack on December 7, 1941, the house at 3350 The Crescent, which had become the Japanese consular residence in the 1920s and was registered in the name of Ichiro Kawasaki, was seized by the Custodian of Enemy Alien property. The Japanese government managed to repurchase the property in the 1950s and continue to maintain the historic home, designed by Maclure & Fox, to this day. Coincidentally, it backs onto the extensive property of the Chinese consulate and residence, which face Granville Street.

With Vancouver more involved in the war, more men overseas and industry running at full speed, a deepening housing shortage in the city began to focus attention on Shaughnessy Heights. On September 9, 1942, Cecil Killam of SHPOA filed suit against Mrs. Anna McAndless, who had allegedly reconstructed the old Melville Dollar house at 3890 Hudson into suites.

The campaign against SHPOA was led by the *News Herald,* which had more of a "common man" readership than either the *Sun* or the *Daily Province,*

37 *News Herald,* February 1, 1940.

38 *News Herald,* January 29, 1941.

A "white elephant" during wartime housing shortages, a 1942 photo from the *News Herald,* collection of the City of Vancouver Archives.

A woman whose soldier husband was captured by the Japanese, and a war widow, both facing eviction and homelessness in Shaughnessy, 1942. Photograph in the Vancouver *News Herald*.

both of whose owners had deep roots in the area. For example, on September 18, "The housing authorities at Ottawa should therefore take timely steps to prevent these [houses] from becoming civic eyesores and white elephants." The type of society that created the neighbourhood will never return, it said. The following day, a photograph of two women, one a war widow, the other with a husband imprisoned by the Japanese, appeared with a caption describing their pending eviction if SHPOA was successful in court. Another newspaper photo showed ivy growing across the front steps of an obviously empty house, without stating that it was the former Japanese consular residence.

The *News Herald* continued its campaign in an editorial on September 29. "What is certain is that the housing authority in Ottawa is not going to tolerate indefinitely the situation where there are empty homes on the one hand and numerous homeless people on the other." In the court proceedings of McCandless vs. SHPOA on October 6, counsel for the defendant C.H. Locke said: "The plaintiff by insisting on going on is neither patriotic nor helpful in the war effort."

Although SHPOA and its president, W.P. Kirkpatrick, were sharply criticized, they fought back. Property owners were asked to subscribe $5 or more to fund the campaign. Another voice, that of Town Planning Commission chair Earl Bennett, said on October 20 that there were not more than 25 vacant homes in the district and that conversion would do no more than scratch the surface of the housing problem.

A decision seemed to be at hand on November 5, 1942, when the *News Herald* crowed: "Shaughnessy Housing Curbs Lifted by New Ottawa Order." Order 200 of the Wartime Prices and Trade Board suspended subletting barriers in Vancouver and elsewhere. It appeared to override "all terms, provisions, covenants or restrictions of any law, bylaw, conveyance, deed, agreement or lease now or hereafter prevailing which, in any way, prohibits, limits or restricts subletting of the whole or part of any housing accommodation."

However, by January 13, 1943, only one building permit had been sought. Ald. George Buscombe suggested that the shortage of plumbing supplies, the scarcity of labour and the inability of most persons to furnish the large homes, had resulted in the lack of interest. A follow-up story a week later suggested only one or two empty homes were available.

On July 10, Cecil Killam and SHPOA sought an injunction against W. J. Burns-Miller of 4850 Connaught Drive in Second Shaughnessy, who wanted to alter a house to accommodate six suites. The suit was dropped on August 1 when Burns-Miller said he would stop. Adding confusion to the issue was F. W. Nicolls, the Dominion Housing Director, who stated that the wartime emergency measure was not intended to override an act such as SHBRA. On July 14, echoing Nicolls's statement, SHPOA announced it would take court action against anyone altering houses.

The following month, a house on Pine Crescent, converted into a 12-suite apartment building without any permits, made the news. City Council said it would take action, but then shelved the issue in September, refusing either to enforce the zoning or offer any other clear-cut policy.

The conclusion of the war in 1945, ending rationing (of gasoline, tires and some food items, which had begun in 1942) and the patriotic purchasing of war bonds, did nothing to end the long-standing divisions between Shaughnessy residents. Some houses were "rat-infested dumps," according to Hon. W. A. MacDonald, former Supreme Court judge, speaking at a court of assessment in January 1945. On August 6th of that year, the day the atomic bomb dropped on Hiroshima, the Town Planning Commission endorsed a plan to rezone the former vegetable garden of "Hycroft" for the "Hycroft Towers" apartment building. In April 1949, the influential UBC professor and member of the Town Planning Commission, Frank E. Buck, declared Shaughnessy Heights to be "blighted" – his term also for the Strathcona area east of Chinatown and, during the war, for the evacuated Powell Street "Japantown," signifying for him an urgent need for urban renewal.

But City Council appeared to favour a return to the pre-war, pre-Depression status quo. On January 25, 1949, it ruled that rooming houses would have to shut down in Shaughnessy Heights as soon as wartime housing regulations were relaxed. Although a severe housing shortage still existed, people across the country were agitating to lift Order 200. Nineteen percent of the area was used for other than single-family purposes, Council noted. (By way of comparison, a 1952 survey found that 179 of 525 houses in the section of Kitsilano north of 4th and west of Bayswater, zoned for single-family, had extra suites in them.)

Order 200, with its rent controls intact, was set to expire on March 31, 1955, but the federal government passed it off in July 1951, to the provincial government. The city made its intention clear to close lodging houses by refusing to issue new licenses.

Other non-conforming uses continued to draw SHPOA's attention. An injunction issued against Fairview Baptist Church at 16th and Pine Crescent in the spring of 1949 was approved in Supreme Court June 22. That summer,

fraternity houses became the issue, particularly one proposed for 1812 West 19th, one of three in the area, which prompted City Council to consider banning them in Shaughnessy Heights altogether. "Every sunny Sunday groups of students sprawl across lawns there drinking beer," according to a news story. Thirty-five cars were parked around residents' homes, some across driveways. On August 10th, Council amended the zoning bylaw to ban them. The issue continued through the fall with the fraternities hoping that Order 200 gave them protection – it permitted shared accommodation regardless of local zoning.

Even though a wedding and catering business operating for three years from "The Hollies" (1388 The Crescent) was considered to be well run and causing no problems, SHPOA obtained an injunction to close it on February 1, 1951. News stories said there were 153 operations in Shaughnessy Heights made possible by Order 200, including a "dice game" in a lodging house on Angus Drive exposed that August. A 1955 survey claimed that 200 of the 495 homes were "revenue homes," of which 48 lodging houses and 12 apartment buildings had licenses.[39]

A new group, the First Shaughnessy Residents Association (FSRA), also called the Shaughnessy Heights Residents Association, with Gerald Vincent Pelton as president, arose to battle SHPOA. Its first attempt in March 1951, to get City Council to withdraw its support for the SHBRA was rejected. One newspaper article in April had the title "Battle of Shaughnessy Heights." By 1954, both the FSRA and SHPOA were canvassing throughout the neighbourhood for support. The city tried a compromise bylaw in November 1955, but the following summer SHPOA announced a campaign to wipe out boarding houses. Provincial hospitals inspector A. H. Rose filed charges in December 1957, against the operators of illegal hospitals at 1427 Laurier and 1375 Nanton.

A resolution of sorts came to pass in the spring of 1959, with a compromise between the two factions. Following a plea from the city not to repeal the SHBRA, the legislature amended the legislation on March 12 to preserve the status quo of rooming houses in existence before April 1955; they were grandfathered for 30 days after ceasing operation.

There had been a glimmer of a new beginning for the area, recognized in January 1955 by *Sun* features writer Don Stainsby: a move "back to Shaughnessy" as a family area. Prices had climbed as high as $40,000. It was perfect for "young executives and professional men, the 'upper-middle class,' who can afford bigger homes for their families." Until this time, most of the attention for that kind of family had been on the North Shore – the British Properties for the upper middle class, elsewhere in West Vancouver and North Vancouver for the middle class, where new modern houses, affordable car ownership and the convenience of Park Royal Shopping Centre offered an attractive lifestyle.

Finally, in 1968, the provincial legislature indicated it no longer wanted to be the zoning board for Shaughnessy Heights. The standing committee on private bills voted on March 27 to turn down a bill to extend the zoning restrictions for another 15 years after 1970. Nearly half a century after its enactment in 1922, the SHBRA was put to sleep.

39 *Vancouver Sun,* January 8, 1955.

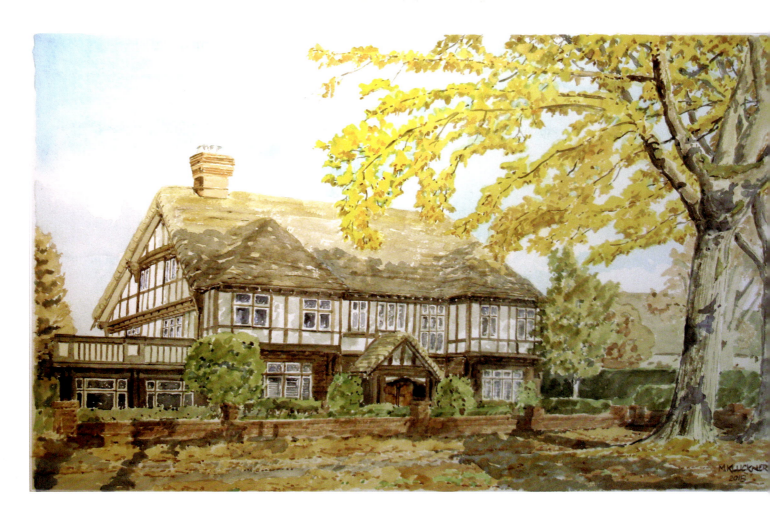

The impracticality of maintaining big Shaughnessy Heights properties in the economically challenged 1970s coincided with a growing awareness of Shaughnessy's unique character, not as a single-family enclave but as a heritage area. The first book to offer architectural and historical information was Harold Kalman's *Exploring Vancouver,* published in 1974 by UBC Press.

That year, the provincial government gave Vancouver the power to protect buildings from demolition; in December 1974, City Council designated as heritage buildings "Hycroft" and "Rosemary" (3689 Selkirk), the latter used at that time as a religious retreat. They were the only two buildings in Shaughnessy of the 21 Council designated. The University Women's Club had purchased "Hycroft" from the federal government in 1962, and infilled townhouses on a portion of its grounds after the city agreed to rezone the property.

An early example of the change in the neighbourhood's character involved "Duart" at 3741 Hudson, which had been forestry industrialist H. R. MacMillan's home until his death in 1976. It stood on an acre of garden. Developer Larry Killam – a key player in the Gastown Revival of the late 1960s – bought the property and wanted to redesign the house's interior into three strata-titled residences with one or two detached coach houses, but the city zoning stipulated single-family, fee-simple lots.[40] "I haven't the heart for a two-year fight," he said, and demolished the house, dividing the property into four lots.[41]

The city belatedly recognized the complexity of the issue and began to look for alternative ways to keep the essential landscape and architectural

Probably the largest house built in Vancouver in the period between the wars, the Brooks House at 5055 Connaught Drive dates from 1921 and is the work of H. H. Gillingham, also the designer of the Commodore Ballroom. For many years, it was occupied by religious institutions. Its "Cotswold roof" of steam-bent shingles is similar to the James House's on p. 50. It was beautifully restored in 2018 by the Sandy family.

40 The Strata-Title Act had allowed for condominiums since 1966.

41 *The Province,* October 19, 1976.

SURVIVING (AN ADJECTIVE) 71

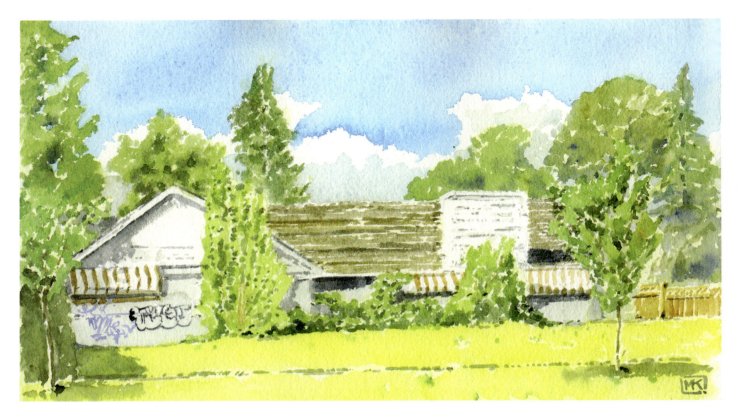

Shaughnessy infill – ranchers and small houses from the '20s through the '50s have been demolished and replaced by mansion-sized new homes. This one was at 1645 West King Edward until about 2015.

character of First Shaughnessy (as it had by then become known, superseding the older Shaughnessy Heights name). On October 6, 1981, the city adopted policies of the First Shaughnessy Plan, including:

"• Special development incentives such as conversion and infill will be permitted on appropriate sites… to encourage the preservation of meritorious pre-1940 houses.

"• All meritorious pre-1940 buildings must be preserved and satisfactorily restored as a condition for approving all infill and conversion development."

The following May, the city adopted Design Guidelines for the area, developed by a team including architect Robert Lemon. The guidelines recommended that new houses in the area (replacing the modest 1940s–1950s-era ranchers that had been built on unsold lots) conform to basic architectural principles of the traditional grand houses: "tripartite" compositions with a strong base, a *piano nobile* of walls and windows, and a picturesque, steep roofline. Landscaping was prescribed to create layers of planting on an estate-like scale, with the houses partially visible through filigrees of greenery. Driveways were to be curved; houses would be framed by large trees; large areas of paving were discouraged.

A design panel of local residents, appointed by the city and supplemented by members of the architectural, landscape architectural, real estate and heritage communities, was set up by City Council to vet all applications in consultation with city staff. For a time it worked quite well.

A few individual events merit a mention. "Glen Brae" on Matthews Avenue had become the Glen Brae Private Hospital for elderly women in 1980. The owners, Julian and Elisabeth Wlosinski, lived in the 15-metre-long ballroom, with their bedrooms in the turrets which had 10 arched windows each. In 1991, before her death, Elisabeth Wlosinski willed it to the City of Vancouver and described her vision of it as an arts and culture centre.

But the city had no ability under its charter to accept such a gift that, regardless, was met with hostility by neighbours. The city responded by

establishing the Vancouver Heritage Foundation in 1992, an arms-length organization that could, in theory, accept such a gift and manage such a project. Then the Vancouver Canucks took it on, and it opened as "Canuck Place," North America's first free-standing hospice for children, in November 1995. Even the neighbours couldn't complain about that.

"Greencroft," the Hamber home at Cypress and Matthews, attracted neighbourhood controversy when it was restored with two smaller residences inserted onto its properties. And "Miramar," the Nichol residence on The Crescent, was also restored, but with a block of townhouses added to the bottom of the property – effectively at the corner of 16th and Granville.

These were the kinds of projects envisaged by the 1982 plan. But in the first decade of this century, a wave of applications to demolish old Shaughnessy houses took the city by surprise. More than 50 of the "meritorious pre-1940 houses" were lost because new owners flatly refused to work with their old houses, preferring to demolish and build new. The issue came to a head in 2015 with the decision by City Council to declare First Shaughnessy a Heritage Conservation Area, using provincial legislation that allows a municipality to designate individual houses and enforce maintenance standards and renovation guidelines.

This new-old Shaughnessy Heights respects the design vision of a century ago, while allowing old houses to be adapted for multi-family occupancy. This is the dichotomy of Shaughnessy: is it an historic area adapted to the 21st century, or is it a bastion of single-family ownership where individual property rights trump the public benefits of heritage preservation and accommodation for more people?

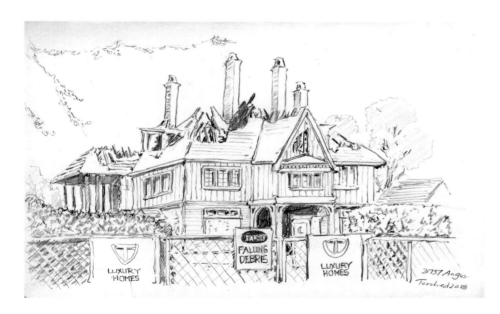

"Realtor warns of Shaughnessy decline with designation as heritage conservation area," said the headline in the *Georgia Straight* soon thereafter, quoting Peter Saito's belief that secondary dwelling structures wouldn't work because "everybody is already rich. They don't need the income."[42] Since then, deteriorating empty houses, fires, and oversized additions have marred the area's character. The city seemed to lose interest and many houses appear vacant, probably owned by people who spend little time in the city. Only the trees are thriving.

In 2022, five years after an arson fire, the house at 3737 Angus Dr., a "Heritage-A" listed building known as the Rounsefell House that had been protected within the heritage conservation district of First Shaughnessy, was demolished. It had caught fire after sitting vacant for several years. Owners Miao Fei Pan and his wife, Wen Huan Yang, hadn't lived there, but apparently had plans to renovate the immaculate 10,000-square-foot Tudor home which they purchased in 2012. In late October 2017 a major fire broke out in the upper floor. The fire was deemed suspicious and Vancouver Fire and Rescue Services eventually confirmed that it had been "maliciously set." The fire left large holes in the roof, and about 40 per cent of the house was destroyed. I skulked on the street with my sketchbook in 2021.

See Kerry Gold, "Shaughnessy heritage home demolished years after fire," *Globe & Mail,* November 25, 2022.

42 Carlito Pablo, September 29, 2015.

SURVIVING (AN ADJECTIVE) 73

Resilient Chinatown

If Shaughnessy had all the advantages, Chinatown has had few beyond the resilience of its residents and the goodwill of many Vancouverites. Like First Shaughnessy, it is a Heritage Conservation Area. Its streetscapes are lined with shops and the buildings of family societies dating back to the first decades of the city's existence. But unlike Shaughnessy, it has been challenged economically by the rise of other "Chinese" areas such as Victoria Drive around 41st Avenue and the malls and shops of Richmond; more dramatically, it has been besieged by the overflow of disorder – crime and graffiti – from the Downtown Eastside a mere block away on Hastings Street (page 88) – as well as random racist attacks perhaps connected in the fevered brains of the perpetrators with the origins of Covid in China.

After surviving the racial-exclusion years of 1923–1947, the period of the Chinese Immigration Act,[43] Chinatown thrived with the arrival of new families in the 1950s and '60s, many of whom settled in the old East End (Strathcona). Pender Street's neon restaurant signs and nightclubs such as the Marco Polo and Mandarin Garden attracted people from every corner of the city. The area narrowly avoided erasure when the downtown freeway was cancelled in the early 1970s.

Forty years later, the homeless and distressed population on Hastings Street began to spill over onto Pender. The closure in 2020 of the original 1917 store at 23 East Pender of Ming Wo cookware, which continued successful operations elsewhere, was a bellwether event. However, the community rallied, led by Carol Lee, chair of the Vancouver Chinatown Foundation that she founded in 2011. It promoted social housing projects including the May Wah Hotel, and cultural events including the Light Up Chinatown festival

43 The "Immigration Act" was actually an exclusion act in the typically slippery way that Canadian governments masked their racism during that era.

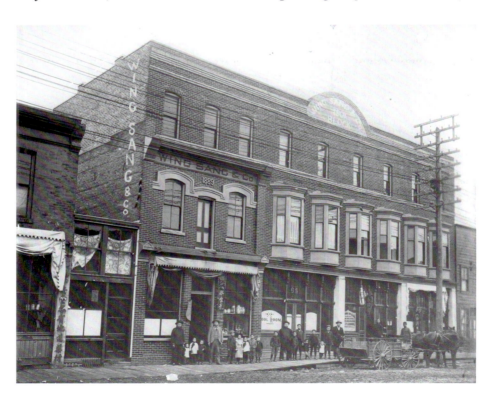

Merchant Yip Sang and family members in front of the Wing Sang Company building, 51 East Pender Street, ca. 1911. City of Vancouver Archives photo CVA 689-54.

74 SURVIVING (AN ADJECTIVE)

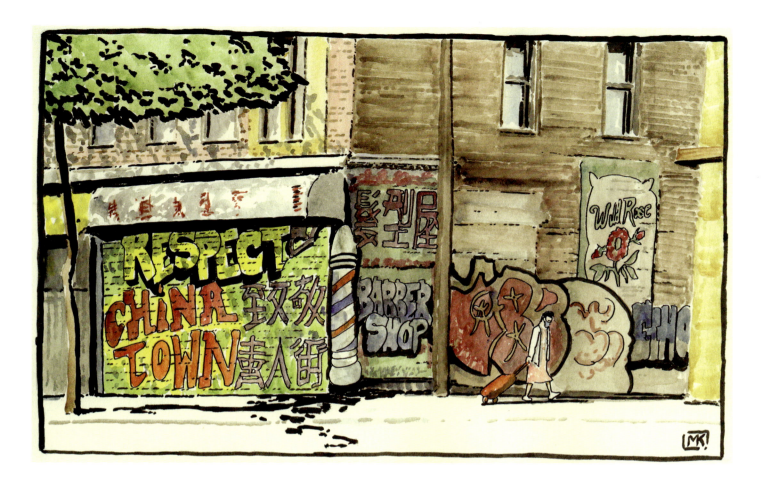

and the wonderful Chinatown Storytelling Centre, which opened in 2021 in a former bank building at 168 East Pender.

Neon became a touchstone: the recreation of the Ho Ho sign at 102 East Pender, and reopening the restaurant itself, were a personal project for Lee.[44] However, a different type of restaurant supporting aging residents and workers, Kent's Kitchen on Keefer Street, shut down in April 2023.[45]

The biggest sign of resilience and rebirth was the opening in 2023 of the Chinese Canadian Museum (on July 1st, Canada Day, known as "Humiliation Day" for the proclamation of the exclusion act exactly a century before) in the oldest building in Chinatown at 51 East Pender. The Wing Sang Building, erected in three stages in 1889, 1901 and 1912 by Yip Sang, had been restored in 2004 and used by condo super-marketer Bob Rennie for offices and art display. The Province of BC provided $27.5 million for its purchase and conversion into the museum. Generous support from individuals has helped it, the Storytelling Centre, and the Chinese Cultural Centre adjoining the Dr. Sun Yat-Sen Classical Chinese Garden.

But Chinatown is "contested space," too. A nine-storey condo proposal at 105 Keefer by the Beedie Group split the community, with a number of local organizations supporting it as a revitalization tool and others decrying it as gentrification, pointing to two large new buildings on Main near Keefer as having added little vitality to the community. The project was a rare rejection by the Development Permit Board in 2017, but came back for reconsideration following a court ruling. It was given the green light on June 25, 2023.[46]

The supportive street art of Smokey D (James Harding), including this on Gore Avenue, led to the declaration on March 11, 2023 of "Smokey D Day" by Vancouver Council. His murals on social issues in the Downtown Eastside contrast with the nihilist graffiti that dominates the area and has spilled over into Chinatown.

[44] Dan Fumano, "Will Vancouver restaurant Ho Ho's neon chopsticks be lit up once again?," *Vancouver Sun,* December 5, 2022.

[45] Joanne Lee-Young, "Loss of programs and businesses hits residents of Vancouver's Chinatown," *Vancouver Sun,* March 14, 2023.

[46] Frances Bula, "Controversial … condo development approved," *Globe & Mail,* June 26, 2023.

SURVIVING (AN ADJECTIVE)

Photo by Hux Lovely in the *Vancouver Sun,* July 19, 1952, p. 15, of the entrance to Fountain Chapel, accompanying "Negroes Live Next Door" by Bruce Ramsey. The photo looks south along Jackson Avenue to Prior and the railway yards on the False Creek flats. A complete history of the church can be found on the Vancouver Heritage Foundation's *Places That Matter* website. It is now the home-studio-gallery of artist Torrie Groening and her partner Stephen Melvin, who writes the eastvangelist.com blog about the building's history.

47 My *Vancouver Remembered,* pp. 110–13, is one source for that history. The Chan house at 658 Keefer is described on the *Places That Matter* website.

48 As were Indigenous (1874–1949), Chinese (1874–1947), Japanese (1895–1949), South Asians (1907–1947), Mennonites (1931–1948), and Doukhobors (1931–1952).

Hogan's Alley

Chinatown has both buildings and culture, a past and a present – tangible and intangible heritage, to use the currently fashionable words. The tangible Black heritage on its doorstep has been harder to celebrate, with the exception of the 1920s–1950s African Methodist Episcopal Church, known as Fountain Chapel, at 823 Jackson Avenue. Ross and Nora Hendrix, grandparents of iconic musician Jimi Hendrix, were founders and fundraisers for the church and lived nearby at 827 East Georgia. Other notable places such as Vie's Chicken and Steak House, on the ground floor of a wooden house at 209 Union, have been demolished.

Oft repeated is the saga of Strathcona's citizens, led by Walter and Mary Lee Chan and their Chinese-Canadian neighbours, fighting back in the 1960s against the freeway and urban renewal program that would have destroyed their community, along with Chinatown and Gastown. Strathcona (known historically as the East End) was first on the list of "slums" to be eradicated in a post-war modernization program that had erased the older, poorer, racialized areas of most North American cities and, especially in the USA, created worse slums in the resulting tower blocks and "planned" communities.[47]

The East End was the only area of racial and cultural mixing in the Vancouver of a century ago, a "League of Nations" including a Black community living there partly because of affordability and the lack of discrimination, and partly due to the proximity of the Great Northern Railway station (demolished in the 1960s, it stood immediately to the north of today's Pacific Central Station) which employed some of them as porters.

Black people did not suffer the *overt* discrimination of a head tax limiting their immigration (like the Chinese) or wartime internment (like the Japanese), and were never disenfranchised,[48] but they were implicitly targeted by a 1910 amendment to Canada's immigration regulations that allowed a customs officer to deny entry to anyone "unsuited to the climate or requirements of Canada," language as slippery as any in the annals of Canadian racism.

The term "Hogan's Alley" entered North American English at the beginning of the 20th century as a nickname for a slum. It was the neighbourhood of The Yellow Kid, a syndicated cartoon begun in the *New York World* in 1895 by Richard Outcault. In Vancouver, the name became associated in the '20s and '30s with the lane between Prior and Union running eastward to Gore Avenue from behind the shops facing Main Street. That area was poor and crime-ridden – Union Street notorious for its brothels and Italian bootleggers, the lane itself a place of cabins, stables and shabby speakeasies where ne'er-do-wells lurked in the shadows and thrill seekers from other parts of town could expect a crack on the head if they were in the wrong place at the wrong time. (Union Street residents east of Vernon Drive successfully petitioned the City in 1930 to change the name to Adanac – "Canada" spelled backwards – because of the reputation the name gave to their properties. "Union Street" resumes on the Burnaby side of Boundary Road.)

Typical of the stories was one on July 25, 1935, in the *Sun,* where "Ernest Banks, 38-year-old Negro," was named by a coroner's jury as the killer of an Italian man who was watching a dogfight in the alley. A woman named Kathleen Newman was convicted of obstructing the investigating detectives when she cautioned "Edward White, Negro witness" to stay silent.

One searches for positive stories about the Black community in the mainstream media of the time, and begins to find them in the '40s and '50s,

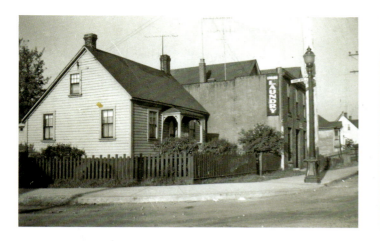
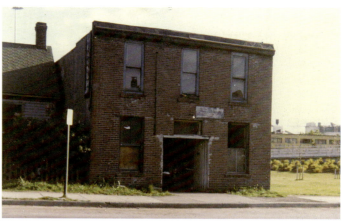

such as the 1952 example highlighted in the photo on facing page about the community services provided at Fountain Chapel. Increasingly, Black entertainers and athletes became celebrated members of the community, and adventurous White diners flocked to Vie's and to Harrison and Rosa Pryor's Chicken Inn, also known as "Mammy's Chicken Shack," at 278 Keefer.

In the 21st century, the focus of commemoration of the historic Black community, led by the Hogan's Alley Society and using information from the 1979 oral history book *Opening Doors*,[49] has become the alley itself from Main east to Jackson where the Fountain Chapel sits, and the destruction of Black heritage by the Georgia Viaduct in 1970–2. But it wasn't just Black history that was erased.

The Union Laundry at 274 Union Street, just west of Gore and backing onto Hogan's Alley, told the story of Harry and May Yuen and their family. They purchased Ginn Lee Laundry in 1948, a two-storey brick building erected in 1920, and renamed it. In the 1880s, Harry Yuen's grandfather Jae Joon Sing had gone to the "Gold Mountain" of western Canada from Guangzou in the Pearl River delta area near Hong Kong; he worked building the Canadian Pacific Railway and at Hastings Mill. His son, Jae Joon Sing, came to BC in 1911 also looking to make his fortune.[50]

Through the generations, the men went back to China, returned, and farmed in Richmond. Harry went to China at 17 in 1937 and married 15-year-old May; when the Japanese army invaded, only Harry was able to return to Canada until 1947 and the repeal of the Chinese Immigration Act. Finally reunited, the Yuens were able to start a family and the laundry business. Their children grew up working with their parents in the laundry, attending Strathcona School, hanging out nearby at Sarah's Café and shopping at the original London Drugs on Main Street.

Son Elwin Xie recalled the 1960s when he was a boy: "In our rental house, long-haired hippie renters sold the *Georgia Straight* newspaper in the daytime and jammed on their musical instruments in the evenings. Behind it, our shack facing into Hogan's Alley was rented out to a bearded loner who handed me hallucinogenic morning glory seeds while playing his Hohner harmonica."

When the City set out to demolish the properties for the freeway, Harry Yuen resisted strongly, holding out against expropriation even after the viaduct was completed (photo, top right). Following the enforced buyout, the family constructed a new laundry twice as large on the other side of Union Street. When their old home and laundry were cleared away, the land became a breezy park, but it has since become Nora Hendrix Place, with a Temporary Modular (social) Housing structure on it.[51]

The corner of Union and Gore, probably in the 1950s, looking west, and, above, the Union Laundry and rental house about 1972, shortly before their demolition, with the new Georgia Viaduct ramps in the background. Photos collection of Elwin Xie.

[49] Carol Itter and Daphne Marlatt, *Opening Doors: In Vancouver's East End: Strathcona,* reprinted by Harbour Publishing in 2011.

[50] The USA banned Chinese immigration from 1882 to 1943.

[51] This story is compiled from Elwin Xie's article "Union Laundry: The Story of Harry and May Yuen," *British Columbia History,* Winter, 2020. Elwin is a museum interpreter for the Chinese Canadian Museum and Burnaby Village Museum as well as a videographer, crafting a permanent record of the Vancouver Historical Society's lectures and archiving them on YouTube.

SURVIVING (AN ADJECTIVE) 77

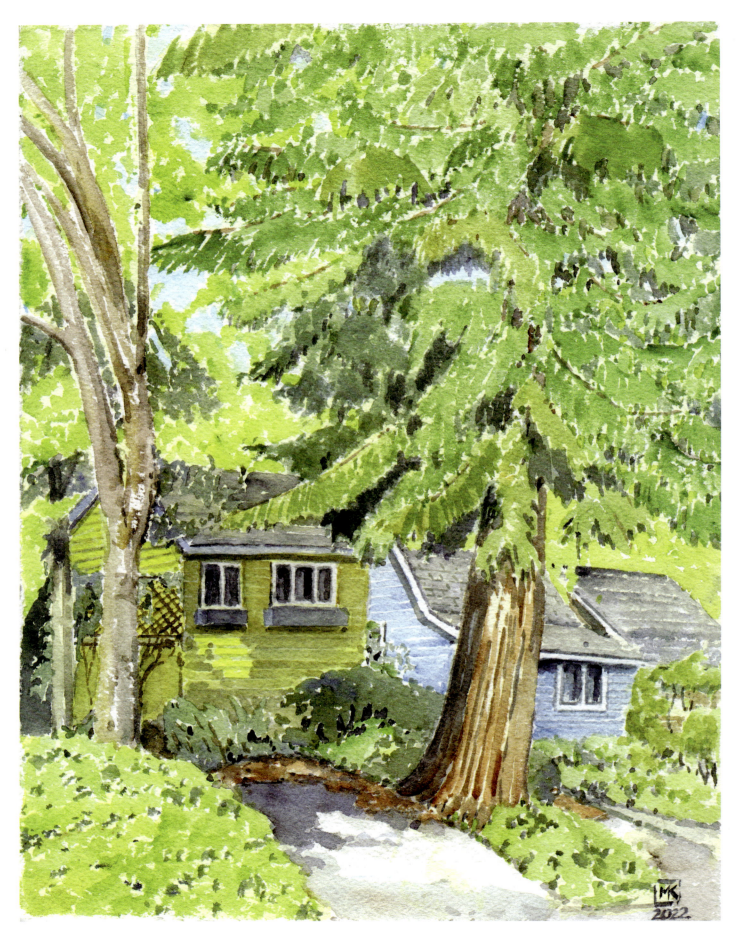

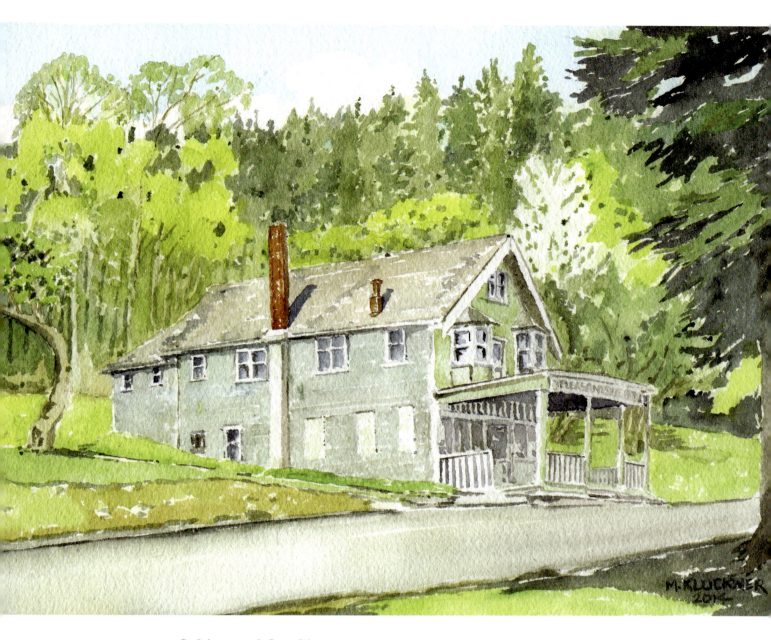

Cabins and Conflicts

The watercolour on the facing page shows a few of the 1920s-era cottages on Nelson Avenue in Horseshoe Bay, rented for the past 50 years until, in 2022, the whole group went up for sale and was purchased by its tenants who had banded together into a housing co-op with the help of CoHo BC. The modest cottages, ranging in size from 400 to 700 square feet, may have been staff housing for the Union Steamships or Blackball Ferries lines that used Horseshoe Bay before BC Ferries was founded in 1960. The new owners resisted the idea of allowing short-term rentals and set out to retain its community feel. Each owner has a share of the property and pays a monthly fee into the privately held mortgage.[52]

A relic in need of a saviour is the Pleasantside Grocery, built for Leander Philip Peltier in 1928. It was purchased in 1934 and run for many years by Attilio Ronco, a Peruvian-born storekeeper of Italian parentage.[53] It sits empty and fading on Ioco Road, now a popular place for lavish new homes with views over the inlet.

The Pleasantside Grocery on Ioco Road on the way to the IOCO (Imperial Oil Company) townsite, named for the refinery established on the north side of Port Moody's inlet. I painted it in 2014. It's been boarded up for at least a decade, its fate uncertain, although it is registered as one of Canada's Historic Places.

52 Jane Seyd, "Co-housing deal breathes new life into historic West Vancouver cottages," *North Shore News,* April 13, 2022.

53 *Canada's Historic Places* website.

SURVIVING (AN ADJECTIVE) 79

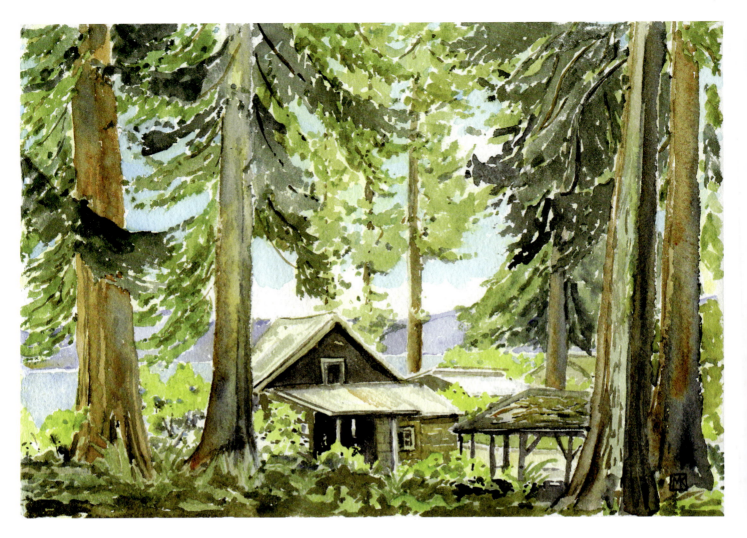

Andrea Ledingham's cottage in Belcarra Regional Park, one of the seven, in April 2014.

54 Diane Strandberg, "Belcarra Regional Park now called təmtəmíxʷtən after historical signing ceremony," *TriCity News*, October 9, 2021.

55 The northernmost cottage is actually in the Village of Belcarra, which did nothing to support the residents.

The road through IOCO eventually winds down the hill to the shoreline at the junction of Burrard Inlet and Indian Arm at təmtəmíxʷtən/Belcarra Regional Park. It received its Indigenous name, meaning "the biggest place for all people," in a 2021 ceremony with the Tsleil-Waututh Nation, as it was the largest of its ancestral winter villages. News reports at the time predicted changes to the picnic area to reflect this history.[54]

In the course of expanding the park's picnic area, a more recent history has been discarded and its residents evicted. Although listed as heritage buildings on the City of Port Moody Heritage Register and on the Canadian Register of Historic Places, the seven "Belcarra South Cottages" were vacated, their residents evicted, following a multi-year jurisdictional wrangle between Port Moody and Greater Vancouver Regional District (GVRD, now Metro Vancouver) Parks.[55]

The cottages date from a century ago and are the last remaining examples in the Metro Vancouver area of rustic summer places (except for a few at Crescent Beach, see page 117). They didn't receive road access, telephone or electricity until 1959. Most significant is the summer home of Judge William Norman Bole, who bought the southern part of Belcarra Peninsula and gave it its name after a locale in County Mayo, Ireland.

The cottagers who lived there year-round formed the Belcarra South Preservation Society (BSPS) in 1976, five years after the regional parks authority had expropriated the property. The group established and maintained its own water supply and single-lane gravel road at its own expense,

80 SURVIVING (AN ADJECTIVE)

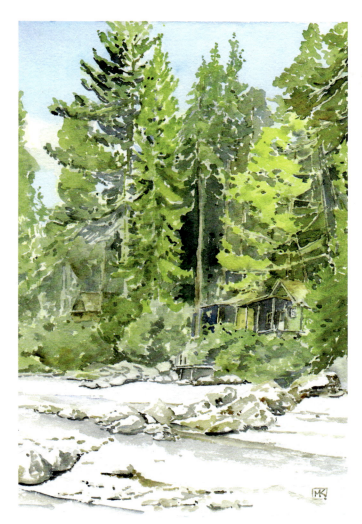 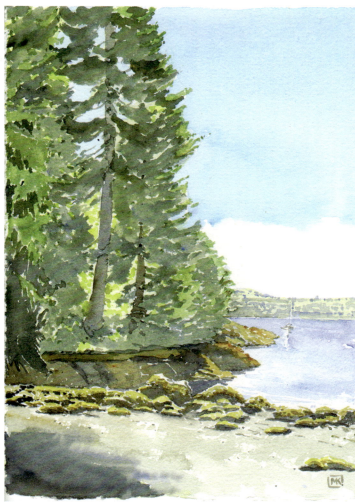

The waterfront along "Cabin Beach" in the park, the watercolour on the right looking south to Burnaby, painted in 2014.

and paid rent to the park authority. Jo Ledingham's family had leased a cottage since 1964; hers, next to her daughter Andrea's, and the others were picturesque reminders of an earlier era. The group became self-appointed stewards which they regarded as "eyes on the park" and recognized as "both a responsibility and a privilege."

The City of Port Moody, led by its mayor Mike Clay, supported retention; however, the GVRD board argued that the cottages were "structurally unsound" and didn't fit their definition of heritage, even though their parks in Coquitlam (Minnekhada) and South Langley (Campbell Valley) contain similar historic buildings. The cabins in the Davies Orchard on Bowen Island (next page) have been vacant in recent years but are being restored. Another example of privately held buildings in a park is Hollyburn Ridge, administered by West Vancouver District, with its cabins dotted along the cross-country skiing trails.

In 2017, the Metro Vancouver Board endorsed a park plan which called for the removal of the cottagers and cottages, despite the fact that it conflicted with Port Moody's heritage preservation bylaw. The following year the board issued a vacate order, which BSPS successfully disputed with the Residential Tenancy Branch. The Metro Vancouver decision was subsequently upheld by the BC Supreme Court and the BC Court of Appeal in 2021. The community dissolved, but as of this writing in 2023 a year after the evictions the cottages are still there, vacant, boarded up and fenced off – park staff can't demolish the cottages without violating Port Moody's heritage bylaw.

SURVIVING (AN ADJECTIVE) 81

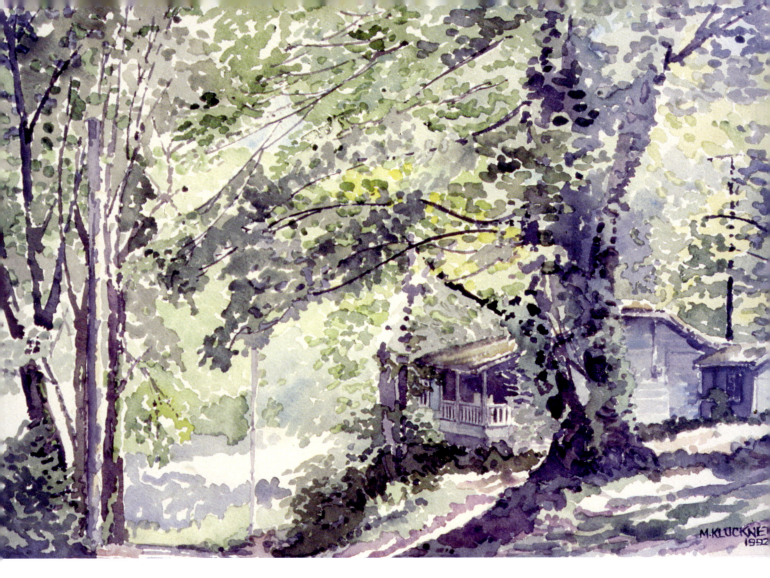

The Davies Orchard cottages on Bowen Island in Crippen Regional Park on the edge of Snug Cove village are true survivors, after years when they were seen as a liability by Metro Vancouver Regional Parks. Five of them were upgraded in 2023 for short-term rentals, one more as a museum. It is the opposite response to the təmtəmíxʷtən/Belcarra cottages, although reconciliation (and more picnic space and car parking) played a role there.

Bowen Island's tourism history is linked with the Union Steamships Company which connected the island with its wharf at the foot of Carrall Street until BC Ferries' founding in 1960; there were romantic moonlight cruises, staff picnics for companies such as Woodward's and BC Telephone, a dance pavilion, and the 1924 general store now used as the public library. William Davies planted an orchard in the 1880s and sold fruit to Bowen residents and visitors, rented tents and, in the 1920s built rental cottages of which these are the survivors.

I spent time researching and painting on Bowen in the 1980s and '90s for the Rogers-Gudewill family, who own property at Fairweather Bay on the south shore, but was always enchanted by the charming, homely cottages in "The Orchard." The light was particularly dappled on the day in 1992 when I happened by with my paintbox.

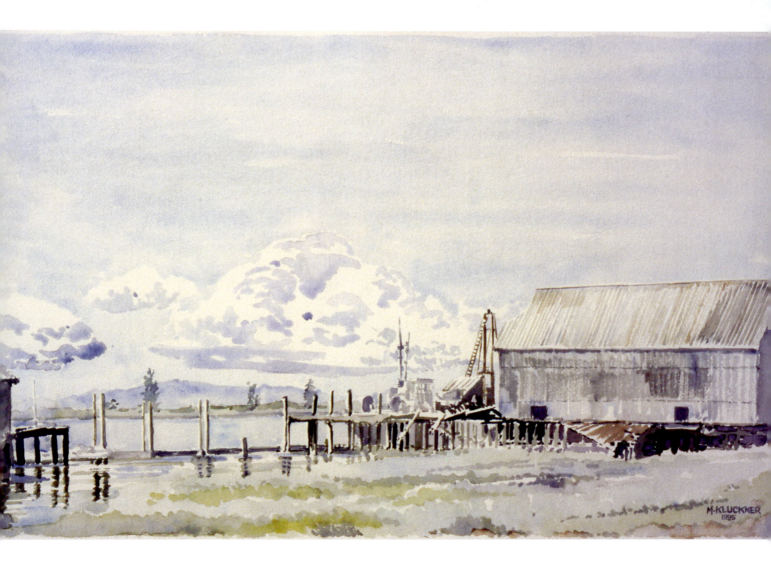

I wrote in 1996 that "the Britannia Shipyard on the Steveston waterfront, dating from the beginning of the 20th century, is undergoing a slow restoration, largely carried out by volunteers who wish to keep alive the West Coast tradition of wooden boat building. Set on pilings sunk into the mud near the river's low-water mark, the sheds have frames of heavy timber and sheathing of galvanized iron."

The restoration has continued, adding another attraction to Steveston, the best historic destination in Metro Vancouver. Part of "Cannery Row" from the decades straddling the beginning of the 20th century, the shipyard sits between the Gulf of Georgia cannery to its west and the London heritage farm near No. 2 Road. The village of Steveston itself still reflects its colourful past, of Indigenous, Chinese and especially Japanese people who lived, fished and worked there, a history recorded at the Japanese-Canadian Cultural Centre and at the Steveston Museum and Post Office, which is a rare surviving example of a prefab by the BC Mills, Timber & Trading Company. An interurban tram that ran from 1905 until 1958 from Steveston to Marpole, connecting to downtown Vancouver along the Arbutus Corridor, is displayed nearby.

Steveston's economy was hit especially hard by World War II and the internment of many of its ethnic Japanese residents, three quarters of whom had been born in Canada. There are many sources of further information on those times, including the *Landscapes of Injustice* website and the Nikkei National Museum & Cultural Centre in Burnaby.

SURVIVING (AN ADJECTIVE)

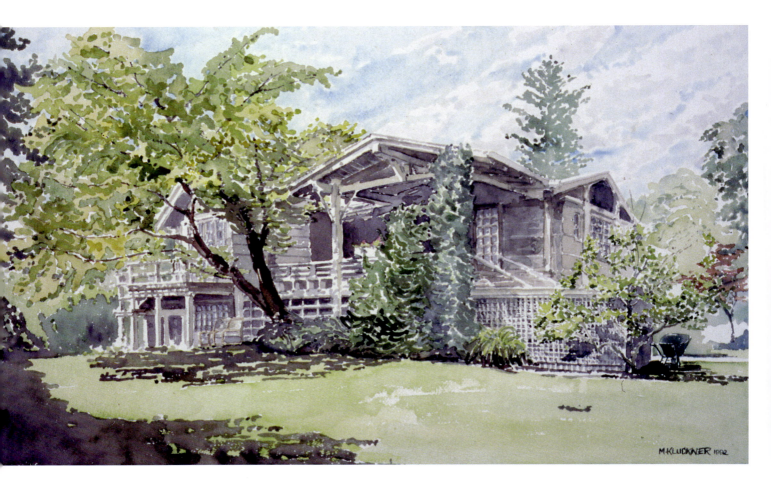

Kerrisdale heritage home to be shipped by barge to West Van; info meet next week

Built in 1912, the Doctor-Stewart heritage house will be removed from its original site at 5903 Larch St. in Kerrisdale.

GAGANDEEP GHUMAN
FEBRUARY 23, 2023 7:55AM

The Doctor-Stewart house, in its original location. See *North Shore Daily Post,* February 23, 2023.

56 See Kerry Gold, "Road blocks for house movers and heritage advocates," *Globe & Mail,* May 7, 2021.

A Mobile Home

Moving buildings was a common activity in the 19th and 20th century but has become rare this century in bureaucratized, permit-obsessed Vancouver. Conformity to rules, the need to upgrade a moved house to make it fit exactly with the building code, and the City's indifference to the embodied energy of an existing house (let alone "heritage"), has put costs through the proverbial roof.

Vancouver Island and the Gulf Islands were the main beneficiaries of the house diaspora, but that has been made more difficult because the Vancouver Park Board won't allow houses to reach the waterfront through parks, citing complexities including "cultural and archaeological issues."[56]

The fine Craftsman house at 43rd and Larch was owned by the Angus family when I painted it in 1992. (Architect W. A. Doctor built several low-pitched Craftsman bungalows, a few of which survive on Templeton Street in the blocks on either side of Hastings.) It was moved by Nickel Brothers in 2020 and sat in a storage lot until June 2023 when a news story announced it was to be moved to West Vancouver's historic Lower Caulfeild area onto 4777 Pilot House Road.

Nickel Bros. has been a leader in recycling for 40 years and has found a more sympathetic market in Washington State, including in Seattle with its difficult topography, and on the San Juan Islands.

West Vancouver might seem an unlikely destination for a historic house, after years of demolitions of its own West Coast Style homes from

84 SURVIVING (AN ADJECTIVE)

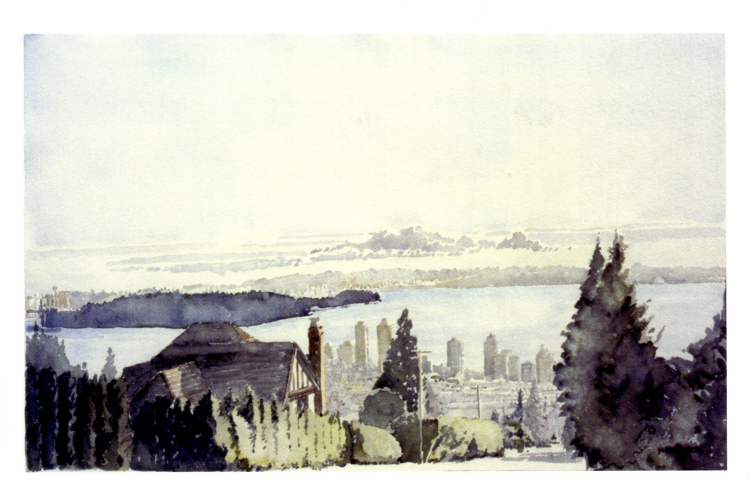

A West Vancouver view – a watercolour from 1996 at 22nd and Queens.

the mid-20th century. As architectural historian Robin Ward wrote, "Sadly, much of this heritage has already been lost, replaced by ostentatious mansions."[57]

However, West Van has made a turn in the direction of preservation recently with the restoration of the 1913 Ferry Building on Argyle Avenue in Ambleside, raised for protection from floods due to climate change and now used as a community art gallery. In April 2023, the District supported a plan to restore the Navvy Jack House, three blocks west of the Ferry Building and the oldest settler building on the North Shore, dating from 1873, for a new use as a coffee house. It too will need to be raised for flood protection.

[57] *Exploring Vancouver 5*, p. 173, a book containing the definitive list of surviving houses from that period.

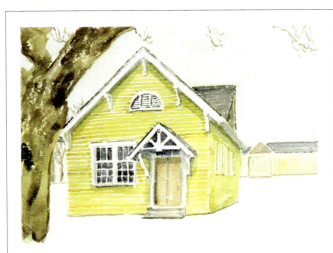

One might think that schools, while teaching about energy use and conservation, would want to live by example, but most attempts to save the small "portables" from a century ago have been ignored. Schools themselves have been demolished following lengthy evaluations of their ability to be seismically upgraded – less of an issue with a wooden building. In 2023, the "little yellow schoolhouse" at Henry Hudson School in Kitsilano engaged a Facebook group and the involvement of Glyn Lewis of Renewal Home Development. The Squamish Nation gave it a new home, and it left Kitsilano by barge for North Vancouver early that August, where it has been established as a language learning centre.

SURVIVING (AN ADJECTIVE) 85

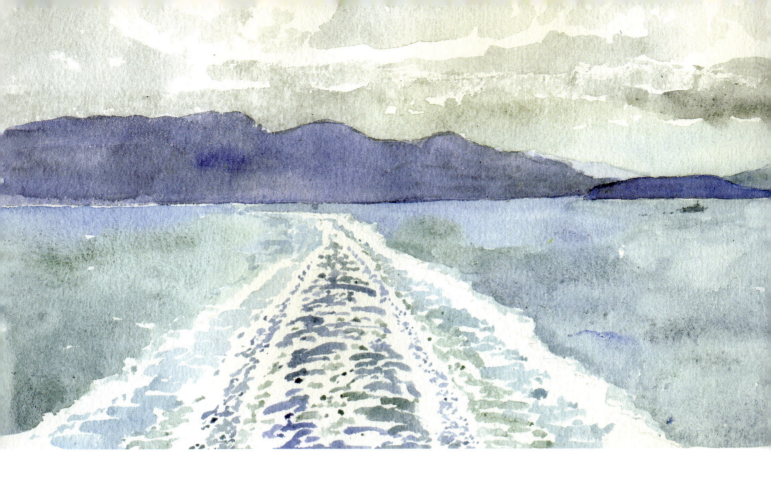

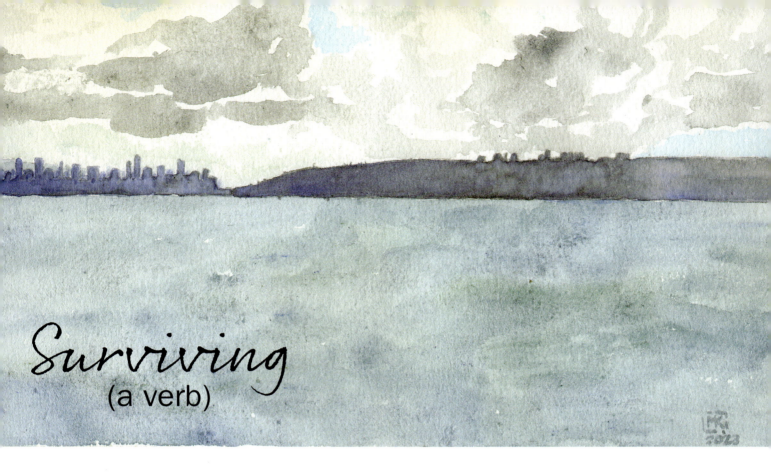

Surviving
(a verb)

This chapter is about surviving *within* Vancouver, or surviving without it. Various strategies, such as choosing one's parents carefully and being able to draw on the Bank of Mom and Dad, have already been explored in the introductory first chapter, along with an overview of the problems of affordability, both of renting and owning.

For some people, "surviving" means getting to Vancouver for social services or to join a community of fellows who are already homeless; for others, "surviving" means "driving till you can afford it," escaping the city into more distant suburbs where you can obtain enough space to raise your family as you wish to. If the suburb is connected to the rest of the region by the SkyTrain, that survival strategy might mean a condo or rental in one of the huge towers in a Metrotown, Brentwood or Lougheed Centre. Sadly, for an increasing number of people a van or motor home is the only shelter they can afford, a precarious existence just a step above the shopping cart and tent of Downtown Eastside Vancouver or its equivalent in most towns and cities in the province.

For others, Metro Vancouver has been the place to escape from, at least for part of the year. A few generations ago, a little shack on a lake was almost a birthright. Whether you were working- or middle-class, it was a getaway that stayed in some families for generations even as their urban, year-round homes were bought and sold. Changes in technology including broadband Internet in the countryside has made a rural home base possible for working-age people, and Covid removed any doubt as to whether it was feasible.

And it's the retirees – the grey river of Boomer seniors flowing to the east side of Vancouver Island, the Gulf Islands, and the Okanagan – seeking a community of similar people and avoiding the upheaval of the metropolis, who are turning the province's summer places into permanent homes.

SURVIVING (A VERB) 87

The Great Divide

A theme throughout Vancouver's history, in this book and many others, is the idea of "contested space," introduced on page 12. A related one, first entering the public consciousness more than 90 years ago at the onset of the Great Depression, is the deep divide between rich and poor. This isn't the "bohemian poor" of my hippie youth, but of true victims of the economy and social system.

The British Columbia economy only developed an agrarian "yeomanry" in a few areas including the Fraser Valley, the Okanagan and the Peace. Compared with the Prairies and the eastern half of Canada, BC was a "grab and go" place of resource extraction. There were capitalists and an industrial proletariat, just like Marxism 101 in school. A century and a half later the division relates mostly to a simple question: do you own property, and how long have you owned it?

Ninety years ago, Vancouver was riven between Conservative governments – the incompetent Tolmie administration provincially and the federal Tories under Prime Minister R.B. "Rotten Bastard" Bennett – and groups pushing toward socialism, if not outright communism. In the summer of 1931 a shacktown of about 200 "jungleers" established itself on the derelict Hastings Mill site at the foot of Dunlevy Street (the Hastings Mill Store made its escape by barge the previous year to the foot of Alma Street, where it became a museum still open today). Many were Great War veterans, a source of shame to some such as the Terminal City Club and Vancouver Club, which sent soup. About 400 drifters lived in cardboard and tin shacks on the old city dump site at Prior and Heatley, close to the First United Church at Hastings and Gore and its soup kitchen organized by the Rev. Andrew Roddan.

And there were squatters in shacks and houseboats along the shoreline, especially in Coal Harbour, on the Kitsilano Indian Reserve where Senákw village residents had been evicted by the provincial government in 1913, and on a spur of False Creek that extended northward under the Georgia Viaduct to the B.C. Electric Company's coal-gas works on the edge of Chinatown, these last dubbed "Canned Heaters" for their alleged addiction to the alcohol in "Canned Heat" or Sterno fuel.

"Direct relief" for the unemployed of 1931 meant a hunk of meat and a hundred-pound sack of potatoes, doled out to the line-up at the old City Hospital Nursery just south of Victory Square (now a parking garage). Vancouver relief recipients in 1931 totalled 6,958 single men, 7,136 married men and 601 women (in a city of 245,000 – the regional population was 308,000). As the Depression bit more deeply, almost everyone's wages were cut and workers let go.

City-sponsored work projects including the construction of Fraserview Golf Course allowed some owners to pay off their tax

A wartime eviction for shipyard construction near the foot of Clark Drive. Matthews collection, CVA.

SQUATTER LEAVES DOOMED HOME—With his violin tucked under his arm and an alarm clock clutched in one hand, Kastor Recmula, 67, is shown above leaving his home, condemned because of shipyard developments on the south side of Burrard Inlet. He is one of numerous squatters who were forced to vacate their shacks today when clearing operations began. — MAY - 7 1941

ALONG THE WATERFRONT
Burrard Inlet Shacks Fired To Clear Way for Shipyards

88 SURVIVING (A VERB)

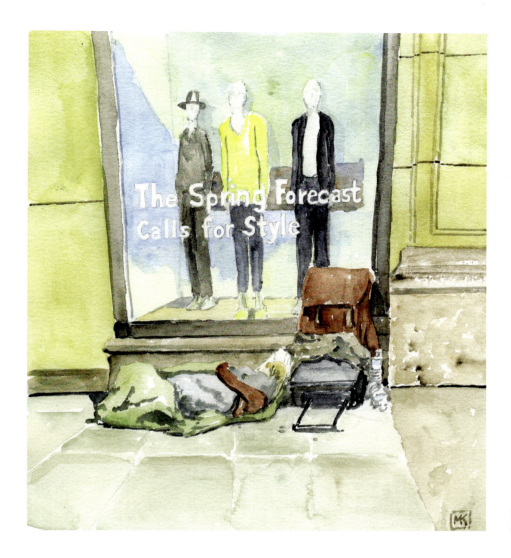

Hudson's Bay Company display window, Georgia Street, 11 am, April 13, 2022.

bills and avoid forfeiture of their homes to the City. Nevertheless, multi-page newspaper advertisements listed the properties that had been surrendered for tax sales, a further blow to property prices which had only partially recovered during the 1920s from the 1913 crash. Even some wealthy Shaughnessy residents, as described on pages 66–9, were stung.

One of the evocative stories from that era is the Mennonite Maids – young women sent to the city to find work by their refugee families who had escaped the oppression of Communist Russia in the 1920s and settled in agricultural areas like the Fraser Valley. Many families were in debt to the Canadian Pacific Railway for their passage and could earn little cash with the crops they were able to grow. A few city houses provided "rooms for boarding, help in matching girls to employers, and a place to commune on Thursdays when all the girls would meet up at the house, share lunches, socialize, play board games, and hear a devotional from a visiting minister." Responding to a book by Dr. Ruth Derksen Siemens and Sandra Borger, the Vancouver Heritage Foundation's Places That Matter program put plaques on the Bethel Home at 6363 Windsor Street (1931–43; it moved to 535 East 49th from 1943 to 1961), and the Mary Martha Home at 6460 St. George Street (from 1935 to 1956 and thence to 605 East 49th until 1960).[1]

The collapsing economy triggered a radical response. The first "red riot" on August 1, 1931 prompted increasingly heavy-handed retaliation. The following January, the City began refusing bed and meal tickets at the city

[1] *Daughters in the City: Mennonite Maids in Vancouver, 1931–1961*. For more information see the Vancouver Heritage Foundation's *Places That Matter* website.

SURVIVING (A VERB) 89

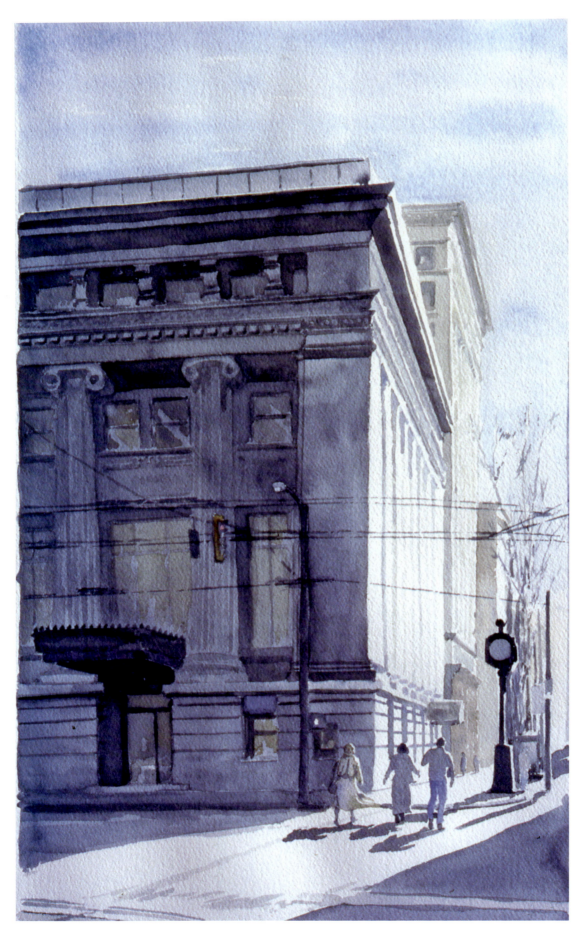

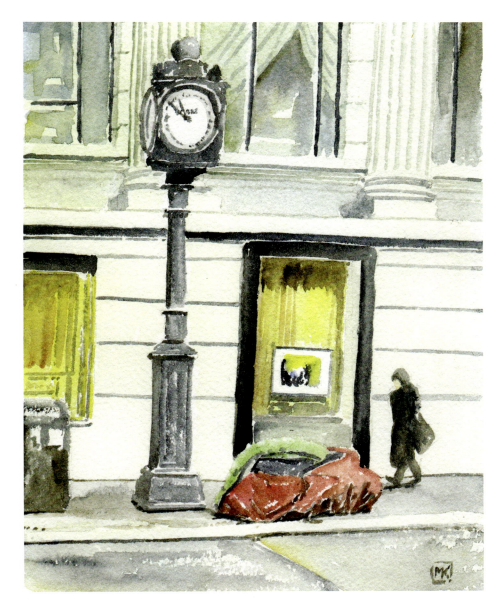

(Facing page) I wrote in my 1996 book: "At the corner of Granville and Hastings on a bright winter day, the Birks Clock heralds the return of shopping to the old downtown – Vancouver's commercial heart at the turn of the 20th century. The clock, which started life marking time for Trorey's Jewellers on the northeast corner of the intersection (the one in the foreground of the painting), went uptown to Georgia with Birks in 1913 and returned 80 years later when Birks decided to restore the old Bank of Commerce building rather than keep its oar in with the Vancouver Centre and Pacific Centre malls. [That Birks location at Granville and Georgia is now a London Drugs outlet.] With its Ionic columns, the bank building is, appropriately, a successor to the pagan temples of ancient civilizations."

(Left) Twenty-seven years later, a morning in April 2023: Birks and its clock are still there, elegant jewellery and art displayed in its window, but there is a tent pitched at the base of the clock. From the tent comes moaning and shouting – a man crying out in a mental-health crisis. He can be heard from a block away, but there is no one to help. People walk by. It's become normal, like the man in the sleeping bag at The Bay on p. 89, or the man sleeping in the Broadway doorway on p. 35.

hostel to single men who wouldn't go to federal government work camps. Demonstrations and riots were followed by brutal crackdowns, including Vancouver Mayor Gerry McGeer reading of the Riot Act at Victory Square on April 23, 1935, the "Battle of Ballantyne Pier" on June 18th, the trek to Ottawa that had a bloody ending in Regina on July 1st, and, finally, the occupation by about 1,600 men of the Post Office and Art Gallery that ended in evictions and injuries on "Bloody Sunday," June 19, 1938.[2]

In broad brushstrokes, the history passes through wartime (with acute housing shortages), then postwar prosperity – John Kenneth Galbraith's "affluent society" of the 1950s and '60s – and the dislocations and upheavals of the 1970s, including a rental housing crisis, the deindustrialization and reimagining of Vancouver's False Creek south shore, and the consolidation of the forest industry's mills onto a few large sites along the Fraser River. About 1970, the South Asian community moved from its neighbourhood in east Kitsilano-Fairview to the south slope and established what became known as the Punjabi Market on Main and Fraser streets around 49th. Its 1908 *gurdwara* at 2nd and Cypress was demolished and replaced by an apartment building[3]; the new Sikh Temple at Ross and South East Marine

2 Daniel Francis's recent *Becoming Vancouver* has an overview on pages 123–41.

3 There is a colour photograph of it on p. 27 of my *Vancouver Remembered*.

SURVIVING (A VERB) 91

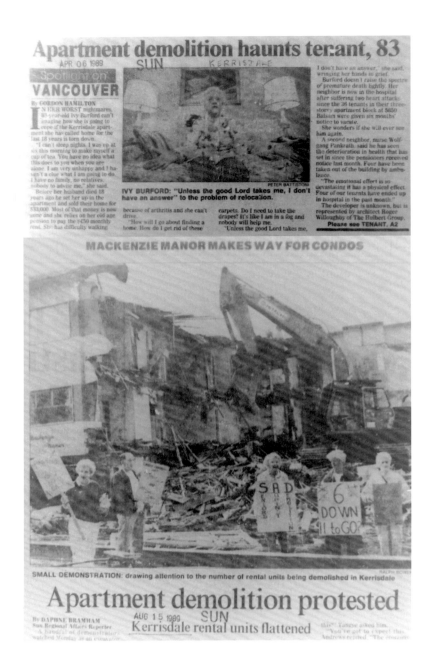

4 Bridgeview is compared with the Maplewood squat in Jean Walton's *Mudflats Dreaming* (Transmontanus, 2018). Jan Morris wrote the foreword to my book *Toronto The Way It Was* in 1988.

Drive is an architectural gem erected in 1969–70 by the premier firm of the day, Erickson-Massey.

Other neighbourhoods were changing, too. An unlikely one showed the deepening divide between haves and have-nots in a place most people identified with settled prosperity: Kerrisdale.

A story by Gordon Hamilton in the *Sun* on April 6, 1989, neatly summed up the evolution of that area, which had been a sort of cradle-to-grave home for generations of people: at a transit crossroads, with a community centre, doctors and dentists, and a good shopping street. Rental apartments built in the 1940s and 1950s had been a transition for many as they aged. The reporter described an 83-year-old tenant, Ivy Burford: "Before her husband died 18 years ago he set her up in the apartment and sold their home for $33,000. Most of that money is now gone and she relies on her old age pension to pay the $450 monthly rent. She has difficulty walking because of arthritis and she can't drive."

The culprit was the luxury condo. Protesters identified "overseas investors" for ruining the neighbourhood. It became a major issue in the 1990 civic election, where left-wing Committee of Progressive Electors (COPE) candidate Jim Green stood up for renters against the incumbent Non-Partisan Association Mayor Gordon Campbell. Green lost, but five of his running mates, exactly half of City Council – Bruce Eriksen, Libby Davies, Harry Rankin, Patricia Wilson and Bruce Yorke – were elected.

However, Kerrisdale was a sideshow compared with the long-simmering problems of the old downtown around Hastings and Main which cooled the city's Expo optimism, including the suicides of several long-term Single-Room Occupancy (SRO) hotel residents who had been evicted for hotel renos for Expo tourists.

In 1987, I met the British travel writer Jan Morris, who was in Vancouver researching an article on the city for an international magazine. "Where are the slums?" she asked me in her Oxbridge accent. I suggested the Hastings and Main area, but she'd already seen it and it didn't make the grade. I gamely suggested the Bridgeview neighbourhood in Surrey near the Pattullo Bridge, but had no other candidates.[4]

By the 1970s, the old "Skid Row" or "Skid Road" name – a play on the skid roads made of logs over which cut trees were dragged to sawmills – used for a generation for the blocks of Hastings Street between Abbott (where the Woodward's Department Store stood like a bastion) and Gore (the Salvation Army Temple and First United Church), faded away and was replaced by "Downtown Eastside," quickly shortened to DTES.

The "industrial proletariat" mentioned at the beginning of this section was largely employed in forestry, the province's biggest industry for most of the 20th century. Loggers were men who worked, for the most part, in remote "homosocial" camps upcoast or in the Interior. There were a few long-established forestry centres such as Comox on Vancouver Island,[5] and pulp mill towns like Port Alberni, where loggers settled, married and raised families, but the majority were itinerant, like the "lonely prospectors" (as they're described in academic articles) who explored British Columbia in colonial days.

[BC's demographics were profoundly skewed – the male-female gender balance didn't equalize until 1961. The loggers tended to be White, except in a few camps such as the Sikh-Japanese-Chinese Paldi on Vancouver Island. Because of the head tax and the search by Chinese men for "Gold Mountain," the ratio of Chinese men to women was 28 to 1 in a population of 21,000 in 1921. For similar reasons, of making money to support families in their home country, the Sikh community was overwhelmingly male – of the 5,000 who had immigrated by 1920, only 9 were women. The Japanese, however, came as settlers – the 1908 "Gentlemen's Agreement" between Canada and Japan, a British ally, stipulated an immigration limit only on male labourers but said nothing about women, with the result that of the 15,000 Japanese in British Columbia in 1921, 6,000 were women; thus, their population increased rapidly during the '20s and '30s.]

5 See Richard Somerset Mackie, *Island Timber: A Social History of the Comox Logging Company,* Sono Nis Press, 2000.

Below: Bruce Eriksen, co-founder of the Downtown Eastside Residents Association which set out to clean up Skid Road. *Vancouver Sun*, December 4, 1973, p. 41.

SURVIVING (A VERB) 93

6 My *Vancouver Remembered,* pp. 45–54, describes that period in detail.

7 Irene Toy, "SRO Hotels, for better or worse," DERA, 2008.

8 "Vacancy rate 'high,'" *Vancouver Sun,* June 25, 1974.

9 My conversation with a retired accountant who wished to remain anonymous, whose firm included clients who owned SROs. Maintenance of a beer parlour and its building was no longer a condition of obtaining a liquor licence as of 2004.

The expression "Wine and Dine, It's Smilin' Buddha Time" described the logger cashing out and heading to Vancouver on a chartered float plane for some extravagant good times, including the Smilin' Buddha Cabaret at 109 East Hastings. Then would come a visit to a Loggers' Hiring Agency on Hastings and a return to the woods to replenish the cash, a yo-yo life that lasted as long as the man's health held up. Aged-out loggers, disparaged as "rubbies" and "derelicts" in the newspapers, hung out in the beer parlours and lived in the SROs. As that population disappeared around 1970, Gastown "boutiqued" itself. Adventurous young people moved in, followed by mental patients released into the community from Riverview Hospital.[6]

The first figures to emerge into the public eye in the 1970s and organize the DTES were Bruce Eriksen (1928–1997); Libby Davies, his partner (who became a City Councillor, as mentioned above, and an NDP MP); and Jean Swanson (a Vancouver councillor from 2018–2022). They organized the Downtown Eastside Residents Association (DERA), which pushed back against the rising tide of drug abuse, crime, displacement and gentrification. Organizer and advocate Jim Green (1943–2012), an American import in the Vietnam era, became a consultant for developers (the Woodward's project) and non-profits as the need for new housing in the area intensified. After campaigns including opposition to the 2010 Olympics, DERA disbanded in 2010 following allegations it had mishandled public money.

During DERA's years, the city lost more than half its stock of SRO rooms – that is, typically, small rooms of about nine square metres (about 100 square feet), possibly with a sink and, usually, sharing a bathroom-shower at the end of the corridor. Occasionally there was some kind of shared kitchen and a usable lobby. This was, of course, the familiar type of "one star" hotel in Europe and North America for much of the 20th century; shared bathrooms and kitchens were also facts of life in most rooming houses.

In 1970, there were 13,412 SRO units in the downtown, the great majority in the DTES as well as in a dozen hotels in Downtown South on or near Granville Street. By 2007, there were 5,985 rooms left.[7]

For a time the balance seemed to be working. Mayor Art Phillips announced in 1974 that there was a 15% vacancy rate in "Skid Road housing" despite the City having closed 1,100 units. In a statement eerily anticipating the mistruths of the 2020s, he said: "We'll be completing a lot more units than we'll be losing," and suggested that the City would take over older hotels on Granville Street and turn them into senior citizens homes.[8]

Anecdotally,[9] the economics of the SROs and their beer parlours began to fall apart at the end of the era of hard-drinking big-spending loggers. The demands of these patrons for a version of the high life kept maintenance standards at a reasonable level. Their replacement by people on meagre pensions and those released from the Riverview mental hospital put a kink in the SRO money hose.

In 2017, BC Housing, the provincial agency, completed an admirable process begun a decade earlier of purchasing and restoring 13 aging SROs, all on Vancouver's heritage register, in a "P3" public-private partnership with non-profits, notably the Portland Hotel Society. PHS was formed in the fight for drug users' rights that culminated in 2003 when Vancouver Coastal Health opened Insite, the first supervised injection site in North America. Its history is detailed in *Fighting For Space*, a book by activist Travis Lupick (Arsenal Pulp, 2018). PHS's internal problems, including a damning audit in 2014 that highlighted extravagant travel spending, clipped its wings for a time. In the spring of 2023, BC Housing became embroiled in an extraordinary controversy involving the conflict of interest between its former CEO, Shane

94 SURVIVING (A VERB)

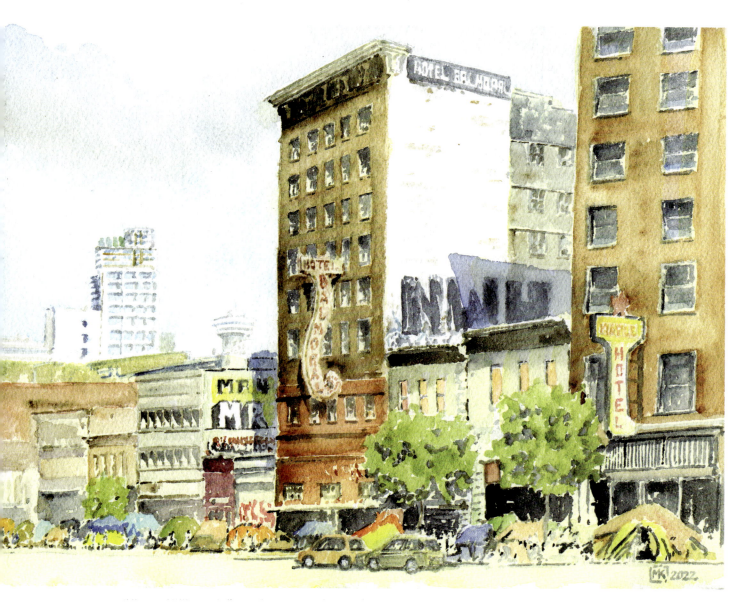

Ramsay, and his wife Janice Abbott, then CEO of Atira Women's Resource Society, the largest provider of housing for women and children in the DTES.

A decade ago, as with today, for every step forward there was one back. "Housing prospects plunge with frozen welfare rates," said a *Sun* headline in 2013. "As decaying SROs are fixed up, rents rise to cover costs." At that time, welfare's monthly shelter allowance was $375, and rents were $500 and up, with only one quarter of the SROs renting at the shelter rate. Gentrification was the culprit; two restaurants, the Pidgin and Cuchillo, appealing to the hip crowd moving into developments such as the Woodward's condos, were singled out.[10]

If you've only ever heard of one SRO, it would likely be the Balmoral, built in the boom years of 1911–12 and in its day the most luxurious of the hotels in the old downtown. After years of problems, the City "issued an evacuation notice after expropriating the hotel from the Sahota family, a family of landlords in Vancouver known for mismanaging a number of SRO buildings," in the careful words of a CBC story.[11] Its familiar sign, designed by Neon Products in the 1940s, may be saved. The City ordered the building's demolition in 2022.

The notorious Balmoral Hotel at 159 East Hastings just west of Main Street in September 2022 when the Hastings Street sidewalks were crowded and almost impassable with the tents of the homeless. It has since been demolished. The Maple Hotel to its right was built in 1912 by architects Parr & Fee and restored, together with the recreation of its historic neon sign, as part of BC Housing's SRO Renewal initiative. It has been managed by Portland Housing Society since 1998.

10 Denise Ryan, *Vancouver Sun,* August 29, 2013.

11 Michelle Meiklejohn, *CBC News,* November 5, 2022.

SURVIVING (A VERB) 95

Trying to make the rent: binners in the city. Although a deposit-return system to recycle beer and soft-drink bottles has been in place in BC since 1970, few people scavenged for them along back lanes until the late '90s. Today, there are 600 to 700 customers who take bottles and cans to the United We Can recycling depot on Industrial Avenue, not far from the poverty of Chinatown and the DTES. Stories of the discrimination faced by Asian binners, many of whom are aged women, and the stigma they face even from their own families, is the subject of a Christopher Cheung article in *The Tyee*, "On bottle binning in Chinatown," published on May 18, 2023.

The BC Housing SRO Renewal program suggested that the neighbourhood would be proud of the restoration of old hotels, neon signs and neighbourhood landmarks, as did the City's own DTES planning process, completed in 2014 and identifying the heritage character of the area as a priority.

However, one modest building from 1911–12 that reflected a century of the area's history but got caught up in the train wreck of recent events was the "Don't Argue" building at 26 East Hastings and its long-time tenant, "The Only" seafood café at 20 East Hastings (visible beneath "Argue" in this detail of a 1936 Leonard Frank photograph[12]). The Holden Building next door with the bunting served as Vancouver's City Hall for a time until the current one opened on 12th Avenue in 1936.

The slogan "Don't Argue" was followed by "Con Jones Makes The Best Tobacco." Jones (1869–1929) was an Australian immigrant with all of the "larrikin" qualities you might expect from his nationality. Besides this café/poolhall and one at 612 West Hastings, his tobacco business, and a bowling alley at 330 West Cordova, he was a well-known sports promoter. Callister Park near the PNE was known as Con Jones Park until 1942. He lived in a house at 1216 Robson, known after his time as the studio of photographer John Vanderpant, and in the '60s and '70s as La Côte d'Azur, the first great French restaurant in Vancouver.

The upstairs of 26 East Hastings evolved from a poolhall into the Loggers Social Club. As for The Only, it was opened in 1919 by Nick Thodos, one of the early generation of Greek immigrants who stirred Greek food and culture into the city's bland British porridge. When Thodos died in 1935, his sons took over the business, and son Tyke commissioned the iconic neon

12 City of Vancouver Archives AM54-S4-: Bu P56.

[13] John Mackie, "RIP The Only, Hastings Street's landmark cafe," *Vancouver Sun,* June 25, 2021.

[14] *Changing Vancouver* blog, June 5, 2013.

Little wooden "McDonough Hall" at Hastings and Columbia, with the riotous colours of tents and graffiti in 2022.

sign, known to generations, from Neon Products in 1950. Subsequently, the restaurant went through decades of Chinese-Canadian ownership, another aspect of its heritage, before closing in 2009.

The Portland Hotel Society bought the building in 2011 and had the sign restored when it announced a plan to reopen the restaurant and refashion the building as a social centre, but the plans foundered when PHS stumbled in 2014. The provincial government bought the building and then let it sit, deteriorating, until 2021 when the city building inspector declared it a hazard.[13]

City heritage staff declined to attempt an intervention that could have saved the façade – façadism is never the best solution, but it would have indicated some pride in the area's past. So desperate had the situation become that even the City's own DTES planning process, dating back to 2014 and identifying the heritage character of the area as a priority, was ignored.

The cultural history of the area is remarkable. An old wooden building containing a grocery store serving the neighbourhood is improbably hanging on a block away at the southeast corner of Hastings and Columbia. Long believed to have been built in 1888 and known as "McDonough Hall," it has an unusual corner bay window on the second floor; W. F. Findlay told City Archivist J. S. Matthews that its second floor hosted the St. Andrews Caledonian Society's first grand ball. Later research suggests that Findlay's memory was cloudy and that it was actually built in 1893.[14] Regardless, it is an "A" on the city's heritage register – the highest possible classification.

Next door at 108 East Hastings was a cycle and carriage repair shop, the Vancouver Auto and Cycle Company, which opened in 1904 and became the

98 SURVIVING (A VERB)

city's first auto garage. According to J.S. Matthews, an Imperial Oil Company employee at the time, it bought its gasoline in cases consisting of two four-gallon cans.

At 112 East Hastings, in 1940, Estonian immigrant Walter Paakspuu, who had made a living distributing newspapers on a bicycle after arriving in the City in 1929, opened the Universal News Stand in the front half of a pool hall. In the '70s, that pre-Internet era, it carried an extraordinary range of publications, including six Ukrainian newspapers, five from New Zealand and Australia, and 20 from Yugoslavia.

"The Universal News is nobody's censor," said a *Sun* article from 1976 when the Paakspuus announced their retirement and the closing of the store and reflected on the number of times it had been raided by the vice squad. "We went to court several times," [his wife] Helga recalled, "but it wasn't for the girly magazines – it was for the books. The police would come in and read the titles and the titles were always telling a little more than the rest of the book." Ultimately there were no convictions, "just fuss."[15]

15 Gary Marcuse, "Here was the news," *Vancouver Sun,* April 9, 1976.

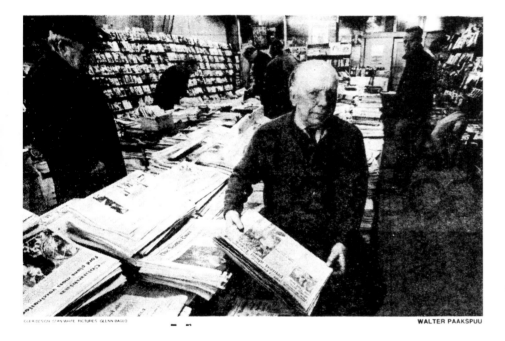

The Glenn Baglo photograph of Walter Paakspuu in Universal News at 112 East Hastings.

Paakspuu's son Eric recalled that "Dad was first to be prosecuted for magazines in plastic. One of his other favourite stories was going swimming in English Bay in the '30s and being told to 'cover it up' because he was just wearing a bathing suit, not the chest-covering swim gear of men back then."[16]

Another landmark was the Pantages Theatre at 152 East Hastings, later known as the Royal, State, Avon, City Nights, and finally the Sun Sing before it closed in 1994. An ornate vaudeville palace erected in 1907–8 by the Spences Bridge hotelier Arthur Clemes and designed by E.E. Blackmore, it had a long-term arrangement with Alexander Pantages's entertainment circuit. Clemes also commissioned the Regent Hotel on the east side of the theatre for $150,000; 75 of its 160 rooms had private baths and could be rented for $1.50 to $2 a day; the shared-bath ones went for a dollar.[17]

In another example of the disarray of the area, the Pantages was torn down in 2011 after years-long attempts to refurbish and reopen it by Worthington Properties, which sought a density bonus and transfer to help

16 Interview, 2023. I went to school with Eric in Kerrisdale in the '60s.

17 Glen Mofford, *Room at the Inn*, Heritage House, 2023, p. 39.

SURVIVING (A VERB) 99

recover its costs while offering to build 136 units of social housing in a new adjacent building. It looked like a perfect solution – a new "draw" for an area in need of revitalization.

However, the City "blew the bank" by accepting too many Heritage Density Transfers. Too much density, more than could be absorbed in other projects, went into the density bank, most from three big projects: Woodward's (where only the original 1906 building was kept), the Wing Sang Building (see page 74), and Arthur Erickson's Evergreen Building on West Pender. They added over 500,000 square feet to the bank, deflating its value. When Council suspended any new transfers into the bank in 2007, Gastown developer Robert Fung was one who was left in the lurch; the Pantages project was another. Council rejected the renewal proposal in 2008 and in 2009 Worthington decided to cut its losses, put the project up for sale, and apply for a demolition permit.

The building remained intact until a fire extinguisher that was dropped from the Regent Hotel next door punctured the roof's membrane, and with the ingress of rain the interior quickly began to deteriorate. As was the case a decade later with the "Don't Argue" building, city building inspectors decided it had become potentially dangerous. Historians and collectors including John Atkin and Tom Carter tried to save what they could of the theatre's extraordinary interior.

The theatre's colourful history lives on in Tom Carter's chapter of the book *Vancouver Confidential* (Anvil, 2018) entitled "Nightclub Czars of Vancouver and the Death of Vaudeville."

Salvaged plasterwork from the first Pantages Theatre at 152 East Hastings, probably the oldest vaudeville theatre surviving in Canada at the time of its demolition in 2011. Collection of Tom Carter.

There are a few bright new buildings replacing the lost ones. Across Columbia Street from the "McDonough Hall" corner store is a new social housing building and health centre for Indigenous people, replacing the Pigeon Park Savings building of VanCity – the vacant lot in the drawing on page 98. It will be run by Raincity Housing and the Lu'ma Native Housing Society; its exterior will be wrapped with a Coast Salish "blanket" motif of coloured tile. The place is especially significant as the low land at Columbia Street was a canoe route called Lek'Leki used to traverse from Burrard Inlet to False Creek. New housing and community support facilities at the First United Church site at Hastings and Gore and a health centre across the street at the Salvation Army site will help.

Almost 30 years after Woodward's closed, the Cohen family's Army & Navy Department Store chain, founded in 1919, shut down in 2020. The original location at 44 West Hastings had expanded across the lane into the historic Dunn-Miller block on Cordova in 1948, and then into the former Rex Theatre at 25 West Hastings in 1959. Jacqui Cohen, the owner, announced in 2023 a plan to rebuild on the site with a mix of housing and retail.

The flood of people into the DTES echoes the move west during the Great Depression – the "Dust Bowl Okies" of John Steinbeck and Sanora Babb novels and the drifters to the Prior Street dump site. Longtime DTES resident Karen Ward said that it "has become the last place where everybody runs to from across Canada. It's the last best place for the people who are the most marginalized people in the country."[18] Paul Mochrie, Vancouver's City Manager, noted that Vancouver has 25 percent of the regional population but 75 percent of the shelter spaces.

In 2022, following the uprooting of the Strathcona Park encampment, which itself followed the multi-year Oppenheimer Park camp, Hastings Street's sidewalks filled with tents. A number of fires, some caused by propane cylinders, threatened to spread to the buildings and threaten *their* occupants. A fire earlier in the year at Atira's Winters Hotel at Abbott and Water in Gastown claimed two lives and displaced 70 residents. The fire chief ordered the tents to be cleared.

The City had reached "a turning point" in dealing with the Hastings Street encampment, said Mayor Ken Sim at a press conference held on April 5, 2023, as the city moved forcefully to remove the tents from Hastings Street. The encampment at CRAB Park at the foot of Main Street is still tolerated at this writing in 2023.

Overwhelming every effort is the mental health and drug crisis – the thousands dying each year of opioids and fentanyl, and the lack of hope for so many. Vancouver's former advocate for the homeless, Judy Graves, remarked that "many men become disposable at certain times in their lives" – the 68 percent of the homeless population who are male. Many are injured construction workers addicted to the pain killers they needed to keep working; there are ex-soldiers with PTSD, and Indigenous migrants who were unable to make meaningful lives in their own homes far from the city.

Many women escape violent relationships and try to find sheltered housing. One in seven BC homeless men became so, they say, because of incompatibility with a partner. The ratio of Black homeless to their population proportion is triple: that is, three percent of the homeless population are Black but they are one percent of the population. The staggering proportion is that of Indigenous people: five percent of the population but 40% of the homeless.[19]

How will this end? The *Sun*'s veteran journalist Ian Mulgrew reflected on governments' efforts since the 1990s: "It's a Band-Aid."[20]

[18] Travis Lupick, "Downtown Eastside residents face dispersal," *Georgia Straight,* April 10, 2014.

[19] Douglas Todd, "Many men become disposable: the painful demographics of homelessness." *Vancouver Sun,* April 4, 2022.

[20] "Decades of politicians ignoring the evidence led to today's opioid crisis," *Vancouver Sun,* November 22, 2021.

Making Room for the Rich

A twenty-minute walk west of the DTES, the urban *flâneur* enters a completely different world. Vancouver is a small town, geographically at least. Alberni Street commences at Burrard and runs west past a string of shops selling international luxury brands, then hosts a set of towers catering to a new Vancouver – not the settled rich of Shaughnessy or British Properties mansions and gardens, but an urban elite in vertical gated communities enjoying views over the masts of yachts to verdant Stanley Park and the mountains. Yachty False Creek also has its share of bold new buildings. "Vancouver architecture is soooo boring," a refrain one used to hear from fans of, say, Dubai or Shanghai, prompted a reaching out to the "starchitects" of the world to dress up the ho-hum skyline.

First on the ground was the Bjarke Ingels design of 52-storey Vancouver House, leaning from its narrow base over the Howe Street on-ramp to the Granville Bridge on the edge of False Creek. But it wasn't just a tower, it was a lifestyle – *Gesamtkunstwerk*, "a total work of art," according to curator-critic Trevor Boddy – defining a new neighbourhood with some chain stores and adding a huge spinning chandelier by artist Rodney Graham under the bleak bridge nearby. It is now the "Beach District," presumably referring to the avenue rather than any stretch of sand. It is "a special moment," according to developer Ian Gillespie of Westbank. In April 2021, soon after the building's completion, there *was* a special moment when a flood from a failed gasket on the 29th floor damaged elevators and 20 floors of condos, allowing many Vancouverites to savour some *schadenfreude*, to use another German expression.[21]

But it is Alberni Street that is "emerging as the continent's leading zoological park for creative luxury highrises," according to Boddy, referring to the idea of "architectural zoos" where different buildings by leading designers can roost. It has become a competition between developers on Alberni and Georgia Street, one block north, continuing a process begun in the 1950s of converting that industrial area into an enclave for the wealthy.

"The Alberni" by Kengo Kuma (with Merrick Architecture as the local firm), illustrated on the next page while it was still under construction, is the most flamboyant so far. At this writing in 2023, it is the only one actually built. Others by international stars Buro Ole Sheeren of Berlin and Thomas Heatherwick of London, partnering with local firms, and Canadian Venelin Kokalov of the late Bing Thom's Revery Architecture, will add eye-popping luxury towers to that quiet street. Not surprisingly, none of them are neighbourly or contribute to the kind of streetscape typical of the West End.

The design that has attracted the most criticism is Scheeren's Jenga-block building at 1515 Alberni with its protruding glass three-level "observatories," setting a new standard for conspicuous consumption. Commentator Trevor Boddy described them as "clear profit centres for Bosa," the developer.[22]

These towers are transforming that corner of the West End. The Coal Harbour shoreline right to the Stanley Park entrance was once as heavily industrial as any land in Vancouver. Businesses like boat-building and factories that served the forestry and tugboat industries needed water access. A hockey arena and an auditorium stood on the northwest corner of Denman and Georgia. Houseboats crowded next to every available piece of shoreline, providing housing for people working nearby. The side streets were lined with cottages and small apartment buildings, despite

Unmistakeable Vancouver House, curving above the north end of the Granville Bridge, and looking surprisingly like an upside-down version of "The Alberni" on the next page.

[21] *City Hall Watch* blog, May 3, 2021, has some background and opinion on the event, the building and its developer.

[22] "Alberni at the Vanguard," *Canadian Architect,* April 1, 2022.

"The Alberni" at 1550 Alberni Street, near the Cardero corner, pierces the sky like an axe handle. It is the first of an "architectural zoo" of luxury condos slated for that modest street. The red house in the foreground – the last wooden gable in the area – is currently a restaurant called The Red Accordion, but had a 35-year life as Le Gavroche, one of the notable French brasseries in the city until it closed in 2014. The house was built in 1910 by A. M. Sharpe for Griffith O. Griffiths, a bookkeeper.

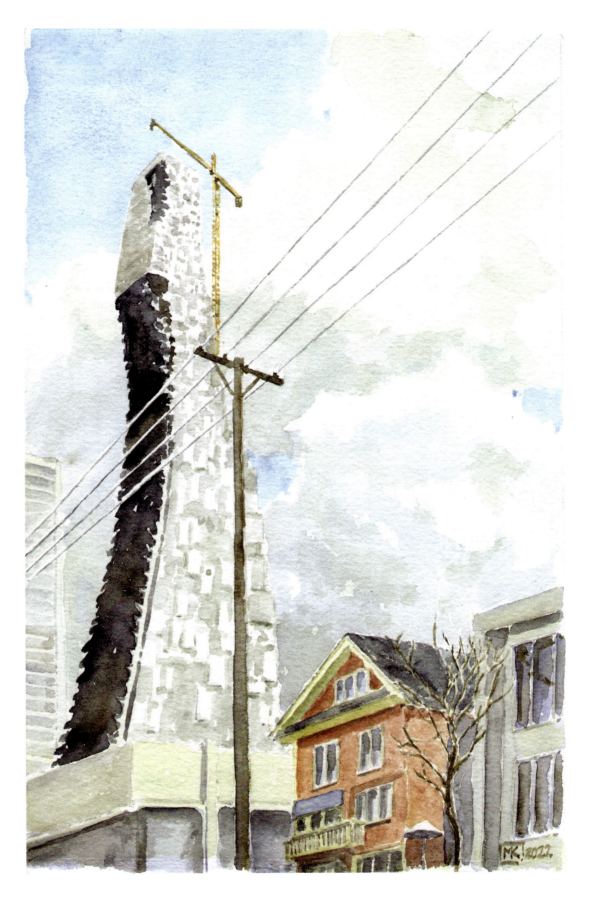

SURVIVING (A VERB) 103

NO PLACE YET FOUND FOR HOUSEBOAT FLEET

HOUSEBOAT TENANTS FIGHT EVICTION

23 For an overview, see my *Vancouver Remembered*, pp. 134–38. *Lions Gate*, by Lilia D'Acres and Donald Luxton (Talon, 1999), is the best history of the entire bridge saga.

24 *Vancouver News-Herald*, June 23, 1944. The desirability of a houseboat lifestyle was explored by Kerry Gold in "Hidden alternatives to get Into the housing market," in the *Globe & Mail*, June 9, 2023, describing the charming "Lilypad" moored at the Richmond Marina. In theory (but imagine the pushback), the yachts moored in Coal Harbour could be evicted and replaced by float houses – a major improvement in housing diversity for that area!

the fact that Vancouver's premier attraction for tourists and residents alike, Stanley Park, was only a few blocks away.

In the early years of the 20th century the Park Board and Town Planning Commission sought to create a Champs Elysées style of grand boulevard for Georgia Street and frame Lost Lagoon with formal pavilion-style buildings. Until the mid-1930s and the successful pitch to create the Lions Gate Bridge across First Narrows, there was no conception of Georgia Street and Stanley Park as a commuter route to the North Shore.[23]

In a situation reminiscent of today's shortages, the wartime shipyard workers of Coal Harbour fought for their housing. A newspaper editorial in 1944 made a plea for affordable houseboat colonies:

"It is unfortunate that the end of the houseboat colony in Coal Harbour should be decreed at a time of acute housing shortage. Perhaps some means can yet be found to postpone the evictions, but the end of houseboat colonies in Vancouver is inevitable. Their extinction has been in progress for many years.

"Our houseboat colonies have been unsupervised improvisations in the low-cost housing class, and though the residents of the colonies have for the most part been neat, clean and respectable, the colonies themselves have been located in dismal and depressing backwaters of the harbour's commercial areas and have been without proper sanitary facilities or decent surroundings.

"But is this a necessary attribute of all houseboat colonies?

"Houseboats can be – and a good many of the present ones are – neat, clean, comfortable, sanitary attractive residences. They are cheap to build and to maintain. They have the additional virtue, shared by no other type of substantial housing, of being mobile. The houseboat owner, bored with residence in one spot, can simply cast off his lines and tow his home away to pastures new.

"Up to the present time, Vancouver's houseboat colonies have been waterborne slums. This has been no fault of the residents – houseboat dwellers do not live in slums from choice. But if we ordered our measures wisely, we could make real civic assets out of the city's houseboat colonies and at the same time increase available low-cost housing, a very pressing need."[24]

The Coal Harbour colony grew to about 700 people in the 1940s. Other squatters, such as the man on page 86 with his violin and alarm clock, didn't fare as well.

The tipping point came in May 1956, when a group of investors bought the block of waterfront west of Cardero, slated for development as a manufacturing plant for bags, bread wrapping and paper towels, and proposed

instead a $25 million development that became the Bayshore Inn – the first major hotel completed since the Hotel Vancouver in 1939 and the war. With its huge parking lot, the Bayshore was the first hotel appealing directly to people arriving by car, rather like the myriad motels along Kingsway and Marine Drive.

An earlier building, now demolished, finished in 1955 as an apartment tower but converted into a hotel in 1958, was the Georgian Towers at 1450 West Georgia, a block to the east. The oldest of the high-rise buildings in the West End, it anticipated the boom in tall apartments that began when the city changed the zoning and development bylaw in 1956. Its "Top of the Towers" nightspot was a magnet for many years. The demolition of such a substantial concrete building (replaced by a 49-storey mixed rental-condominium tower approved by city council in 2021) can only be described as a climate crime, like the removal of the Sheraton Landmark hotel on Robson (in the background of this book's cover image).

The next tipping point was the waterfront entrance to Stanley Park. A 1962 high-rise proposal evolved through the '60s into a 15-tower mini-city, including a Four Seasons Hotel, that would look out onto the moorage of the Royal Vancouver Yacht Club. However, the "Northern Lunatic Fringe" of the Youth International Party (the Yippies) had a different idea, and occupied the site in June 1971. The squat continued peacefully through the summer, surprising in retrospect given the support for the development by confrontation-seeking Mayor Tom Campbell and the police riot that ended the Gastown Smoke-In that August. Ultimately it was the federal cabinet that killed the project by denying the developers a lease on a critical piece of waterfront. The land became an entrance parkway to Stanley Park itself. When the seawall path was completed, it tied the area to downtown.

The last of the old boat sheds and factories were cleared out early in the 1970s by which time many had become craft outlets and artists' studios.

My re-creation of the "All Seasons Park" squat in the summer of 1971 that protested a multi-tower luxury development and saved the Stanley Park entrance as open space. From *The Rooming House*, 2022.

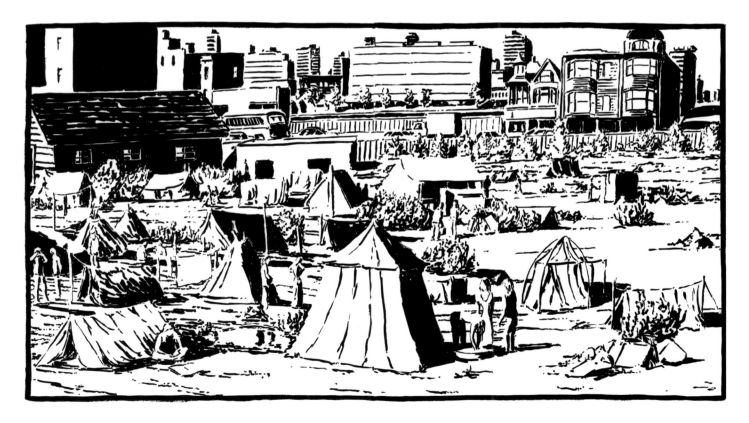

SURVIVING (A VERB) 105

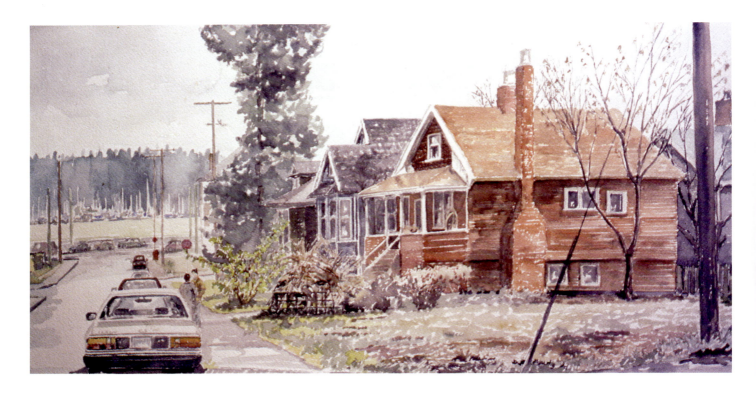

Gilford Street, a block from Lost Lagoon, awaits the arrival of the big new condos.

I painted the watercolour above in 1988 and wrote in *Vanishing Vancouver* that "the blocks of Georgia Street and Alberni near Stanley Park have deteriorated sadly over the past thirty years, leaving garbage-strewn vacant lots at the point where the Stanley Park causeway emerges into Vancouver." The row of bungalows was built in 1904 (a fourth one stood on the vacant lot in the foreground); the near two were first occupied by a widow named Annie Chace and a teacher named "Buck, M. Madame."

"Following years of little maintenance on the houses," I wrote, "and skyrocketing land values in the area, the tenants were evicted and the houses boarded up, but the plywood over doors and windows did little to deter transients, and a neighbourhood rumour alleged that they had become 'crack houses' [a new thing in Vancouver]. They were razed in April 1989, but redevelopment did not commence until a year later."

The image on the next page from 2022 shows in the background the brown mid-rise building that replaced the bungalows. The wooden building is Lagoon Lodge at 778 Gilford, the last of the old house conversions in the area. W. F. Gardiner was the architect and it cost $2,800 to build in 1909. It remained a private home with some rental rooms until 1936 when it became Lagoon Lodge Apartments, containing seven suites. The little informal park in the foreground had a similar large rooming house on it until the 1990s.[25]

[25] Historical information from the *WestEndVancouver* blog. There is a photo of the long-gone rooming house in my *Vanishing Vancouver: The Last 25 Years*, p. 137.

106 SURVIVING (A VERB)

26 Charlie Smith, "Owner of $24.3 million property obtains court order forcing review of City of Vancouver-imposed empty-home tax," *Georgia Straight,* December 23, 2021.

27 David Carrigg, "Squatter on multi-million dollar Vancouver lot arrested and campsite taken down," *Vancouver Sun,* April 11, 2023.

The mansions on the blocks northwest of the corner of 4th and Blanca, bordering on Pacific Spirit Park and overlooking Spanish Banks, are a traditional expression of wealth and prestige. International money is parked there, negotiating at glacial speed with the City to build even bigger homes. As an example, He Yiju, the wife of Chinese billionaire Zheng Jianjiang, fought the City beginning in 2019 over a $344,000 empty-home tax slapped on the property at 4769 Belmont Avenue after she applied for a development permit in 2018. The house on the $24.3 million property was assessed at only $10,000.[26]

The empty 7,000 square foot house at 1611 Drummond Drive, illustrated above in 2022, was built in 1926 for K. G. Nairn, the manager of a real estate and investment company. It has been for sale for years for about $21 million; restrictions on foreign buyers enacted on January 1, 2023, ban non-Canadians from buying properties such as this for two years.

The area is so devoid of people and activity that squatters took notice. A group who had erected shelters at 4883 Belmont Avenue in April 2023, was evicted following complaints they had cut down a 100-year-old tree and were firing pellet guns. They had occupied three vacant lots owned by the company of investor Edison Washington, a.k.a. Qiang Wang, and valued at $60 million.[27]

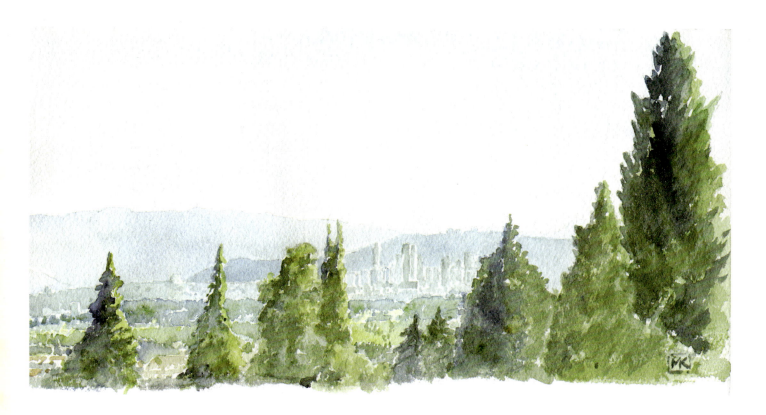

"Amazing Brentwood" and the Flight to the Suburbs

Metro Vancouver's SkyTrain system, now approaching its 40th birthday, has had a profound impact on the skyline of the suburbs. The towers of Joyce-Collingwood, Metrotown, New Westminster Quay, and Surrey Central stations pop up above the bungalows and trees along the Expo line. In this century, the Millennium-Evergreen line through East Vancouver, North Burnaby, and Port Moody-Coquitlam has created high-density mini-cities at Brentwood and Lougheed – a leap from 1960s shopping malls directly to "complete communities" of renters and owners in towers that can be seen from miles away.

The Millennium SkyTrain Line opened in 2002 and linked to the 1986 Expo line in a loop from Broadway-Commercial to New Westminster. It was criticized as a pet project of Premier Glen Clark, bringing investment to the working-class parts of the region that supported his NDP government. Commentators noted that it is within earshot of the Expo Line through East Vancouver and suggested that a north-south line, eventually built as the Canada Line to Richmond and YVR in time for the 2010 Olympics, would have been a better investment and spurred stronger ridership. Was that criticism justified? For most of each day, two-car trains are all that are needed on Millennium-Evergreen, while six- and eight-car trains are packed with passengers on the Expo and Canada lines.

As mentioned on page 32, the Broadway subway extension of the Millennium Line and its likely impact on the established renters' community there became a major issue in the 2022 Vancouver election. The idea that it would create a second downtown for Vancouver, rather than spreading development and jobs more equitably through the region, was criticized by unsuccessful candidates. The support of UBC and the First Nations-owned Jericho development suggest that the subway will eventually be extended all the way to Point Grey.

The view in 2022 from Queen Elizabeth Park, looking to the northeast across the bungalows of East Van and Burnaby to the towers of Brentwood jutting into the misty air. Atop Burnaby Mountain (in the background), Simon Fraser University may get a direct connection to the SkyTrain via a gondola from the Production Way-University station in 2026.

Transit-oriented tower developments haven't necessarily been a boon to affordable housing supply. Burnaby was the worst, with hundreds of rental apartments razed and few new ones built; between 2011 and 2019, Metrotown alone lost 685 rental apartments to make way for condo towers. As services lagged, Burnaby continued to collect Community Amenity Contributions from developers and amassed a billion dollar reserve fund.[28]

This policy failure contributed to the replacement of its long-established civic government, including its NDP-connected Mayor Derek Corrigan, and the new council's adoption of a one-for-one replacement of rental units in any redevelopment. Burnaby was also the first city in BC to mandate rental-only zoning.[29] The new council headed by Mayor Mike Hurley, a former firefighter, featured the Green Party's Joe Keithley, formerly known as lead singer "Joey Shithead" for the punk band DOA.

For years, the unaffordability of housing at transit hubs was pushing people further away. A decade ago, Coquitlam Mayor Richard Stewart said: "It's almost impossible to get purpose-built market rental housing development in the suburbs. Economically, it doesn't work." He noted that the alignment of the Evergreen Line was putting its stations close to rental houses, making them "unviable."[30]

The transit-oriented lifestyle still has to make room for the car, at least in Burnaby. An 80-storey tower under construction next to the Lougheed SkyTrain station made the news not just for its height, but because it had to include 14 storeys of parking according to city regulations. That cost of $50 to $100 thousand per unit would be passed on in the purchase price and rents.[31]

The situation became even more complex with the pandemic that began in the spring of 2020. Population data from Statistics Canada showed that Vancouver lost 6,780 people over the subsequent year; regardless, its property prices increased. Surrey gained 13,000 new residents.[32] Working from home was technically possible, even desirable, but difficult in small condo spaces. Demand for larger homes pushed people far out into the Fraser Valley. It was a trend noted across the country. Bloomberg News reported that Toronto's urban area lost nearly 100,000 of its residents, three quarters of whom moved to other parts of the province in 2021–2, but gained almost a quarter million from immigration.[33]

In Metro Vancouver, Langley Township has seen steady growth in its rural areas outside the Agricultural Land Reserve (ALR). The Willoughby district between Langley City and Highway 1 has been built out with townhouse clusters and apartments. South of Langley City around 40th Avenue, the semi-rural Brookswood area has recently been rezoned for detached housing. But Chilliwack, where housing prices were red-hot during Covid, is predicted to see the biggest decline in home values in BC.[34] It's too far away, presumably.

What's it like to live in an "Amazing Brentwood" (as it is now branding itself)? *Sun* columnist Douglas Todd wrote about the glassy crossroads of the Canada Line with Marine Drive in South Vancouver – the only real hub of towers created by that SkyTrain route – and summed it up as "Nice views. Handy transit. Intense street traffic. Convenient shopping and services. But bland character, at least so far."

Todd quoted UBC's Patrick Condon, who noted that Metro Vancouver politicians had embraced the tower district-transit station model more avidly than most others in North America, and said that the "lifestyle is completely different from one enjoyed in traditional neighbourhoods, like Kitsilano or Commercial Drive, where you will see lots of people you come

[28] Jen St. Denis, "Metrotown rental demolitions shake up Burnaby's left-wing political dynasty," *The Star Vancouver,* July 17, 2018.

[29] Kelvin Gawley, "Burnaby passes bold rental-only zoning plan to protect, create housing," *New Westminster Record,* May 28, 2019.

[30] Kelly Sinoski, "Soaring land costs drive some buyers away from transit hubs," *Vancouver Sun,* April 12, 2014.

[31] Amy Judd and Aaron McArthur, *Global News,* June 13, 2023.

[32] Martin MacMahon, "Vancouver's population drops," *CityNews,* January 13, 2022.

[33] Randy Thanthong-Knight and Erik Hertzberg, "People are leaving Canada's biggest cities amid a housing crunch," *Financial Post,* January 11, 2023.

[34] Eric Welsh, "BCREA predicted Chilliwack will see BC's biggest home value decline," *Chilliwack Progress,* September 9, 2022.

Arriving on the SkyTrain at Brentwood Town Centre, a.k.a. "Amazing Brentwood," with Lougheed Highway traffic streaming past below. When it opened in 2002, the sleekly futuristic station appeared completely out of character with the highway, mall, parking lots, and low-rise commercial buildings, but the surroundings have caught up. Architects Perkins & Will received a Governor General's Medal in Architecture for the station design.

SURVIVING (A VERB) 111

At the game, 1995.

35 "Highrise clusters not so bad, but a 'bit cold,'" *Vancouver Sun,* January 21, 2023.

36 "From a city of glass to a city of care," *The Tyee,* December 12, 2022.

to know and there is a general diversity of interesting landscapes and buildings."[35] And businesses – chain stores lease most of the spots in these tower communities.

"As a lifelong Vancouverite, I often wonder: why is it so easy to feel alone here?" wrote Kaitlyn Fung, repeating a commonly held belief about the city that goes back decades, long before the imposed isolation of Covid. She quoted a national study in 2015 that ranked Vancouver as the unhappiest city in the country, and a Vancouver Foundation report from three years earlier which concluded that social isolation and loneliness were the most important issues facing the city.[36]

Is urban design the cause of social isolation, or is it the Internet and the tenuous camaraderie of social media? Too much diversity, too many neighbourhoods of different cultures to mesh? Or just the scale of cities, whether it's a Vancouver or a Surrey? Is the friendliness of, say, a Kamloops or a Qualicum Beach due to its size or the homogeneity of its population?

The practicality of a work-from-home life, saving hours every week in commuting time as well as the costs of a car or transit, has changed the paradigm completely, threatening myriad small businesses in downtowns like Vancouver's which counted on a lunch and coffee trade, as well as the viability of the office buildings themselves. Increasingly, labour settlements hinge on this home-office balance. A real-estate survey in 2023 said the office vacancy rate in Vancouver is more than 12 percent, about 20 times the apartment vacancy one. Although it may be practical, loneliness on a computer screen with Zoom or Teams meetings might be the result.

And yet some condo clusters have recreation rooms and host active communities of friends who watch videos, play cards, and organize outings together. They appear to work as well as the best traditional neighbourhoods of detached houses, gardens and over-the-back-fence chats. Maybe the key word there is "condo," and the shared connection of a relatively homogenous population. The co-ops of an earlier generation accomplish the same thing. Although there have been a few co-housing projects completed recently in Vancouver, there's less of a grass-roots desire to come together to create a communal experience than there was in the 1970s. Perhaps people are too individualistic now, too much living in their own silos.

It's Not Easy Being Green

The trendy term is "15-minute city," the idea that all one's daily needs can be found within a 15-minute walk from home, cutting down on energy use and infrastructure costs. Old pre-auto neighbourhoods, whether in New Westminster, Fort Langley, North Van City, Ambleside, or the Vancouver set of West End, Strathcona, Mount Pleasant, Kitsilano, and Grandview (with Kerrisdale thrown in for good measure) accomplish this as well as the poster child *arrondissements* of Paris.

Planners and architects would like to *build* green "15-minute cities" such as Port Moody's Newport Village by Bosa Developments, but, as discussed

Being green in the 15-minute city, 1995. An ever-improving transit system and the invention of diverse personal mobility contraptions – everything from ebikes to electric scooters to scary hoverboards – has kept Vancouver in the vanguard of cities that are reducing automobile use and congestion. Electrically assisted cargo bikes with a bin in front, or with two seats behind the rider, take a parent and kids swiftly along the bike routes, or deliver food to time-starved urbanites.

SURVIVING (A VERB)

37 Marcus Gee, "Pickup trucks are a plague on Canadian streets," *Globe & Mail,* July 25, 2021.

on pages 44–47, there's comparatively little support for retaining the buildings of the existing ones, those described in American architect Carl Elefante's phrase that "the greenest building is the one that's already built."

Tower living is embraced by some, and the "Missing Middle" of duplexes, rowhouses and six-storey apartments is touted as a way to "make room" for new people while the city feels ever more crowded. Meanwhile, daily news reports list weather disasters and confirm climate change. However, the small sedans of decades past have been replaced by enormous pickup trucks and SUVs polished to the gleam of a 1960s-era custom car show. Even narrow neighbourhood streets feel this "obnoxious assertion of dominance and division."[37] "Safetyism" – the belief that a huge vehicle will help your family survive any accident – is some people's justification. Who could claim that humans are rational creatures?

Ford's F-150 pickup has been the best-selling "auto" in Canada for years. As Marcus Gee wrote in the *Globe*, few of them are used for hauling anything. He quoted author Angie Schmitt that American pickups have added almost 1,300 pounds to their weight in the past 30 years. Any improvements in emissions or fuel efficiency by the auto industry have been wiped out by the increased size and weight of new pickups and SUVs.

Yet, for every step back there is a step forward. The Agricultural Land Reserve, 50 years old in 2023, was a giant step forward. Proclaimed by the incomparably progressive NDP government of that time, it sought to protect the most fertile land in this mountainous province. Food security was the underlying concern, combined with an understanding that greenbelt, whether or not it was used in the short term for growing essential food, would limit the sprawl that cities like Los Angeles and Toronto were experiencing. Metro Vancouver's municipalities were right behind them.

Remarkably, the ALR survived the return to the conservative Social Credit governments of the late '70s and '80s, but its viability was chipped away by the Agricultural Land Commission's inability or unwillingness to limit the size of residences and position them in such a way that the property's productive capacity was retained. When Christine and I lived on 10 acres in South Langley in the '90s and 2000s, most properties had relatively modest houses – it was an area divided between berry farms, vineyards, and horse ranches, the last having a lot of stables and riding rings under spreading roofs, but at least they were easily reversible. There were a few mansions

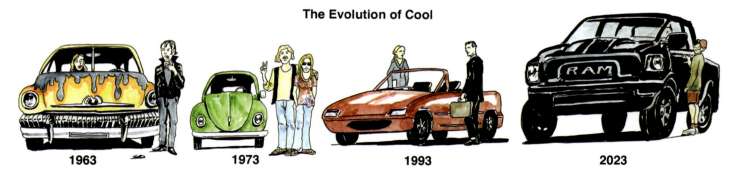

The Evolution of Cool

1963 1973 1993 2023

Agricultural land on No. 6 Road in "Ditchmond" just north of the Steveston Highway; on the left, one of the big new homes, and below, a typical small farmhouse from the 1920s nearby.

on properties with views, set way back from the road, and other large places that housed the extended South Asian families who produce much of the region's food.

Richmond has the dubious distinction of hosting the most mansions on its excellent farmland, with one in particular of 22,300 square feet at 9431 No. 6 Road being offered for sale in 2021 for $22 million.[38] Religious institutions set up shop on agricultural land along Highways 99 and 91.

After years of supporting the mansions, or at least tolerating them, and two years of debate about speculation on farmland, Richmond Council voted unanimously in December 2018 to reduce the maximum house size to 400 square metres (4,300 square feet). The previous month, the provincial government enacted its own rule, Bill 52, that limited a house's size to 500 square metres (5,400 square feet). By comparison, a typical East Vancouver *lot* is 370 square metres (3,960 square feet): 33 feet by 122 feet.

Metro Vancouver is not alone as a fool's paradise, of course, but its precarious food supply, as California swings from lengthy drought to record floods in the blink of an eye, ought to keep everyone awake at night. Ironically, it is a piece of land *not* in the ALR that produces a significant amount of the vegetables consumed in the region, including 70 percent of the potatoes harvested in the province from May to August.

A former radar site of a square kilometre in Campbell Heights about six kilometres north of the American border, on 36th Avenue at 192nd Street just west of the Langley Township boundary, it has sandy soil and can be planted earlier in many years than delta lowlands. It has been leased to Heppell's Potatoes for 50 years, providing millions of carrots, parsnips, cabbages and other vegetables, as well as potatoes, to BC stores. The alarm was sounded early in 2023 that the federal government was considering disposing of the property, possibly to become an extension of the huge Campbell Heights Business Park that has been created over the past decades along 32nd Avenue.[39] However, Surrey Council voted in February 2023 to support the inclusion of the Heppell farm in the ALR.

The business park's current expansion plan will negatively affect salmon spawning on the Little Campbell River, yet was supported by Metro Vancouver in 2022 despite objections from the Semiahmoo First Nation and environmentalists. As with everywhere, it is "contested space."

38 "A look inside: Richmond megamansion on farmland relisted for $22 million." *Daily Hive Urbanized* blog, February 24, 2021.

39 Glenda Lymes, "Surrey vegetable field could be added to ALR to save it from development," *Vancouver Sun*, January 15, 2023.

The direct impact of climate change will be felt here with sea-level rise and the increasing frequency of storms such as the atmospheric rivers of November 2021 that flooded Sumas Prairie farmland and put a temporary dent in the region's dairy and produce industries. Sumas Prairie is the former Sumas Lake of pre-colonial times, where the Semá:th people lived in stilt houses. The lake had served as "a spawning route and rearing habitat for salmon, and supported many different kinds of waterfowl, fish, plants and animals. In the language of the day, fertile farmland was 're-claimed' from the lake bottom to facilitate Xwelitem settlement and agriculture in the area; however, the draining of the lake can also be seen as the greatest single loss of a productive waterway in S'ólh Téméxw. Moreover, the event took place without the consultation of those whose storied past was intrinsically linked to the lake."[40] The provincial government of farmer/premier "Honest John" Oliver initiated the draining of the lake in the 1920s.

40 Sumas Lake Transformations, in *A Stó:lo Coast Salish Historical Atlas*, p. 104.

41 "Climate change and sea-level rise," vancouver.ca.

Richmond has been maintaining, and raising, its dykes since the 1948 Fraser River flood. A 2011 provincial government study concluded that local governments should prepare themselves for at least one metre of sea-level rise over this century. Surrey's coastal floodplain's adaptation cost was estimated at $1.5 billion. Flooding of land, largely agricultural, is predicted for the Boundary Bay region, but in South Surrey the charming little community of Crescent Beach is in the tidal crosshairs; the future of its 400 houses is at stake, following a proposal by Surrey to stage a "managed retreat" – buying up the houses and allowing the area to revert to its natural state, which might cost no more than building some kind of dyke or barrier to protect the community.

Vancouver continues to allow construction, including the 6,000 unit Senákw development at the mouth of False Creek, on land identified in its own coastal floodplain map as "vulnerable to flooding due to a major storm" today and "vulnerable to flooding," period, by 2100.[41] And, in what seems like an evangelical belief in dyking and earthquake resilience, the provincial government is building the new St. Paul's Hospital on land that, a century ago, was the tidal flats of False Creek east of Main Street – land filled for the yards and stations of the Great Northern and Canadian Northern Pacific railways. What could possibly go wrong?

Thriving amidst the human folly are crows, raccoons, coyotes, black squirrels, and of course the Canada Goose species, our country's most identifiable brand along with hockey and maple syrup. After years of semi-tolerance, the newly elected Vancouver Park Board decided in 2023 to control the booming, pooping population with a program of egg-addling, asking the public to report nesting sites and human feeders of wildlife who could be fined $500.

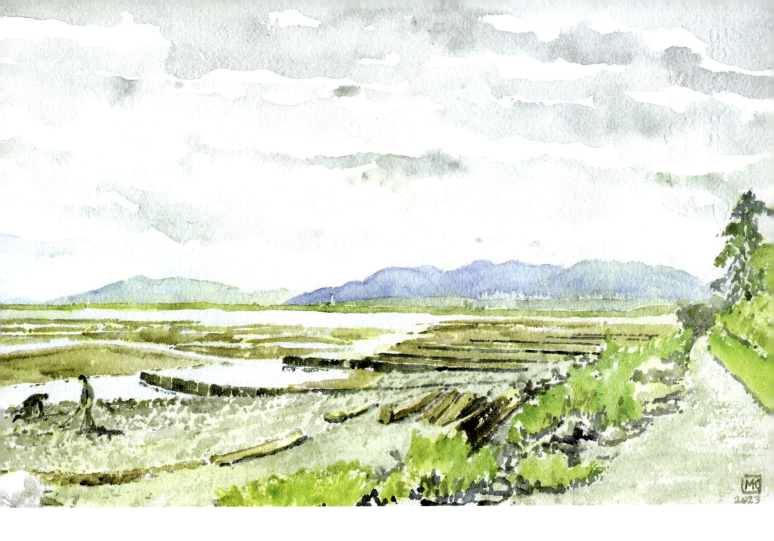

(Below) Two Walker & Ward postcards from the 1950s of Crescent Beach, showing the mix of small cottages and more substantial homes built along the beachfront, and the beginnings of a high-tide protection system.

(Above) The same beach at low tide in 2023, looking north toward the towers of Metrotown while a pair of coin scavengers worked the rocky shoreline with metal detectors. A hand of iron fingers extends into the water to stabilize the beach. The City of Surrey has built a berm between the sea (the pathway where I sat to paint) and Crescent Beach's cottages (out of the picture on the right and about three metres below the top of the berm). The cottages are at sea level and would be inundated if the berm were breached.

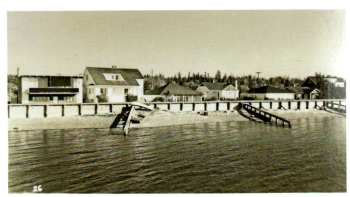

Beach Front Homes, Crescent Beach, B.C.

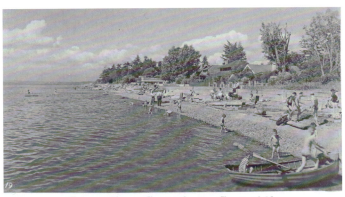

"Tides in" Centre Beach, Crescent Beach, B.C.

SURVIVING (A VERB) 117

The Great Escape

A couple of generations ago, a cabin or cottage on a lake or the Salish Sea a.k.a. Strait of Georgia seemed almost like a birthright, whether you were a member of a blue- or white-collar family. Thirty years ago, I wrote that "the language seemed to reflect the distinction between interior and coast: a small dwelling on a fishing lake was a cabin, while a Gulf Islands hideaway was usually a cottage. In earlier years, and to some extent still (although now people range so much farther afield and travel internationally on a whim), you could divide Lower Mainlanders into two groups: those who holidayed on fresh water and those who went to salt water: the Gulf Islands, Bowen or the other Howe Sound islands such as Gambier or Bowyer, or the Sunshine Coast. We were fresh-water people, and spent summers in a cabin on Shuswap Lake in the Interior.

"There were also people who had summer places at Crescent Beach or rented at White Rock, which seems absurd now that those little resorts have been submerged by vast tracts of housing inhabited by commuters. Much more remote, and exclusive because of it, is Savary Island and its sandy beaches; property there is handed down from generation to generation, moms still summer there with their children, and dads band together and charter seaplanes to visit on weekends."[42] Cortes is another island with a regular back and forth of the "Daddy planes" flying from the terminus at Coal Harbour. The carbon footprint of that kind of lifestyle is huge.

They were summer places. Islands had very small year-round populations and the province itself 50 years ago was home to little more than two million people. Today, with about the same amount of land and parks, there are five million people. Even with a reasonable expansion of road and ferry capacity the place is feeling decidedly crowded.

"Spontaneous park culture," as Port Moody Mayor Rob Vagramov described the ability of people to get a quick nature break on their weekends, has disappeared in some parts of the region. The online booking systems for parking suffer under the crush of people looking to go to Buntzen Lake, Belcarra, Cultus Lake in Chilliwack, Cypress Bowl in West Vancouver, or Crescent Beach.[43] The provincial campground system is similarly overloaded,

42 *British Columbia in Watercolour,* p. 48.

43 Glenda Luymes, "Is BC park space keeping up with population growth?" *Vancouver Sun,* August 5, 2022.

(Right) Broken-down motor home in a rest area on Highway One, Abbotsford, 2022.

with stories each year of the reservations website crashing within minutes of summer spaces becoming available.

Getting on the road with a tent or an old van was the spontaneous escape a generation ago. Unlike in longer-settled places like Ontario or Quebec, a dirt road rarely led to a locked gate and private property sign. People camped responsibly, or at least most of them did, on Crown land and, indeed, on traditional Indigenous territory, without asking permission.

"You can only camp (on Crown land) for two weeks, but there's nobody enforcing that. And where do the people go if you start enforcing it?" asked Patti MacAhonic, Fraser Valley Regional District Area E director, in response to an abandoned encampment near the Chilliwack River in 2022.[44] Appalling garbage-strewn camps with abandoned vehicles dot the province. Thousands of people, unable to afford a conventional home, are living in campervans and motorhomes.

The RV parks and pullouts in areas like the Fraser Canyon are full of semi-permanent residents, as are rest areas along Highway One through the Fraser Valley – the movie *Nomadland* in real time. The few unsupervised corners of Vancouver had similar camps: Vernon Drive under the Grandview Viaduct and Slocan Street near the Grandview Highway were two of them. Even the parking lots at Spanish Banks below the mansion belt (page 108) hosted a campervan community, with one story describing a man who drove his Tesla for Uber during the day and slept in his van next to the beach at night.[45]

Although it's illegal to park large vans on city streets between 10 pm and 6 am, campers look for the edges of parks in areas such as East Van, hoping not to be noticed, reported and moved along. What looked like an escape for people in the past, or even a romantic lifestyle choice in the hippie-VW Van era, is now everyday reality.

44 Glenda Luymes, "Frustration: Volunteers clean up one abandoned Chilliwack encampment as another pops up." *Vancouver Sun,* December 30, 2022.

45 Nono Shen, "He sleeps in a van but drives a Tesla: life on wheels in Vancouver's camper community." *Canadian Press,* January 6, 2023.

(Below) The campervan that parked on McLean Drive next to Woodland Park for the first two years of Covid.

SURVIVING (A VERB) 119

46 Angie Oshika, "What happens when boomers sell their houses?" *Vancouver Courier,* September 6, 2013.

47 Ashley Joannou, "Sunshine Coast breweries brace for drought water restrictions," *Global News,* October 18, 2022.

A decade ago, some real-estate analysts were predicting "a flood of houses suddenly listed for sale across Canada, overwhelming supply and causing prices to drop dramatically," a nightmare scenario for them as Baby Boomers retired and downsized. But a Royal LePage survey study reported that nearly half of Boomers who planned to move intended to find or build a very similar new home, the same size or bigger, with a yard and garage for all their toys.[46]

The "great escape" for many Boomers was a dream retirement to a year-round property on the Gulf Islands or, more practically, to the communities on the east side of Vancouver Island: Duncan, Parksville, Qualicum Beach, Courtenay and Comox, all within a reasonable drive of Victoria's hospitals. More than half the residents in Qualicum Beach, Sidney, Parksville, the Southern Gulf Islands, and the Nanaimo suburbs are more than 65 years old. Compared with Metro Vancouver, they are very White – not as racially diverse. In the Okanagan, Penticton, Osoyoos and Vernon have aged populations, while Kelowna has a more youthful family vibe.

The swarm of people moving to the small islands and the Sunshine Coast has created its own problems: crowded ferries, lack of health care, lack of rental accommodation for "service workers" including builders and BC ferry crews. Home prices have spiked. Travellers have difficulty catching ferries to the Southern Gulf Islands that have become overweight, as well as crowded, with heavy construction vehicles. The Sunshine Coast, which is in the middle of a building boom of large houses, has discovered it is running out of water, with Stage 4 restrictions in the summer of 2022 shrivelling vegetable gardens and even shutting down a local craft brewery in October, a time when the rains have usually returned.[47]

What about that dream cabin in the pine forests of the Interior? Sadly, climate change has made every summer a wild fire and smoke crisis, with the 2023 season the worst one ever. This was not something we worried about 40 years when we built a little shack in the mountains east of Princeton (left).

Perhaps it's better, we say to ourselves, to stay in the city and work to make it a better place.

The cabin we built in 1982 with a chainsaw and hand tools; 200 square feet with a loft for our daughter; off the grid; no Internet because it hadn't been invented; a woodstove and buckets of water from the creek; accessible on skis for winter visits. Would people spend even summers in a place this primitive now? We sold it in 1989. It was demolished in 2022 and replaced with a new house.

120 SURVIVING (A VERB)

There's a tranquil spot at Georgina Point on Mayne Island where I sat in 2021 and looked back across the Salish Sea to the mainland. It was a clear day, the North Shore mountains and the towers of Vancouver faintly visible in the left distance but so far away as to be just a memory. As I painted, the water lapped against the rocks and a seal swam slowly by.

A gnarled arbutus tree clings to the rocks there – like many on the BC coast, it is ailing, slowly dying from a fungus and the repeated droughts of climate change. I thought of the totem poles on Haida Gwaii, left to fall to the forest floor and slowly return to the soil, not preserved the way the settler culture – my culture – tries to do with its art, buildings and monuments. And how many years I've spent watching Vancouver change and evolve, trying to keep its past alive.

Acknowledgements

As evidenced by the number of footnotes on these pages, this book has many authors. Metro Vancouver is extremely fortunate to have so many excellent journalists interpreting and commenting on the "contested space" that is the theme of our life here. I want especially to mention the invaluable writing and analysis of Douglas Todd, John Mackie, Joanne Lee-Young, Dan Fumano and Lisa Cordasco in the *Sun*; Frances Bula and Kerry Gold in the *Globe & Mail*; Christopher Cheung, Jen St. Denis and Andrew Nikiforuk in *The Tyee;* and Charlie Smith in the (old) *Georgia Straight.* Patrick Condon of UBC, SFU's Andy Yan, and developer-architect Michael Geller contributed to my evolving thinking with their insights on the city. Although I rarely agree with their conclusions, the learned analyses of Tom Davidoff, Nathanael Lauster and Jens von Bergmann have been helpful. Blogs I follow include *CityHallWatch* and the upbeat posts by Kenneth Chan on *Daily Hive Urbanized*.

Coast Salish artwork, especially by Susan Point and her family, has been a touchstone as I come to understand reconciliation with Indigenous people, both of the three local First Nations and the many migrants who have settled in the "colonial construct" known as Vancouver. My colleagues at the Vancouver Historical Society, working to present a diverse set of lectures every year, deserve credit for broadening my perspective on the City's history. And no study of Vancouver could avoid consulting the City of Vancouver Archives, a priceless asset for 90 years: my thanks to City Archivist Heather Gordon and her staff.

I also want to acknowledge my neighbourhood of Grandview, bisected by Commercial Drive, for demonstrating that a medium density, mixed, walkable place can be both historic and evolving, with a carbon footprint probably lower than the glassy poster-child concrete towers of "Vancouverism." My neighbourhood *and* my neighbours – in the thirteen years since Christine and I returned to Vancouver from Australia and settled here, we have made dozens of friends, both the people who live here and those who work in local stores such as Donald's Market and Uprising Bakery. Be it ever so humble, this is what paradise looks like.

My thanks go to my publisher, Louis Anctil of Midtown Press, who has been steadfast in his support, and to Denis Hunter for production assistance. And my greatest debt is to Christine Allen: my wife, best critic and editor, and companion on all our adventures.

Bibliography

Books relating to Vancouver by Michael Kluckner

1984: *Vancouver The Way It Was*. North Vancouver: Whitecap Books (10th anniversary edition, 1994).
1990: *Vanishing Vancouver*. North Vancouver: Whitecap Books.
1993: *British Columbia in Watercolour*. Self-published.
1996: *Michael Kluckner's Vancouver*. Vancouver: Raincoast Books.
2005: *Vanishing British Columbia*. Vancouver: UBC Press.
2006: *Vancouver Remembered*. North Vancouver: Whitecap Books (2nd edition, 2011).
2012: *Vanishing Vancouver: The Last 25 Years*. North Vancouver: Whitecap Books.
2020: *Here & Gone*. Vancouver: Midtown Press.

Adderson, Caroline, et al. *Vancouver Vanishes*. Vancouver: Anvil Press, 2015.
Belshaw, John (ed.). *Vancouver Confidential*. Vancouver: Anvil, 2018.
Carlson, Keith Thor (ed.). *A Stó:lo Coast Salish Historical Atlas*. Vancouver: Douglas & McIntyre, 2001.
Francis, Daniel. *Becoming Vancouver*. Madeira Park: Harbour, 2021.
Itter, Carol, and Daphne Marlatt. *Opening Doors: In Vancouver's East End: Strathcona*. Madeira Park: Harbour, 2011 (reprint of the original).
Lupic, Travis. *Fighting for Space*. Vancouver: Arsenal Pulp, 2018.
Luxton, Donald, and Lilia D'Acres. *Lions Gate*. Vancouver: Talonbooks, 1999.
Mackie, Richard Somerset. *Island Timber: A Social History of the Comox Logging Company*. Winlaw BC: Sono Nis Press, 2000.
Mansbridge, Francis: *Cottages to Community: The Story of West Vancouver's Neighbourhoods*. West Vancouver Historical Society, 2011.
Ravvin, Norman. *Who Gets In: An Immigration Story*. University of Regina Press, 2023.
Robin, Martin. *The Rush for Spoils: The Company Province 1871–1933*. Toronto: McClelland & Stewart, 1972.
Siemens, Ruth Derksen, and Sandra Borger. *Daughters in the City*. Vancouver: Fernwood Press, 2013.
Walton, Jean. *Mudflats Dreaming*. Vancouver: Transmontanus, 2018.
Wyness, Anne. *The Larder of the Wise*. Vancouver: Figure 1 Publishing, 2020.

Index

"15-minute city," 112–13

affordability. *See* housing affordability.
agriculture: land, 89, 110, 116; ALR, 114–15
Army & Navy Department Store, 101
apartments. *See* housing, rental
architecture: 18, 37, 46, 54, 114, 122; demolition of, 39; downtown, 40–45; downtown office supply, 40, 43, 112; downtown waterfront, 40–41; re-use of, 40, 43; West Coast style, 39, 59–60, 71–72, 84–85, 91–92, 95, 102–103, 106, 111; "starchitects," 102; art and art spaces, 34

Barman, Jean, 9, 54
beaches, 12, 15, 18, 80–81, 118–120
Beasley, Larry, 26
Binners, 96
Black community, 76–77, 101
Boddy, Trevor, 102
Boomers, 29, 87, 120
Bowen Island, 81–82, 118
Broadway Plan, 26, 32, 35–37
builders (tradesmen), 31–32, 36, 101, 120
Burnaby, 7, 22–23, 26–27, 32, 76–77, 81, 83, 109–11

Canadian Pacific Railway (CPR), 11–12, 22–23, 43–44, 56–61, 66, 77, 89
Cannell, Kelly, 9
Chinatown, 34, 58, 69, 74–76, 88, 96
Chinese community, 28, 30, 63, 67, 74–77, 83, 93, 95, 98, 108
churches, 30, 36, 43, 47, 51–52, 62, 69, 76, 88, 92, 101
climate, 4, 15, 21, 76, 105
climate change, 44, 85, 114–16, 120–21
Coal Harbour, 10–11, 27, 41, 56, 88, 102, 104–05, 118
Cohen, Jacqui, 101
Community Amenity Contributions (CAC), 37, 59, 110
commuting (working from home), 43, 104, 112, 118
condominiums: luxury, 4, 15, 27–28, 32, 39, 43–44, 47, 56, 71, 75, 92, 95, 102–06; renting of, 33, 87, 109–11; winding up, 29
Condon, Patrick, 26, 28–29, 32, 110, 122
Covid: impact of, 15, 25, 32, 43, 74, 87, 110, 112, 119
corner stores, 46–47, 79, 98, 101
cottages and cabins, 50, 76, 79–82, 102, 117–20
Crescent Beach, 80, 116–18

Davidoff, Tom, 28, 50, 122
Davies, Libby, 26, 92, 94
Delta, 7, 22–23, 26
density: 32, 36–37, 50, 52, 99–100, 122; "hidden," 52–53; Missing Middle, 47, 50, 52, 114
Downtown Eastside (DTES), 12, 34, 74–75, 87, 92–101; DERA, 94
drugs, 7, 32, 94, 101
Dunbar, 29, 34, 46, 48, 56

EcoDensity, 26, 34

Elefante, Carl, 114
Eriksen, Bruce, 92–94
environmental issues. *See* climate change
Expo 86, 6, 92

Fairmont Academy, 54–55
foreign buyer tax, 27–28
foreign investment (in real estate), 27, 108
Francis, Daniel, 12, 91

Gastown, 22, 40, 57, 71, 76, 94, 100–01, 105
Geller, Michael, 29, 33, 122
gentrification, 30, 48, 75, 94–95
Gordon, Josh, 27
Grandview, 32–33, 39, 48, 52–53, 112, 120
Graves, Judy, 101
Gulf Islands, 84–87, 118, 120; Mayne, 121

harbour. *See* Port Metro Vancouver
Harland Bartholomew Plan, 34, 36
Hardwick, Colleen, 26
Hastings Townsite, 22
heritage: attitudes toward, 39, 44, 47, 78–82; city policy on, 39, 49, 56, 71–72, 74, 81, 97–100; environmental value retention of, 40, 44, 47, 50, 83; incorporation into new developments, 40, 50–51, 73
Hogan's Alley, 76–77
homelessness, 7, 12, 65, 68, 74, 87–95, 101; living in vehicles, 119
Horseshoe Bay, 79
hospitals, 54, 66–67, 70, 72, 88, 94, 116, 120
hotels, 4, 40, 44–45, 57, 74, 105; single room occupancy (SRO), 92, 94–95, 97–101
houseboats, 88, 102, 104
houses: adaptability to change 43–44, 46, 54–55, 73; basement suites, 33–34; converted to rental, 34, 47, 65–69; duplexes, 34, 53–54, 66, 114; energy efficiency, 46–47; mansions on farmland, 114–15; moving, 21, 32, 58, 84–85, 95, 120
housing affordability, 12, 27–33, 37, 39, 43, 47–53, 76, 87, 110
housing co-ops, 79, 112
housing investors, 27–29, 32–33, 92, 104
housing, public (subsidized), 94–95
housing, rental: evictions, 30, 81, 91, 104; programs, 27, 33, 52; proportion of tenants to owners, 7; rents, 7, 27, 30, 33–34, 46, 69, 81, 92, 95–96, 110; rooming houses, 33, 47–48, 52, 62, 65, 69–70, 94, 105–06; supply, 26–33, 40, 43, 47, 110, 120; towers, 4, 10, 15, 26, 30, 41, 43, 87, 102, 109–10, 117, 121–22;
housing speculation, 26–29, 31, 50, 115

"Icepick," 40, 43
Indigenous matters: 6, 22, 31, 76, 80, 83, 110, 119; art, 9, 122; Deadman's Island, 10; land rights, 22, 59, 101; homelessness, 101; reconciliation-residential schools, 22, 36, 54–55, 122; Sen̓áḵw and other developments, 9, 22, 43,

54–55, 85, 88, 101, 109, 116
Internet, impact of, 34, 87, 99, 112, 120

Japanese community, 58, 60, 64, 67–69, 76–77, 83, 93
Jewish community, 60, 63, 66
Jones: Con, 97; Petley, 6; Craig, 28

Kerrisdale, 8, 22, 32–33, 48, 57–59, 65, 92, 99, 112
Kitsilano, 18, 22, 32–33, 39, 47–48, 57, 60, 69, 85, 88, 91, 110, 112

Langley: City of, 6–7, 22, 32, 81, 110, 114; Fort, 7, 112; Township, 7, 110–15
Lauster, Nathaniel, 26, 122
Lee, Carol, 74–75
Lemon, Robert, 44, 72
"Little Saigon," 30
livability, 26
loneliness (social isolation), 110–112

Maple Ridge, 32
Marine Building, 40–41
McRae: A.D., 59, 63–65, 67; Blanche, 59
Meikle, Marg, 25
Mennonite: community, 76; maids, 89
"Missing Middle" *See* density
Mount Pleasant, 34, 39, 53, 59, 112

Naam, 46
neon, 45, 74–75, 95, 97–98
New Westminster, 7, 22–23, 26, 39, 52, 109, 112
NIMBY, 26, 28
North Shore, 13, 22–23, 26, 39, 70, 85, 104, 121
North Vancouver, 7, 22–23, 60, 64, 70, 85, 112

Oakridge, 6, 32, 36, 43
office supply (vacancies), 40, 43, 112

Paakspuu, Walter, 99
parks: 6, 18, 37, 58, 62, 77, 80–81, 84, 116, 118-19; Belcarra, 80–82 112; Callister, 97; Con Jones, 97; CRAB, 12, 101; Crippen, 82; Maple Grove 8; Oppenheimer, 101; Pacific Spirit, 108; Pidgeon, 101; Queen Elizabeth, 59, 109; Stanley, 102, 104–06; Strathcona, 101; Vanier, 22; Woodland, 119
pets, 25
Point, Susan, 9, 122
Point Grey, Municipality of, 18, 20, 22–23, 34, 48, 56–58, 61–62, 65, 109
population change, 22, 26, 29–31, 34, 44, 48, 53–54, 93, 110, 118
Port Metro Vancouver, 6, 12–13, 15, 18, 41
Port Moody, 7, 22–23, 56, 79–81, 109, 112, 118
Price, Gordon, 32
property rights, 33, 56, 60–62, 65, 73
public art, 7, 75, 102

racism, racialized groups, and government policy, 28, 30, 60, 63–64, 74–77
real estate industry, 27, 29–31, 50, 67, 72, 108, 112, 120
retail, 25, 29–30, 34, 36, 46–47, 101, 110–12

Richmond, 7, 22–23, 26, 74, 77, 104, 109, 115–16
Robertson, Gregor, 27, 28

San Juan Islands, 84
Savary Island, 118
schools, 22, 36, 54–55, 57, 59, 77, 85
Shaughnessy, 22–23, 33, 39, 50, 56–74, 89, 102; Golf Club, 57, 59, 62; SHBRA, 62, 66, 69–70; SHPOA, 65–70
Sim, Ken, 26, 101
Simon Fraser University (SFU), 27–28, 32–33, 52, 109, 122
SkyTrain. *See* transit
Smokey D, 75
South Asian: community, 63, 76, 91, 115; Sikh, 91–93
South Granville, 33, 57
South Vancouver, Municipality of, 22–23, 56–58, 65, 110
Spaxman, Ray, 36
speculation. *See* housing speculation
SROs. *See* hotels
Steveston, 57, 83, 115
Stewart: John, 64; Kennedy, 26, 32; Richard, 110
Strathcona: neighbourhood, 34, 39, 47, 57, 65, 69, 74, 76–77, 112; Park, 101; School, 77
Sullivan, Sam, 26
Sumas Prairie, 116
Sunshine Coast, 118, 120
Surrey, 7, 22–23, 26, 32–33, 43, 54, 92, 109–10, 112, 115–17
Swanson, Jean, 94

Thom: Bing, 43, 102; Ron, 39
transit: public, 58, 92, 110, 112–13; Broadway subway, 26, 32, 109; bus, 25; Light Rail, 52; SkyTrain, 37, 50, 87, 109–11
Trutch, Joseph, 22, 56

Umberto's, 44
University of BC (UBC): campus, 9, 26, 28–29, 32, 64, 69, 109–10, 122; land, 32; News, 47: Press, 54, 71; Women's Club, 71

vacancy tax, 15, 50
Vancouver Heritage Foundation, 73, 76, 89
Vancouver Island: region, 26, 84, 87, 93, 121; communities, 120
Vancouverism, 26, 30, 122
von Bergmann, Jens, 47, 122

weather. *See* climate
Westbank Developments, 43, 102
West Coast, 11–12, 83
West End, 4, 13, 18, 20–21, 33, 43, 47, 57–58, 62, 102, 105, 112
West side, 13, 22, 26, 34, 50, 58
West Vancouver, 7, 23, 56, 60, 64, 70, 79, 81, 84–85, 118
White Rock, 7, 33, 118
Woodward's Department Store, 6, 82, 92, 94–95, 100–01
working from home. *See* commuting

Yan, Andy, 28, 30, 33, 52, 122

Zoning: By-law, 26, 30, 34, 36, 49–50, 52, 56, 64, 70–71, 105, 110–11; CD-1 (conditional), 36–37